THREADS *of* IDENTITY

*The author and publisher acknowledge
with gratitude the generous contribution of
Mrs Widad Said Khoury
towards the publication of this book*

THREADS *of* IDENTITY

Preserving Palestinian Costume and Heritage

Widad Kamel Kawar

RIMAL PUBLICATIONS

© Widad Kamel Kawar, 2011

The right of Widad Kamel Kawar to be identified as the author of this work has been asserted by her in accordance with the Copyright, Designs and Patents Act 1988.

All rights reserved. No part of this work, its text any or part of the illustrations and drawings, may be reproduced, stored in a retrieval system, or transmitted in any form or by any means, electronic, mechanical, photocopying, recording or otherwise, without the prior permission of the copyright owner.

First published 2011
Rimal Publications
Nicosia, Cyprus

ISBN 978-9963-610-41-9

Rimal Publications, Nicosia
and Melisende, London

For information on our publications, visit our websites
www.rimalbooks.com and www.melisende.com

Editors: Leonard Harrow and Nora Shawwa
Design: Salua Qidan, Syntax Design

Printed and bound at Calligraph, Lebanon
www.calligraphpress.com

Cover (from left) Helaneh Saleh, Nour Samara, Im Abdullah, Im Ghazi, Manneh Hazboun

Back cover (from left) Woman from Azazmeh tribe, Nathmieh Abdul al-Nabi, Helaneh Silhy, Im Amin, Helweh Bendak

Frontispiece Hand of Fatima, a silver amulet made by *Shihadeh* in Amman, 1968

For Kamel who is always by my side

Acknowledgements

Over the many years of collecting, documenting, researching and exhibiting Arab costumes, textiles and artifacts related to women's public and private lives, I have received inspiration, motivation and support from so many people. Here I can only mention a few of them.

First and foremost, I would like to express my gratitude to all women and their families who so generously allowed me into their lives, shared their histories and entrusted their dresses to me. This book would not exist had it not been for their openness, helpfulness, wit and compassion. It is my hope that this book will in many ways be an honour to their legacy.

I feel I must also mention those from whom I took my initial inspiration in traditional Palestinian costumes, such as Mrs Phyllis Sutton, who opened my eyes to the glories of Palestinian embroidery, Mrs Violet Babour, one of the first to start collecting Palestinian embroidery back in the 1930s; she donated samples of this embroidery to the British Museum, making it the first to house such a collection, and Myrtle Winters Chaumany, UNRWA's official photographer, who volunteered her summer holidays to photograph my collection thus making me realise its growing significance.

Others who touched my life through a similar passion for heritage and collecting are George al-Aama, Hervig Bartels, Mamdouh Bisharat, Anya and Elsa Bushnaq, Abdul Karim Gharabieh, Samia Halaby, Cecil Hourani, Raouf Abu Jaber, Leila Mantoura, Tania Naser, Edward Said, Lena Saleh, Brigitte Schon, Margarita Skinner, Yasmeen Zahran and Sally De Vries. In addition are all my dear friends who have devoted their lives to keeping embroidery and traditional crafts alive, while also providing a livelihood for many women; these include Samiha Khalil in Ramallah; Leila Jiryis, Mariam Abu Laban and Ruqiya al-Santareasy in Amman; Shahira Mehriz in Cairo; and

Left *Malak* wedding dress with a unique embroidered silk panel, from Bethlehem area (circa 1920)

Malak Husseini and Najla Kanazeh in Beirut. There are also many institutions and museums that were instrumental in helping me develop as a collector. (See list of exhibitions p441) I am sure there are many more to whom I am indebted as they have helped and inspired me in various ways.

I am fortunate to have had several skilled people put in a lot of hard work in order for this book to materialize. I thank Sally Bland for tirelessly editing my manuscript over a long period of time and for her commitment, patience and helpful comments, designer Salua Qidan who threw herself into the project with a passion, zooming in on the collection as a living entity and reflecting this in the production, and photographers Falak Shawwa and Nabil Quttaineh for their professional vision that brought the collection to life in these pages. My daughter Mary was an essential support from the original conception to the completion of the book. Through her incisive commentary and critical eye, she pushed me beyond my natural limits and for this I am grateful.

A special thanks to Nora Shawwa of Rimal Publications for believing in the importance of this book, and to the editors Leonard Harrow, Gerald Butt and Aileen O'Donoghue for their patient reading and helpful suggestions.

Above all else is my family. My husband Kamel and children Zeena, Reema, Amin and Mary who never ceased to provide support, encouragement and enthusiasm. I am indebted to their open-heartedness and patience, but most important their pride in their heritage.

Contents

Introduction		1
PART I	The Collection & the Collector	5
Chapter 1	The Story of the Collection	7
Chapter 2	Reconstructing a Disappearing Heritage	27
PART II	Palestinian Costumes, Palestinian Lives	59
An Overview of Palestinian Costume		60
Map		64
Chapter 3	Ramallah	67
Nour Samara from Aboud		74
Collection Ramallah Area		89
Chapter 4	Jericho	93
Alya (Im Suleiman)		98
Chapter 5	Hebron	107
Fatma Musa from Qubayba		114
Sabeeha from Deir Samet		122
Collection Hebron Area		129

Chapter 6 Bethlehem	135
Habiba	150
Manneh Hazboun	156
Jamila Hazboun Mahyub	160
Helaneh Silhy	164
Collection Bethlehem Area	169
Chapter 7 Jerusalem	177
Urban Jerusalem	187
Tayseer al-Asmar	194
Mufeida	198
Jerusalem Villages	203
Chapter 8 Jaffa	215
Beit Dajan	225
Ruqiya al-Santareasy from Beit Dajan	230
Im Said	238
Halimeh and Ruqiya Dajani	244
Chapter 9 Ramla & Lydda	247
Ramla Villages: *Im Zuhdi of al-Ne'ane*	256
Aysheh of Abu al-Fadl	260
The textile merchants of Lydda	265
Collection Ramla & Lydda Area	269
Chapter 10 Galilee	273
Nazareth	279
Nazareth Villages	287
Safad and Area	290
Alma: *Hind*	294
Acre	299
Acre Villages: *Fatma from al-Damun*	302
Iqrit : *Abu Elias*	308
Collection Galilee Area	311

Chapter 11 Nablus	319
City of Nablus	323
Wardeh from Qalqilia	330
The *Janna wa Nar* (Heaven and Hell) dress of Asira and Tubas villages	335
Collection Nablus Area	337
Chapter 12 Gaza	343
Majdal	349
Isdud	353
Hasna of Isdud	354
Fatma Jaber of Summail	362
Collection Gaza Area	367
Chapter 13 Southern Palestine	377
Hamdeh of the Tayaha Tribe	388
Sabha of the Tarabeen Tribe	394
Mariam of the Azazmeh Tribe	398
Collection Southern Palestine Area	405
Chapter 14 The New Dress: Born of Camp Life and Resistance	413
A new world of textiles	415
Adjusting to the diaspora, and its effect on the *thob*	416
Embroidery as a symbol of Palestine	419
Changing styles – variations on a theme	424
The Intifada dress	429
Chapter 15 Tying the Threads	433
Glossary	439
Photograph Credits	441
List of Exhibitions of the Kawar Collection	442
Selected Bibliography	443
Index	445

THREADS OF IDENTITY

My collection is more than a statement of indignation at how the world continues to ignore the Palestinian people's rights and distorts Arab culture. My aim is to capture the complexity of Palestinian society through these personal histories and bitter-sweet memories of the women who owned the dresses

Above Im Adel from Bitounia village and the author, 1995

Introduction

This book is a record of the 50 years I have spent researching, collecting and preserving part of the heritage of Palestine. My endeavour evolved into the Widad Kawar Collection, the largest to date of Palestinian, Jordanian and other Arab traditional dress and accessories, comprising more than 3,000 items. While my focus here is on Palestine, I plan to publish a similar volume on my collection from Jordan.

In the following chapters I present the story of how the collection evolved and, more importantly, I introduce the life stories of the women who produced the beautiful costumes it contains. For me, each item calls to mind an individual or a place: a wife, a mother, a daughter, a family, a house, a village, a town, a field, a market. Each item was worn on special occasions, happy and sad, that marked the owner's life. Much of my knowledge stems from the personal narratives of these women whose embroidery and dress-making skills I so admire. With this book I pay homage to Palestinian women.

The centrepiece of Palestinian costume, and thus of my collection and this book, is the typically colourful and richly embroidered costume called the *thob,* as well as the jewellery and other accessories – belts, shawls and headdresses – that complement it. The *thob* and its embroidery patterns are primarily an outgrowth of village life in the region during the 19th and early 20th centuries, reflecting the natural surroundings and daily routines of the peasantry and Bedouin. Each area and population group had their own style of dress, though there were overlaps. To address this diversity, the book covers Palestine, area by area, highlighting cities, towns, villages and Bedouin tribes in each.

The importance of the Widad Kawar Collection is twofold. Firstly, traditional dress and the way of life that inspired it have almost disappeared, in the face of rapid modernisation. So one aim of this collection is to preserve these elements of Palestinian heritage and popular history.

Secondly, Palestine experienced a major disruption during the 1948 war when Israel was established and the majority of the Palestinian people were forced out of their homes and villages and dispossessed of their property. Preserving Palestinian heritage, therefore, is a way of holding fast to historical truth. The *thob* is a vivid symbol of the vibrant society and culture that prevailed in Palestine until the violent uprooting of its people. It attests to the Palestinians' determination to sustain their national identity and their hopes for the restoration of their rights.

When I started collecting dresses I had no thoughts of establishing a large private collection. But looking back I now understand what set me on this path. I was a young, privileged woman just out of school when I witnessed the birth of Israel in our very midst. Today, I realise that salvaging Palestinian costumes developed as a personal form of resistance. As the years passed, I became more systematic in my collecting and documenting, expanding my range to include the costumes of Jordan and other Arab countries.

Documenting and preserving Arab traditional heritage in this way is especially urgent in view of Israel's appropriation of elements of our culture, and the many misrepresentations of Arab society that prevail in Western countries. However, my collection is more than a statement of indignation at how the world continues to ignore the Palestinian people's rights and distorts Arab culture. My aim is to capture the complexity of Palestinian society through these personal histories and bitter-sweet memories of the women who owned the dresses. While most of their stories are spun around trauma, loss and destruction, they also contain golden threads of love, humour, harmony and personal triumphs. These stories recall pre-1948 life in Palestine, and describe how Palestinians became refugees and coped with their new and difficult circumstances.

Introduction

The traditional dress is a reflection of society, a visual language identifying the village of origin of the wearer and/or the social group to which he or she belongs. So the photographs vividly illustrate the women's stories.

Threads of Identity is a history of Palestinian women of the 20th century told through aspects of popular heritage, focusing on traditional dresses but also including information about textiles and rug weaving, rural and urban customs, cuisine and festivities. The interviews with women who lived through the traumas and changes of the 20th century are a contribution to oral history, augmenting standard historical accounts. While most writing about the Middle East concentrates on politics, my book focuses on the dignity of ordinary people, and women in particular, bridging the gap between major events of history and everyday life.

My collection and this book reflect not only my passion for preserving the past, but also my firm belief that heritage matters for the future. It defines the roots of our identity. With each generation, society changes and new customs blend with established ones, creating new traditions and redefining our sense of who we are. So while my collection records my personal perception of contemporary history, I hope it will become a source for my children, their children and future generations. For if we connect with our past we are better able to create our future.

Palestinian embroidery has become a powerful national symbol. Preserving traditional heritage and reconstructing the culture that inspired it can play a dynamic role in reasserting the Palestinian people's national identity and their right to freedom, dignity and independence.

PART I

The Collection & the Collector

Previous pages *Deyal* (the back) from a Sinai Bedouin dress (circa 1935)

Above The first two costumes of the collection: *jellayeh* (circa 1880) and *tubsi* (circa 1900), wedding dresses of the Ramallah area

Chapter 1
The Story of the Collection

Many years ago, while visiting Aboud, my mother's home village, a relative gave me two *thobs* (traditional costumes), one of them dates back to the 1800s. One was a *jellayeh* (a costume with a slit down the front, worn over trousers) from Ramallah, and the other from the same area was a bridal dress called a *tubsi*, referring to the striped linen from which it was made. This was the start of my collection. At the time I was already interested in textiles and jewellery, but I never thought that this present would be the first two items in what is now the largest existing collection of Palestinian and Jordanian traditional costumes.

Above The author in her twenties

Collecting traditional costumes of Palestine, and later of Jordan and other Arab countries, was my way to save a part of our culture that I love and to share it with my children and grandchildren

Perhaps my background propelled me in this direction, for I was raised in an environment rich in culture. I grew up in Bethlehem and later went to school in Ramallah. Both towns were treasure troves of Palestinian heritage and traditional dress. Both were centres for weaving and embroidery, and the women of Bethlehem and Ramallah were widely known for their handiwork.

The other motivation for acquiring costumes was the tragic fate that befell my homeland, Palestine. The wars and occupation of 1948 and 1967 destroyed hundreds of villages and dispossessed many of the Palestinian people, separating them from their extended families and driving them into exile. This caused a rupture in Palestinian society and culture, undermining familiar patterns of life. Particularly apparent was the disruption of rural life. Villagers, who were able to grow their own crops and make their own clothes, were reduced to dependence on rations and bare subsistence in refugee camps. Their colourful and richly embroidered handmade costumes were in danger of becoming extinct, for the refugee women lacked the means to continue making such dresses and were sometimes forced to sell the ones they had. At the same time, Israel began appropriating elements of Palestinian heritage and presenting them as part of the newly evolving Israeli culture.

Collecting traditional costumes of Palestine, and later of Jordan and other Arab countries, was my way to save a part of our culture that I love and to share it with my children and grandchildren.

THE STORY OF THE COLLECTION

Above The Irani family, from left to right (seated) Fuad, parents Jalil and Hanneh, (standing) Najib, Jalal, the author and Munir

Family and Childhood

I was born in Tulkarem, in the Nablus area of the West Bank, where my father was working at the time. My parents, Jalil Irani and Hanneh Daoud, met at the American Alliance School in Jerusalem. My father went to the American University of Beirut (AUB), where he studied education, while my mother stayed in Jerusalem and taught in the American Alliance School which she had attended as a child. Because life was so difficult during World War I, they waited until the war was over to get married. In 1920, Palestine was placed under the British Mandate, and my father worked in the Department of Social Welfare as director of reformatory schools in Palestine. I was the only daughter of five children. My brothers' names were Fuad, Jalal, Najib and Munir, and all five of us attended Quaker schools in Brummana, Lebanon and Ramallah.

Our family soon moved from Tulkarem to Brummana and then, in 1941, to Bethlehem. While living there, my younger brother and I attended the Swedish School in the Musrara quarter of Jerusalem. Life was so safe at that time that we used to travel alone by bus each day to school and back. By contrast, for children in Palestine today, going to school can be dangerous or even impossible, due to the numerous checkpoints, frequent curfews, closures and, most recently, the separation wall. Today, the short journey from Bethlehem to Jerusalem takes a minimum of three hours if one has the correct permits, whereas it used to take only a quarter of an hour.

From those early days I began to discover Bethlehem, the fashion and weaving centre for many villages in different parts of the country – the Paris of central Palestine. Its *suq* (market) catered to all the items needed for village costumes, from fabrics and thread, to ready-made embroidery pieces fashioned by Bethlehem women. In every home that I entered, I would see a woman embroidering, for her own use or for the market.

There were also centres in the market where embroidery was taught and finished pieces could be bought. The leading embroiderers of the day were women like Jamila Hazboun Mahyub, Im Barhum, Nuwarra Ghneim, Hanneh Banayot, Helaneh Silhy, Sabina Skafy, Jamila Abu Zarour and Helaneh Qateemy, as well as Manneh, Wardeh, Farah and Mariam Hazboun, and there was lively competition among them to make the best products.

Every city and town had a weekly market day where people from surrounding villages gathered. Saturday was the market day in Bethlehem. Dressed in their best attire, women from villages such as Artas, En Karem and al-Khader, crowded into the bazaar. Our home was on a hill with a balcony overlooking the street leading to the market, so every Saturday I watched as colourfully dressed groups of village women passed by, and this has remained a vivid image in my memory since those distant days. That rainbow of colours climbing the hill each Saturday morning stimulated my consciousness and appreciation of traditional Palestinian dress.

The Story of the Collection

Every Saturday I watched as colourfully dressed groups of village women passed by, and this has remained a vivid image in my memory since those distant days. That rainbow of colours climbing the hill each Saturday morning stimulated my consciousness and appreciation of traditional Palestinian dress

Above A sleeve of a Bethlehem jacket with silk cord couching on cotton velvet (circa 1925)

The women came to sell their goods and to buy fabric, thread, embroidery pieces and silver jewellery. They bought *malak* (royal) fabric, used in the Bethlehem costume, at the shop of Naser, who owned the weaving factory. Some also visited Helwy Bendak's shop next door which specialised in embroidered jackets called *takaseer*, and some stopped in to see Im Elias, who sold all varieties of thread. Next to her small shop was Sammour, the jeweller, who sold *heidary* bracelets and *znag* chains which were designed to be attached to each side of a hat, passing under the chin to hold it in place.

But unlike Bethlehem women who were famous for the couching stitch, Ramallah women were known for the red cross stitch on black or white linen

After elementary school, I attended the Friends School for Girls in Ramallah (established by the Quakers in 1889) as a boarding student, and this was a new and difficult experience for me. Sharing a dormitory with 40 other girls required a lot of adjustment. There were over 100 boarding students from all over Palestine. Around 15 of the girls were from Jordan, and I remember how intrigued we were to hear what they said about life in Amman, Salt and Madaba. The boarding section of the school was like one big family, with the older girls bossing the rest of us around. The friendships that developed in those years have lasted to the present.

In addition to academic work and cultural activities, my years at the Quaker School in the 1940s were ones of growing political awareness. Jewish immigration to Palestine was on the rise, and we were feeling the threat posed by Zionist colonisation and the support it received from the British Mandate authorities. There were some days when a strike was declared, and we did not go to classes, such as on the anniversary of the Balfour Declaration signed on 2 November 1917 in which the British government pledged to facilitate the establishment of a national home for the Jewish people in Palestine. Generally, the school administrators were understanding about our activities as they realised the impact that the creation of a Jewish homeland would have on our futures.

In Ramallah, I was further exposed to the variety in Palestinian embroidery and textiles. When invited by classmates to their homes, I witnessed scenes similar to those in Bethlehem, with women of all ages doing embroidery work. But unlike Bethlehem women who were famous for the couching stitch, Ramallah women were known for the red cross stitch on black or white linen.

THE STORY OF THE COLLECTION

Above *Shinyar* (back panel) of a Ramallah *jellayeh* (circa 1890)

Miss Daoud, my maths teacher, owned a weaving centre next to her home where linen and cotton fabric was handwoven for costumes. The family of another teacher, Miss Hishmeh, opened a workshop for producing Spanish-style floral shawls, like the ones Palestinian men, who had emigrated to Latin America for work, were starting to send back to their female relatives as gifts. Gradually, floral shawls began replacing the *kesaya* (linen shawls) that had traditionally been worn.

We learned the Ramallah embroidery patterns in sewing class, where we made simple table runners and napkin holders. I also learned to repair worn-out embroidery pieces. This early experience helped me to appreciate the skills involved in such work.

THREADS OF IDENTITY

Above Aboud village, 1970s

Summer Holidays in Aboud

During some school vacations my family would go to Aboud, my mother's village, in the Ramallah area. It is an ancient village of white stone houses built amongst olive trees, vineyards, springs, hills and valleys, with nine ancient churches, including the 4th-century Virgin Mary Church, considered to be one of the oldest in the world.

The population, approximately 3,500 in 1948, was half Christian and half Muslim. The villagers wore the same type of costume, regardless of religious affiliation. The only exceptions were the women of the Barghouti family who wore urban-style dresses topped with an *abaya* (cloak).

The historical significance of Aboud was eloquently described by Israel Shamir in an article protesting the destruction of the village's olive groves:

The Story of the Collection

'It is a good place to understand the complete lunacy of the prevailing Jewish narrative, of the "land without people" sparsely inhabited by the Arab nomads who came in the 7th century. Archaeologists proved this village was never destroyed or abandoned since time immemorial, and our eyes agree with it. Age-old olive trees cover the hills, confirming the deep roots of Aboud and providing it with olive oil, its main staple food and source of livelihood.' [1]

These holidays in Aboud instilled in me an understanding of Palestinian village life. I not only learned about costume and embroidery, but also about the intricacies of social relations in the village, especially among women. Almost every day after lunch the women of Aboud, old and young, would put on their best clothes and get together to embroider. During these embroidery sessions they would discuss everything from new patterns, cooking and the latest gossip, to herbal medicine, marriage, family relations and politics.

In July and August, the women's get-togethers would shift to the fields and vineyards where they made preserves of grapes, figs and other fruit, in preparation for winter. Still, these activities did not prevent them from continuing their embroidery in the evenings.

Before 1948, embroidery was a lifelong pursuit for most village women, and they took special pride in their accomplishments. They praised or criticised each other's work: the reverse side of the piece had to be smooth, without any knots; the stitches had to be fine, the pattern complete and balanced, and the finishing in line with tradition and of good quality. In this rich and beautiful world, I found myself mesmerised by the colourful costumes and the dynamic women who created them.

[1] Israel Shamir, *Olives of Aboud* http://shamir.mediamonitors.net/june182001.html, 18 June 2001

University, War, Occupation

Having completed my secondary education in 1948, I attended the Beirut College for Women, and later the American University of Beirut, where I majored in Arab History and Sociology.

My English teacher during my freshman year, Phyllis M Sutton, became a great source of inspiration to me. She had previously taught in Ramallah and Amman and had co-written a pamphlet on Ramallah embroidery with Grace M Crowfoot in 1935. Mrs Sutton presented me with a copy of that rare pamphlet and she also gave me an embroidered *qabeh* (chest panel) from a Ramallah costume.

Mrs Sutton would often invite a group of Palestinian and Jordanian students for afternoon tea to work on samples of the traditional patterns, and through those occasions we developed a deep appreciation of embroidery. She later published an account of the 50 years she spent in Palestine, Jordan and Lebanon, entitled *Thank You, Arabs*.[2]

In 1950, having completed my freshman year, I returned to Bethlehem for the holidays and witnessed the drastic impact of the Israeli occupation. Vanished overnight was the beautiful picture I had cherished of village women dressed in their best costumes going in groups to the market. Their villages – Malha, En Karem, Lifta, etc – had been occupied. The women and their families had been moved to refugee camps where they were faced with radically different living conditions and forced to recreate their culture. The change was dramatic: the women's costumes had faded, their head coverings were worn out and their faces were noticeably more furrowed.

This tragedy unfolding in front of my eyes, the changed face of my town, Bethlehem, and the surrounding villages now under Israeli occupation, affected me deeply and led me to think about the need to preserve the world as I had known it by collecting costumes and information about them from their owners. The idea was in my mind as I continued my studies, returning home for vacation from time to time. At this stage I was collecting pieces, but was more driven by instinct than a conscious effort to develop a collection.

[2] Phyllis M Sutton, *Thank you, Arabs*, Beirut, 1972

THE STORY OF THE COLLECTION

Above James Sutton (left), Abla Kawar (second from left), the author (fourth from left), Phyllis Sutton (fifth from left), 1952

Below Sample page from Sutton's Ramallah embroidery book

Marriage and the Move to Jordan

In 1955, I married Kamel Kawar, a mining engineer and geologist, who was born in Nazareth but had moved to Amman. His sister, Leila, was a cherished friend. We had gone to the Friends School in Ramallah together and were roommates at Beirut College for Women. Kamel's father and uncle, Amin and Baz, both AUB graduates, had moved to Amman in the 1930s. Baz set up the Jordan Postal Service, while Amin opened the first pharmacy in Amman, and later discovered and invested in phosphates, which became Jordan's main export industry.

After we married, I moved to Amman where Kamel and I lived next door to his family in Jabal Amman. For the first week I felt like a complete stranger and was homesick for Bethlehem and Beirut. But with the help of Kamel and his family I soon became part of the community.

Kamel's work often took him abroad and, as a result, I developed a deep attachment to his parents who made sure that I was not lonely. My mother-in-law, Mary Kuzma, was a loving homemaker with superb culinary talents. She influenced my collecting without realising it. She was from a Damascene family who had settled in Nazareth because her father, Iskandar Kuzma, was the head of the Russian Seminary School there. The family had close links to Russia. Mary's uncles and brothers studied there, and one uncle never returned; he had married a Russian and was teaching Oriental Studies in Kiev. From her mother's side of the family, the Zureiks, Mary had acquired an exquisite trousseau, made in Damascus in the early 1920s, which was influenced by Ottoman styles. She eventually gave me many items from her trousseau. Until I moved to Amman I had been fixated on the embroidery and costumes typical of Palestinian villages and towns, but now I began to understand the broader textile heritage of the cities of the Levant, first and foremost Damascus.

My father-in-law was an avid reader with a very inquisitive mind and I enjoyed his company tremendously. He travelled widely and enjoyed meeting different types of people. He was frequently invited to embassy

THE STORY OF THE COLLECTION

After we married, I moved to Amman where Kamel and I lived next door to his family in Jabal Amman. For the first week I felt like a complete stranger and was homesick for Bethlehem and Beirut

Above Wedding photo of Kamel Kawar and Widad Irani in Amman, 1956

receptions which did not appeal to my mother-in-law who was deeply involved in running the household. As Kamel travelled a lot, I accompanied my father-in-law to social functions.

Amman was still relatively small at that time, and we knew everyone in our neighbourhood such as the families of Abu Jaber, Mango, Budeir, Qaqish, Mufti, Hashem, Abu al-Huda, Asfour, Paltekian and Kardous. There were frequent visits among friends, but few formal dinners, except for special occasions. The hectic social life in Amman now makes me nostalgic for those days.

During my first years in Amman I gradually acquired items for my collection during trips to the West Bank. I visited many villages around Bethlehem and Ramallah where difficult economic conditions were forcing people to sell their cherished costumes.

At that time, I also began to notice the many different types of apparel whenever I went to the Amman *suq*: the grand costumes and elaborate headdresses of Salt, dresses from north Jordan with multi-coloured, vertical stripes, and the colourful costumes of Ma'an, made of Syrian silk. In addition, one could see Palestinian refugees still wearing their traditional attire, alongside an increasing number of women dressed in Western styles.

It was not long before I had two daughters, Zeena and Reema, but I carried on with my work. I was a member of the YWCA (Young Women's Christian Association) and the Women's Auxiliary of UNRWA (United Nations Relief and Works Agency – a special body created to aid Palestinian refugees after 1948). Through these organisations I did volunteer work in two Palestinian refugee camps in Amman, Hussein and Wihdat. There I became acquainted with many refugee women and their way of life, and was particularly impressed by the women from Beit Dajan and their costumes.

The Story of the Collection

My mother-in-law, Mary Kuzma, was a loving homemaker with exquisite culinary talents. She influenced my collecting without realising it. From her mother's side of the family, the Zureiks, Mary had acquired an exquisite trousseau, made in Damascus in the early 1920s, which was influenced by Ottoman styles

In the refugee camps, I interviewed many women from villages, such as Beit Dajan, En Karem, Malha, Beit Jibrin, Majdal and Isdud. Some of these villages, like hundreds of others, had been obliterated from the map, and their Arab inhabitants evicted by the Israeli occupation forces. I had to locate the people from these villages in order to get information on their pre-1948 life and local culture.[3]

In 1962, I accompanied my husband, Kamel, to Tucson, Arizona, where we lived for two years while he studied for his MA in geology at the University of Arizona, specialising in underground water. I took sociology courses related to museum work, and did a project on the weaving of the Navaho Indians. This increased my interest in weaving techniques and broadened my outlook on traditional handicrafts beyond Palestine and Jordan. I discovered that the Navaho patterns, based on lines and triangles, were similar to those in the weaving of Jordan and Southern Palestine. Discovering this cross-cultural similarity was an illuminating experience.

Back in Amman, and still making frequent trips to visit my parents in Bethlehem, I acquired a few more costumes and many individual pieces of embroidery, jewellery and accessories. I had two more children, Amin and Mary, in 1963 and 1967.

Left Detail from Mary Kuzma's wedding dress

Left above Wedding photo of Amin Kawar and Mary Kuzma, Nazareth, 1924

[3] For in-depth documentation of the destruction of Palestinian villages, see Walid Khalidi, *All That Remains: The Palestinian Villages Occupied and Depopulated by Israel in 1948*, Institute for Palestine Studies, Washington DC, 1992

A Second War: 1967 and its Aftermath

The 1967 war confronted me with an entirely new reality: all the villages of Palestine, like the country itself, were now occupied. This was a turning point: I started to collect genuine examples of the complete attire of each geographical area before they were lost or influenced by the emerging refugee camp styles. I also wanted to gather the items that women prepared for their marriage, such as embroidered cushion covers and home decorations, as well as handicrafts like straw work, weaving and pottery.

After 1967, conditions for Palestinian refugees worsened and many were uprooted for the second time. In 1948, people from the part of Palestine that became Israel had found refuge in camps in the West Bank and then many were forced to flee again, ending up in Jordan and other nearby countries. As an example, over 35,000 people, who had been living in Aqabat Jaber Camp near Jericho, came to Jordan where they were sheltered in tents as they had been in 1948. As conditions deteriorated, people had to let go of treasures they had been hanging onto since their 1948 exodus from their original homes. They started selling on a grand scale. My first experience with this was when Halimeh from Beit Jibrin, in the Hebron area, knocked on my door, saying, 'I want to sell you my dress because I know that you will keep it. If I sell it to a shop, they will cut it into pieces. I want mine to be preserved.' I have always wanted to tell Halimeh or her family that her dress has been exhibited around the world and photographed for catalogues and books. I am proud that I kept my promise to preserve her costume.

Halimeh's fears were well founded. Costumes were indeed being cut up for use as chair covers or wall hangings. I was invited to a sit-down dinner at a friend's house one evening and could hardly swallow my food because I was sitting on a chair upholstered in a most beautiful, rare costume from Isdud. For me, this piece of textile represented a woman's life and I could not detach the aesthetic value from the human history.

THE STORY OF THE COLLECTION

Above Halimeh's *jellayeh*
from Beit Jibrin (circa 1930)

Threads of Identity

Over 35,000, people who had been living in Aqabat Jaber Camp near Jericho, came to Jordan where they were sheltered in tents as they had been in 1948. As conditions deteriorated, people had to let go of treasures they had been hanging onto since their 1948 exodus from their original homes

Above Refugee women at UNRWA medical centre in the 1950s

Specialised dealers appeared on the market, selling costumes to upper-class locals and foreigners, and sending them abroad to Europe or America. I was stunned one day when I walked into a party and half the ladies there were wearing old Palestinian costumes. I froze, seeing this outcome of the Palestinians' dispossession. Despite the good intentions of these women to preserve our culture, the costumes appeared to me as ghosts separated from their original owners by tragedy. Such experiences made me realise the urgency of preserving the traditional costumes and spurred me on to expand my endeavours to collect. It was at this stage that I started looking at my acquired costumes as a collection.

I had always loved the Galilee costumes but the chances to study them had been few. In 1972, I had the opportunity to visit al-Rameh and, later, Nazareth and Acre. Here women had stopped wearing the traditional costumes much earlier than in other areas of Palestine. There were very few costumes left and few people who could give me information. I did acquire good background knowledge from Wajeeh Irani, curator of the Folklore Museum in Acre, and from a famous collector in Abu Snoon, Sheikh Abdullah Kheir. After his death, I bought most of the Galilee costumes from Sheikh Abdullah's collection.

The Story of the Collection

Strangely enough, people did not keep children's costumes. I hardly came across any. Menswear did not attract me, except for the beautiful handwoven belts made in Syria and Egypt, and some of the *qumbaz* (brocade overcoats) worn in the cities. At my exhibitions, I am always criticised by male viewers for not representing them.

Prior to 1967, traditional costumes and jewellery were not sold on a large scale. They could be found in some shops in the Old City of Jerusalem, and were bought mainly by foreign staff of the UN, Red Cross or embassies. Most women in the camps hung on to their costumes, though many sold their silver jewellery as it was going out of fashion and they replaced it with gold jewellery which was worth more and thus seemed a more secure way of investing the little money they had.

I made a point of buying all my pieces from the actual owners, because that way I could get accurate information about each item. I especially appreciate handwoven textiles and embroidery, so I bought the very best, sometimes disregarding costumes that were worn out, lacking in embroidery or made for purely practical use. When I did buy a dress with very little embroidery, I often gave it away as a present. For this reason, I have more festive costumes in my collection than everyday ones.

My preference for embroidered costumes also kept me from collecting dresses from Nablus or Tulkarem until much later. I started buying from this area after my first big exhibition in Kuwait in 1970. I had not included anything from Nablus, Jenin, Tulkarem or Safad, because these costumes had little or no embroidery. It so happened that most of the viewers were from those areas and they came up to me after the show, vigorously protesting that I had not exhibited their costumes. Ten years later I met some of them who had still not forgiven me for this omission. Back in Amman, I began to work on this area and found the costumes to be most attractive because of the way different types of cloth are combined.

Chapter 2

Reconstructing a Disappearing Heritage

People who see my collection for the first time usually ask me: 'When did you start, what made you collect, and how did you go about amassing this large collection?'

Few people really understand why someone starts to collect. All I remember is that I felt the need. The Israeli occupation of Palestine angered and frustrated me. Collecting turned my anger into a challenge and achievement. It served as a therapy to help me deal with the trauma I felt, although I did not realise this at the time.

Left Sab'ah in her everyday dress at home in Aboud, 1970s

THREADS OF IDENTITY

Above left to right The author interviewing women from different areas of Palestine:
(1) Yusra Hmeid in Aboud;
(2) Fatmeh Jibrin in Hussein Refugee Camp, Amman;
(3) Im Omar (right) and Erder (left) in the Jordan Valley;
(4) Halimeh Dajani in Hussein Refugee Camp, Amman

Interviewing the Women behind the Costumes

I was fortunate to meet many outstanding women over the years who enabled me to obtain the items and information presented in this book. Through our interviews, these women kept up my enthusiasm for collecting as I came across a wealth of material culture. The women still possessed their precious costumes and accessories and some were interested in selling these pieces, others not. Their life stories spurred me on to constantly research our heritage. I gained great insight into their lives and characters, their position in the family, their roles in a rapidly changing world, their attachment to their heritage and their endurance under stress. Only by virtue of their strength were they able to keep their families together in harsh conditions. These women remain my chief inspiration.

RECONSTRUCTING A DISAPPEARING HERITAGE

The hours I spent interviewing were very happy intervals in my life. With time, I became quite close to some of the women, as I would see them again and again and learn more of their life stories. Most were happy to talk about the past, even though it often entailed returning to memories of a time of great suffering.

For some of the older Palestinian women, the experience of leaving their native villages and ending up in a crowded refugee camp had been so devastating that they did not want to speak about it, whereas others were eager to share their memories. They described in great detail their villages and former homes with its courtyards and gardens, their engagement and marriage ceremonies, their costumes and jewellery, their outings to the city,

29

Although, in many cases, I was digging up sad memories, personal jokes would often pop up in these women's narratives. Unfortunately, I was not always able to record these asides

and other events. Their vivid descriptions evoked rich and detailed images in my mind, recreating the environment in which the costumes I was enquiring about had been produced and worn. I often thought to myself that the impact on these women of being uprooted from their ancient villages and patterns of life would never be fully understood by outsiders.

In the beginning, it was not always easy to get the women in the mood to talk. However, as time went on, I found my own ways of reaching them. In the end I believe that I became very good at interviewing. In posing and following up my questions, I discovered that it was best not to be restrictive. The women should be left free to divert my questions in whatever direction they wished.

With Palestinian women, this inevitably led to the story of their *hijra*, or emigration, when Israel occupied Palestine in 1948 – the hardships they endured, and the horrible uncertainty of not knowing where they were going or why. In these 'diversions', they would always speak about their family members and what had happened to them.

My greatest regret is that I did not always carry a camera. I noticed that the women I interviewed did not feel comfortable in the presence of cameras and tape recorders, so I left these aside. Not relying on a tape recorder also meant that I had to reconstruct the interviews after the fact. However, I tried to remain true to the detail and spirit of the life stories these women imparted to me.

Although, in many cases, I was digging up sad memories, personal jokes would often pop up in these women's narratives. Unfortunately, I was not always able to record these asides.

Reconstructing a Disappearing Heritage

Above The author with Aysha al-Sutaria (left) and her bag of amulets, and Im Zuhdi (right) showing her embroidery, 1985

When the men of the family were present they usually tried to interfere and express their point of view, but I did not pay much attention to their comments. I was most interested in the women and their tales of the past. I never imagined, back in the 1960s, that these stories would some day become valuable historical accounts.

While we were speaking about costumes and embroidery, women disclosed important elements of their lives as individuals and as part of a family and a community, often revealing their intimate family relationships, political ideas and nationalist feelings. On the other hand, their choices of style, colour, cut and pattern reflected their interests in the field of fashion.

The Evolving Trade in Heritage Items

By the 1980s, it had become difficult to buy items directly from their owners. Besides, a new branch of trade had started up whereby men and women collected items from their original owners and then went around Amman, selling them door-to-door. I worked to keep especially good relations with these traders so that they would come to me first.

Im Fathy was the smartest of them all. She was a refugee from Jerusalem who had learned the trade from her neighbour, Im Sa'adeh. I trained Im Fathy to know what I wanted and what to look for. She competed with all the others, men and women, to obtain the best pieces for me, with some information as well. Then she moved on to collecting silver and gold jewellery. Now she is well established in the gold market, owns a jewellery workshop, and is doing very well.

Im Fathy was always honest with me and true to the aims of the collection. However, other men and women, both in Amman and Jerusalem, opened workshops where pieces from different costumes and even different areas were mixed together to produce odd-looking dresses, hats and shawls. Most buyers did not know that these were not authentic.

Others worked hard to preserve genuine Palestinian handiwork. Embroidery became a way for Palestinians to support themselves, while ensuring the survival of their culture. Worth mentioning are the embroidery centres that exported their products around the world. The earliest of these was the one opened by Asya and Sonya Halaby in 1935 in Jerusalem, where they held classes to teach teenage girls the best traditional embroidery. Another such initiative was the Ramallah Handicraft Cooperative launched by Mariam Zarour, along with a few other women, in 1952. Both projects provided women with much-needed income, until they were forced to close down a few years after the 1967 occupation due to high Israeli taxes.

Right Patterns of a Hebron-area head shawl (circa 1920)

Threads of Identity

34

Reconstructing a Disappearing Heritage

Collaboration with Researchers and Museums

I had the opportunity to hone my interviewing techniques by collaborating from time to time with various scholars and museums over 20 years. We interviewed women from many different areas of Palestine. The objective was often preparing for an exhibition or a publishing venture. One example was when the Museum of Mankind, the Ethnography Department of the British Museum, decided to expand its small section of Palestinian costumes which had been collected by the Church Missionary Society in Palestine. Consequently, Shelagh Weir, who was responsible for that section, was dispatched to Palestine to study the culture that lay behind these costumes, and complete the collection. She was one of a number of scholars from whose help I benefited and who – I hope – benefited from the unique experience I was able to offer.

In 1968, Shelagh and I began conducting joint interviews in the Hussein and Wihdat camps, two large Palestinian refugee camps on the outskirts of Amman. I would translate the questions and answers. However, this procedure did not always suit the women; some of them resented the interruption. In such cases, we would tape the interviews, and I would translate them later. While this method allowed the women's answers to flow freely, there were some who were uncomfortable with the tape recorder.

We also did good research among refugee women from villages in the Hebron area, as many of them worked with an embroidery centre near my home in Amman. We gleaned much information from these interviews about pieces I had in my collection from Hebron villages which have a very rich and diverse folk culture.[4]

I researched Galilee while visiting Acre, al-Rameh and Nazareth. In Amman, I continued working on Hebron, Nablus, Gaza and the Bedouin

Left *Memoire de Soie* exhibition of the Kawar Collection at the Institute du Monde Arabe, Paris, 1988

Above The author with Her Majesty Queen Noor at an exhibition at the French Cultural Centre, Amman 2001

[4] Some of my own research was published alongside Shelagh Weir's in the article 'The Bridal Headdress of Hebron Area,' in the *Palestine Exploration Fund Quarterly*, January-June 1975.

costumes of Southern Palestine. For an exhibition at the Museum of Mankind (now part of the British Museum) in 1988, I loaned 65 pieces from my collection.[5] A number of Palestinians, including some of our friends, helped sponsor the exhibition, which was a great success. Palestinians were very proud of it.

The precise and thorough methods of the researchers and scholars with whom I worked helped give me a systematic approach, to which I added the human touch enabling me to get as much information as possible from the women we interviewed. For example, professional researchers often posed very formal questions which usually caused the interviewees to become uncooperative and give rather uninformative answers. I noticed that these same women loved to talk about their engagement, their dowry, their wedding and their trousseau, so I developed a system of beginning the interview by focusing on these things. This made the women more communicative. Naturally, they loved recalling the one time they had been the most important girl in their village and the centre of attention.

[5] Many of these appeared in the book *Palestinian Costume*, by Shelagh Weir, London, 1988.

Reconstructing a Disappearing Heritage

Above left to right Scenes from exhibitions of the collection in Europe:
(1) Switzerland, 2003;
(2-3) Moesgaard, Denmark, 1991;
(4) Gothenburg, Sweden, 1992 under the auspices of Princess Majida Raad

When working with others, I used to choose the areas of Palestine that were particularly accessible to me. For example, our family driver, Wafa, was from Beit Dajan, so he introduced me to most of the good embroiderers from his hometown who were living in the Hussein and Wihdat refugee camps. He was very proud to do this and became part of our team and a great asset. We did good work in my hometown, Bethlehem, and the refugee camps around it. We were also welcomed in Ramallah and Aboud because of my relatives in this area. Through my relative, Said Jeryes, and other textile merchants, I learned of the great trade in cloth between Syria and Palestine, and made trips to Aleppo, Homs and Damascus in Syria. There I found weavers and dyers who had specialised in producing fabrics and accessories for the women of Palestine, until this trade was severed by the Israeli occupation.

THREADS OF IDENTITY

Above Costume of the Irbid area, north Jordan, decorated with the *ragmah* hand embroidery (circa 1940)

Expanding the Horizons of the Collection

Jordanian Costumes

My motivation to preserve Palestinian heritage was coupled with an acute awareness of the disappearing Jordanian heritage, albeit not as a result of occupation but due to rapid modernisation and urbanisation. This concern started in the 1970s when I realised that I rarely saw women in traditional Jordanian costumes any more. The Bedouin costumes in particular intrigued me, especially the embroidered dresses of the Adwan clan. I started collecting samples and information, but there was a problem, for Jordanian costumes were simply not available in shops, and the owners of such dresses were not interested in selling them, although later on I was able to purchase some.

My basic source of information in the beginning was Mrs Sa'ddiyah al-Tel who established the Jordan Museum of Popular Tradition, which was next to the Roman theatre in downtown Amman, and one of the best museums of its kind in the Arab world. Unlike Palestine and Syria, Jordan's traditional arts were under-researched. Jordan's archaeological treasures, like Petra, overshadowed its folklore.

Hoping to research Jordanian popular heritage, I slowly started developing a network of friendships in Jordanian villages, an activity that dovetailed with family picnics and exploration of the countryside.

Above Detail of *ragmah* embroidery pattern taken from the back of the same dress

Textiles of Syria

Early on I realised that Syria was an indispensable part of the textile heritage of both Palestine and Jordan. My information would not be complete without a full understanding of the Syrian context in terms of silk and cotton production and weaving. Also, traditional styles in cities like Amman and Jerusalem were greatly influenced by what was worn in Damascus and Aleppo.

Over the years I made many visits to Syria where silks, belts and some types of head shawls were woven especially for Palestine and Jordan. In some ways, these visits were disappointing, as the beautiful textile world of Syria was rapidly changing. By the 1960s, the techniques of handweaving were being replaced by mechanised looms.

On my early visits to Syria I needed to trace information back to the source. To do this, I received valuable assistance from Shafiq al-Imam, curator of the folklore museum in Qasr al-Azem in Damascus. The journey took me to Aleppo, Homs and Damascus to find the weavers of the silk and cotton fabrics used in Palestinian costumes. I met many weavers who had kept their looms, but they sadly informed us that while they used to cater to the needs of Palestinian traders, after 1948 their work had diminished. In Homs, I met a weaver who had made *safadiya* (wrap-around cloaks) for 40 years, exclusively for the inhabitants of Safad in northern Palestine. On his loom was a half-finished piece, which he kept as a souvenir of that time.

The Samman family's silk factory in Homs was barely functioning. The Sammans had produced silk thread for the different fabrics used in the costumes, belts and headbands of Palestine, Jordan and Syria. The weavers of the Samman factory inherited their craft from their fathers and forefathers, who had been weaving for the Palestinian market for centuries. They sold to traders from Nablus and Jerusalem, to the Jeryes family in Nazareth, the Halty and Batshon families in Lydda, and the Shawer and Sunnukrut families in Hebron. These merchants would come

Left Samples of Syrian textiles commonly used in Palestine and Jordan

once or twice a year, stay at the weavers' homes, buy their products and submit their orders for the coming year. If they saw something new, they would buy it and introduce it to their area. The *ghabany* fabric was one such new product introduced at the end of the 19th century and used for the costumes of Lifta, near Jerusalem, as was red and purple *karmazut* (watered silk taffeta), used in the Jaffa area.

On another trip to Damascus I looked up Wasfi al-Rihany, head of the dyers' syndicate, who was a walking encyclopaedia on dyeing. He took me to workshops where both indigo and chemical dyes were used. I also visited the Nukta brothers in the tailors' market. They had been weavers of *karmazut*, *ghabany* and different kinds of belts worn by men and women in Syria and Palestine.

On some of my trips to Syria in the 1970s I stopped in Hama to see the weaving of the Madani family. They wove all the textiles needed for the bath – embroidered towels, bathrobes and *wazra* wrap-arounds for men and women, made from cotton or silk, or a blend of the two. The head of the Madani family had his sons assisting him in the work.

On my most recent visit to Hama, in June 2006, I went with my old friend, Sally DeVries, to the same address where we found the six sons of the older Madani running the weaving workshop. They are still making the same bath items, plus many others of traditional design, but geared for modern usage. For example, they make *wazras* to be used as tablecloths, and traditional-style washcloths to be used as placemats. Each son is specialised in a particular part of the weaving. Their biggest markets are Lebanon and Scandinavia. One of the sons, Samer, served as our guide for two days and was well versed in all the stages of their work.

We also visited the Hawwa family who block-print designs in black on cotton cloth of various colours. In the past, they printed pieces for quilts and the gauze fabric used for headscarves in villages all around Belad al-Sham (Syria, Lebanon, Palestine and Jordan). I had known the grandfather of this family, Abdul Karim, and his son, Muhannad. Now the grandson, Hassan, is in charge and has developed their work into

RECONSTRUCTING A DISAPPEARING HERITAGE

Above Syrian costume of hand-woven linen from Muhardeh with a variety of stitches in Syrian silk (circa 1920)

printing on tablecloths, table runners, curtains and dinner sets. Hassan carves his own wooden printing blocks and mixes dyes in the traditional way, blending in walnut shells and pomegranate skin.

It was such a pleasure to see that these two very old textile techniques were being continued and modernised, while remaining family businesses, with the secrets of the trade kept in the families.

43

THREADS OF IDENTITY

Above left to right Costumes from Yemen (circa 1935), Saudi Arabia (circa 1940), Egypt (Siwa Oasis) (circa 1935) and Iraq (circa 1910)

Reconstructing a Disappearing Heritage

Other Arab Costumes

At my early exhibitions in Europe, I showed Palestinian and Jordanian costumes, as well as a few from southern Syria. Hundreds of Arabs came to the exhibition at the House of World Cultures in Berlin in 1991. Many of them expressed disappointment that there were no costumes on display from their countries of origin, such as Yemen, Egypt, or the states of North Africa. This experience prompted me to add a small Arab section, which enriched the collection and gave a basis for comparison with the Palestinian and Jordanian costumes.

Jewellery

My collection of silver jewellery, an important component of traditional dress, is comprehensive. I believe silver jewellery represents Palestinian heritage and history as much as the dresses. Every piece carries with it a trail of traditions and stories. I was lucky to be able to spend time with jewellers and learn from them, and my best sources were the Zakharia brothers who specialised in heavy silver necklaces. Yacoub lived in Amman, and Nicola in Bethlehem.

Other sources included Jerusalemites Hanna al-Jouzy and Khalil Salman and his sons, known for their filigree jewellery; Tarazi in Gaza, who was famous for his bracelets; and Nicola Ghali, a Damascene. Ghali came to visit friends in Salt in 1920, and seeing the great demand for silver jewellery in the area, he stayed and opened a shop where he worked until 1970. In Salt, there was also Haj Amin Sharkas who did black-on-silver *niello* work on fish-shaped designs and amulets.

Left Silver *khiarah* necklace

Above (1) Silver *maskeh* amulet with Quranic verses
(2) A child's amulet with Quranic verses
(3) A Christian amulet with *niello* work

Traditional gold jewellery did not attract me much. When it was introduced, it was made entirely of coins without much art or technique. This was for reasons of financial security, for it was feared that gold might lose its value, whereas coins would not. Beautiful silver jewellery began to be replaced by connected gold coins. Later, from 1940 on, gold jewellery

THREADS OF IDENTITY

Above Tools for making silver jewellery from the Afghani shop in Jaffa

became more decorative due to the influence of jewellery made in the urban centres of Syria and Egypt. My collection includes only a few pieces of gold jewellery that I think are genuinely Palestinian or Jordanian.

Making silver jewellery was a skill that was handed down through generations of the same family. Silversmiths, like the Zakharia brothers, told me that they would not change to gold as they were not willing to abandon their craft or change their family profession. Mustafa and Abed, two young jewellers from Jerusalem who opened a silver shop in downtown Amman in 1968, fared very well at first, especially due to the number of Bedouin who came to shop in Amman and continued to buy silver jewellery. In the 1970s, the men were buying and reselling old jewellery after repairing and cleaning it, but by the following decade their shop was empty. There was no demand for new silver jewellery and no old pieces were available, so they moved to the Jabal Hussein district in Amman and opened a gold shop, specialising in the type of jewellery that was in demand. Although their new shop flourished, both would have preferred to continue working with silver in order to maintain their families' traditions.

Reconstructing a Disappearing Heritage

There are a few examples of the reverse trend: Hanna Hanania, a goldsmith in Amman, particularly liked the black-on-silver *niello*. In 1980, he often went to Irbid to sit with Rihany, a well-known silver- and goldsmith, who taught him this technique. Hanna then left gold work and started producing silver fish-shaped designs and amulets with traditional *niello* decoration, which became collectors' items.

Above (1) Crescent amulet
(2) Five *heidary* bracelets
(3) Amulet with Quranic verses
(4) *Karameel* hair ornaments
(5) Amulet with Ottoman coins

Bilal and Hussein Afghany in Amman treasure the silver moulds which their father and grandfather used in Jaffa. They sometimes produce copies of old filigree pieces for the pure pleasure of the work. These include amulets, fish and the small balls used on *znag* chains. It was a hobby, Bilal told me, which compensated for his routine work of selling souvenirs.

RECONSTRUCTING A DISAPPEARING HERITAGE

Left Amulet in *niello* made in Nablus by Armenian jewellers for brides in Irbid

Above Im Ghazi from Ramallah area wearing her headdress mounted with gold coins

Coins as Jewellery

Using coins in jewellery is an ancient art. Gold coins were treated like gems and mounted in a variety of settings. In the 19th and early 20th centuries, both village and city women in Palestine had gold coins mounted on their jewellery. While silver was most common among villagers, a peasant bridegroom with the means would buy his bride gold coins to sew around her hat, framing her face like a halo. Besides being decorative, these coins were like a savings account for the woman. Ottoman, Arab and European coins were set in necklaces, bracelets, rings and earrings. Frames with a double-ring construction were made to hold the coins in place and show both sides.

The reasons for using coins on jewellery were many, ranging from giving a sense of security, to showing off. When marrying, a man had to show his generosity and love for his fiancée and her family. In the past, the items most easily available in villages to serve this purpose were coins. The number and quality of coins to be given by the bridegroom were discussed and fixed in the marriage contract. The bride sewed some of the coins on her wedding hat, and the rest were used in her jewellery.

As an example, the bridal hat worn in Ramallah required 90-100 Ottoman quarters and around 10 riyals. Riyals were large coins, usually from Europe, the most common being Maria Theresa dollars, so called because they bore the image of the Hapsburg empress.

During the 19th and early 20th centuries, mainly Ottoman coins were used. These were available in great quantities and ranged in quality from good silver to coins that contained no silver at all, like the *barat*. Later, these were mixed with European coins brought into the country by pilgrims visiting the Holy Land. The most popular coins in Palestine and Jordan were riyals. Among these, the most usual – apart from the Maria Theresa – were Abu Reesheh, Abu Kalb and Abu Amud riyals, each named after the design stamped on the coin. The last two were sometimes used as amulets.

Egyptian silver coins were used in Gaza, Bir Saba' and Southern Palestine. The earliest of these was known as the Hussein Kamel coins, then coins for King Fuad and King Farouk. The villages around Jerusalem and Bethlehem used Russian, Spanish and Austrian coins brought by pilgrims.

After World War I, the British Mandate authorities issued their own coins in Palestine and Jordan. Among these, only the 5 and 10 piastre pieces were silver and the rest were copper. In villages, these also found their way onto hats and silver jewellery.

Gold coins have been used in villages for centuries, but in small quantities. The most common gold coin was called *mashkhas*, meaning the picture of a saint. This type of coin was found in archaeological digs. It is thought to be a Venetian coin used in Palestine by the Crusaders. It was also used as an amulet.

Reconstructing a Disappearing Heritage

Women in the Hebron area used the golden Hamidi, an Ottoman coin named after Sultan Abd al-Hamid (1876-1909). Another gold Ottoman coin, the Rashadi, was used in Nablus and Galilee villages, while women in the Ramallah and Jaffa areas used the British gold sovereign, stamped with a picture of St George and the Dragon.

These coins have lost part of their value as antiques because of the holes punched in them, in order to fasten them to hats or jewellery.

Above (1–2) Coins from the Greco-Roman period
(3) Gold Ottoman coin
(4–5) Front and back of Maria Theresa coin
(6) Silver Ottoman coin

Reconstructing a Disappearing Heritage

Amulets

The amulets in my collection require a section of their own. They are included in silver jewellery, yet because of the beliefs attached to them, they stand apart. I have collected hundreds of objects that have been used as amulets. They come in the form of silver jewellery, glass or stone beads, wooden pieces, animal teeth, pieces of cloth, paper, seashells, etc. I have separated the small charms from the rest, but many of the amulets remain with the silver jewellery as they are difficult to separate.

The silver amulets worn as jewellery are usually in the shape of fish, palms of hands, lizards or frogs. There are also triangular or square boxes and small cylinders designed to contain talismanic writings. Other objects in the amulet collection are snake skins, alum, beans, old coins, Venetian beads that women found in the fields, semi-precious stones (especially agate in all colours), amethyst and amber beads.

These charms were passed down in a family from mother to child, with each generation adding new ones. Aside from those that were supposed to protect people, the collection includes amulets for animals, such as a large crescent and beads put on the forehead of a horse. Still other amulets, like the Hand of Fatima, are hung above the front door to protect the home. Moreover, I have seldom seen a new car without a cluster of objects – miniature Qurans, alum and various beads – hanging from the rear-view mirror.

Together with the amulets and charms, I have also collected bowls, known as *tasset el-ra'beh*, 'the bowl of fear'. The insides of these bowls are covered with inscriptions, and a person inflicted with extreme anxiety should drink water from it.

Many of the amulets in the collection could be used by persons of any religion, yet most are Islamic, as identified by the Quranic verses appearing on them. Some are specifically Christian, bearing images of the Cross, the Virgin Mary or St George and the Dragon. A few are Jewish, with Hebrew writing and the Star of David.

Left and Above Amulet with the Star of David and *Allah* (God) on the front and Quranic verses on the back, worn in the Sinai

Threads of Identity

Above A selection of amulets with bones, beads, agate and glass

By the time I had started working on my collection in the 1950s and 60s, the styles of amulets were becoming similar all over Palestine, perhaps because jewellers were moving from place to place. However, earlier collections made by Lydia Einsler and Dr Tawfiq Kan'an showed that amulets varied according to their area of origin. Dr Kan'an wrote many articles about his collection which was later donated by his family to Bir Zeit University. Lydia Einsler's collection is in the Ethnographic Museum in Dresden, Germany.[6] Also, a jeweller named Ohan assembled a collection of amulets in Jerusalem, and there is a collection of amulets at the Pitt Rivers Museum in Oxford, England.

In conversations with the women I interviewed, different beliefs and variations of amulets came up continuously. Amulets were connected with love, marriage, pregnancy, childbirth, breastfeeding and so on. The Arabic word for amulet, *hijab*, denotes both the object itself and the charm or message attached to it. These words could be inscribed on the object or written on a small scroll by a sheikh or person specialised in the art.

Throughout history, women have used amulets to defend themselves, their children and their homes against 'the evil eye' – a tradition found in many parts of the world, but especially the Middle East. Another method of defence against 'the evil eye' is fumigation, i.e., burning substances such as salt, incense or certain leaves. 'The evil eye' is inflicted by envy. It is thought that a jealous person can harm or kill through envious looks. Some of the women I interviewed believed in 'the evil eye', while others felt it was only a superstition.

To understand the subject better, I discussed it with my friend Inger Mortenson, a Danish anthropologist who has done research in Luristan, Iran, and other places. She explained that amulets are used to ward off 'the evil eye', whereas talismans are used to bring good luck and invite the positive elements of life.

As I said earlier, costume and jewellery, to me, represent the lives of the women who made and wore them.

[6] Gisela Helmike, curator of the Museum of Islamic Art in Berlin, has published an article on the L. Einsler and Kan'an collections. *Eine Sammlung palästinensischer, Amulette and Schmuckstücke*, p99-132, Akademie Verlag, Berlin

PART II

Palestinian Costumes, Palestinian Lives

THREADS OF IDENTITY

An Overview of Palestinian Costume

It is surprising that a small country like Palestine should have such a large variety of styles of traditional dress. Every area has a different style; often every village has its own distinctive costume, and even within the same village there might be more than one style.

The differences can be detected in the cut of the costume, the type and colour of fabric, the embroidery patterns and stitches, the combinations of patterns and shades of colour. As an example, red is the dominant colour used in Palestinian embroidery, but it is brownish red in parts of the Hebron area, fuchsia in Gaza, and wine red in Ramallah.

The cut of the Palestinian dress differs from one part of the country to another. In Galilee it is a slim-fitting, coat-like costume, the further south you go from Galilee, the wider the costume gets, reaching its widest in the Naqab (Negev) Desert among the Bedouin.

Galilee was famous for its *jellayeh* decorated with embroidery and patchwork in many colours of silk fabric. Under the coat, the woman wore a simple linen dress and embroidered trousers. The embroidery in Galilee was stem stitch and some cross stitch in geometric patterns. In some villages and towns, women wore costumes with the same cut but little or no embroidery.

In the areas of Nablus and Qalqilia, women had costumes of the same cut but replaced the embroidery with cord couching.

In central Palestine, including Ramallah, Jerusalem, Bethlehem, the Hebron Hills and the coast, another cut appears in the *thob*. This area has a long tradition of cross stitch and couching embroidery. The fabrics from which the *thob* was made were usually narrow, no more than 16 to 20 centimetres, so the style of the dress was determined by the width

Previous page Part of a head shawl from the Hebron area (circa 1920)

Palestine before 1948

of the fabric. A length of fabric was taken to match the height of the woman and then doubled to form the front and back of the dress. To give the dress the desired width, *banayek* (two long triangles) were cut and inserted in the sides. The sleeves were set in a straight cut; for winged sleeves, a triangle was added. Sometimes, a square was cut separately and embroidered and sewn on as a *qabeh* (breast piece).

In Southern Palestine, including Isdud (Ashdod), Gaza, Bir Saba' (Beersheba), Faluja and Majdal, costumes were generally very colourful in fabric and embroidery and rich in patchwork. Gaza, Faluja and especially Majdal were known for their weaving. Majdal produced a variety of fabric for womenswear and menswear, the most famous being the navy cotton dress fabric with coloured silk stripes on the salvage – pink, white, green and black.

Galilee: Nazareth, Acre and Tabaria

Central Palestine: Ramallah, Jerusalem, Bethlehem, the Hebron Hills & the coast

Qabeh
Qumm
Deyal
Banayek

Stem stitch

Galilee pattern

Couching

Bethlehem, Ramla, Lydda and Jaffa areas

In Bir Saba' and the Naqab Desert, among the Bedouin, the cut of the dress was very large with a lot of geometric embroidery, even on the skirt front, and often long pointed sleeves. Each tribe had its own embroidery patterns. Head coverings were also heavily embroidered.

Concerning textiles, everyday dresses were made of handwoven linen or cotton, in its natural colour or dark blue. Cotton was cultivated in Galilee and used for dresses. The silks used to decorate festive costumes were imported from Syria. In well-to-do towns and villages, like those around Jerusalem and Bethlehem, the whole costume was made from Syrian silk. Bethlehem produced its own *malak* fabrics from handwoven linen and silk.

Cross stitch embroidery was common all over Palestine. In central areas, couching was used as well. Stem stitch was found extensively in Galilee. Other stitches were used for hems, yokes and sleeve openings, and the connecting stitch was chosen to put the dress together.

Southern Region: Bir Saba', Gaza, Faluja, Majdal and the Naqab Desert

Textiles

Festive, Syrian imported silk

Festive, *malak* handwoven fabric

Handwoven linen

Cross stitch

Gaza pattern

Gaza pattern

Girls in villages in Palestine would start to learn embroidery from their mothers at about the age of 10. Each was taught the special embroidery styles of her own village; she was proud of them and they became a part of her identity. Each village had its own pattern arrangement which was copied from mother to daughter with little change and only occasional innovations.

Besides the *qabeh* (breast piece), embroidery covered the *deyal* (lower back of the costume) and *banayek* (the side triangles). There were two embroidered vertical panels, one on each side of the dress. The embroidery of the area also adorned the woman's hat and headscarf, cushions and other household accessories.

Thus, each area of Palestine was identified by its own embroidery patterns and style of costume. The woman's costume was her flag, denoting her identity.

THREADS OF IDENTITY

Palestine

1- Aboud
2- al-Bireh
3- En Karem
4- Artas
5- al-Tireh
6- Ezariya
7- Abu Deis
8- Abbasiyya
9- al-Qubab
10- Abu Shusha
11- al-Haditha
12- Abu al-Fadl
13- Acre
14- al-Bassa
15- al-Damun
16- al-Rameh
17- al-Mughr
18- al-Buqei'a
19- Alma
20- Anabta
21- Attil
22- Asira
23- al-Jura
24- Bal'a
25- Beisan
26- Beit Jann
27- Beit Dajan
28- Beit Nabala
29- Burdus

57- Iqrit
58- Imwas
59- Isdud
60- Jifneh
61- Jericho
62- Jaffa
63- Jerusalem
64- Jenin
65- Jaiyus
66- Jiljuliya
67- Jimzu
68- Kafr Ana
69- Kafr Yassif
70- Kafr Qassem
71- Khan Younis
72- Lifta
73- Lubiya
74- Lake Hula
75- Lydda
76- Majd al-Kurum
77- Marus
78- Malha
79- Majdal
80- Nablus
81- Beer Sheba Badia
82- Nazareth
83- Ne'ani
84- Qalqilia
85- Qubayba

Overview of the Palestinian costume

Naqab

Bir Saba'

Wadi Araba

• Villages
– – Armistice Line
▢ District

Villages and towns mentioned in the book

30- Beit Sahour
31- Beit Hanina
32- Bir Zeit
33- Bitounia
34- Bethlehem
35- Beit Jala
36- Beit Lahya
37- Beit Jibrin
38- Bir Saba'
39- al-Dawayima
40- Deir Samet
41- Dura
42- Deir Tarif
43- Deir Yasin
44- Deir Abu Salama
45- Deir Hanna
46- Dannaba
47- Deir al-Ghusun
48- Deir Sharaf
49- Faluja
50- Gaza
51- Shafa Amr
52- Halhul
53- Haifa
54- Hamama
55- Hebron
56- Innaba

86- Qibya
87- Ramla
88- Rafah
89- Ramallah
90- Safad
91- Sakhnin
92- Safiriyya
93- Safsaf
94- Sheikh Muwannis
95- Sarafand
96- Shu'fat
97- Summail
98- Salama
99- Saqiya
100- Silwan
101- Sa'sa
102- Shweikeh
103- Sabastiya
104- Tarshiha
105- Tulkarem
106- Tubas
107- Tell es-Safi
108- Tiberias
109- Yazur
110- Yajur
111- Yebna
112- Wadi Araba

© Salman Abu Sitta, Palestinian Land Society, London

Chapter 3

Ramallah

Ramallah, with its rolling hills and cool summer evenings, grew to be a summer resort for Palestine and neighbouring Arab countries. It also became a centre for education with many schools and colleges such as the Friends Boys' and Girls' Schools, and the Teacher Training College. Ramallah is the twin town of al-Bireh, and a centre for many surrounding towns like Bir Zeit, Jifneh, Aboud and Bitounia.

Left Woman from Ramallah (circa 1925)

Above *Znag* (double chin-chain), to hold the Ramallah headdress

THREADS OF IDENTITY

Above left Back of Ramallah headdress showing Maria Theresa coins (circa 1940)

Below left Im Abdullah wearing her Ramallah floral shawl, 1940, and gold coin pin

Right Afaf modelling her mother Nour Samara's costume

Above Outskirts of Ramallah, 1945

The town's name comes from the Aramaic and means 'the hill of God', and the people of Ramallah believe that God led them there and gave them a rich and fertile farmland, abundant with olive groves and fruit orchards, and mild weather. Between 1910 and 1920, a wave of mostly male emigration to the Americas started. Money sent back by these men to their families went into building spacious villas with large gardens, schools, businesses, hotels, restaurants and public parks.

The Ramallah costumes are well known for their wine-red cross stitch, embroidered on hand-loomed linen called *roumi*. For summer dresses it would be white, and for winter, black. The embroidery was based on geometric patterns, such as one called 'Palm Tree', and placed on the

Threads of Identity

Ramallah

back of the dress, which was a distinctive feature of Ramallah costumes. Ramallah women also wore a very distinctive headdress and shawl, again richly embroidered in red.

Through the influence of foreign schools and centres, new and varied patterns started to appear. Moreover, emigrants returned from South America, bringing new items, such as Spanish shawls with floral designs. At some stage, special factories were opened to make copies of these shawls. While women were very proud of their Ramallah costume, they did not shy away from change.

Left Ramallah costume showing Bethlehem couching on sleeves and chest panel in gold threads (circa 1925)

Above Woman from Ramallah

Ramallah

While women were very proud of their Ramallah costume, they did not shy away from change

Left *Bughmeh* (silver bridal choker). The women would be recognized by the sound of the *bughmeh* as they walked

Above Ramallah area women embroidering

Nour Samara

from Aboud and her vivid memory of the past

Above Nour Samara in her 70s

I always had a special attachment to my mother's village, Aboud, about 30 kilometres from Ramallah. Along with childhood memories, I associate Aboud with my early awareness of Palestinian embroidery and the degree to which it was intertwined with everyday life.

I probably knew Nour all my life as she was married to one of my relatives and was always a highly respected woman in Aboud. Her children, all well educated, respected and successful, today live in Aboud, the United States and Jordan. We would often meet, either in Amman or Aboud and therefore, it was over a long period of time that I compiled her story:

'Coming home from school one afternoon when I was 12 years old, I was surprised to see so many women gathered in our small courtyard. My father had just returned from Lydda with a hand-operated sewing machine for my mother. In our village my mother was considered an expert on the arts that made a house a home, from sewing and embroidery to cooking. Women often gathered in our home to consult her on such matters, or to have her cut the fabric they had bought for a new costume. Our house was a gathering point for women in their free time. They would sit and embroider, drink tea, exchange news and comment on each other's embroidery. It was in such sessions that I developed my embroidery skills as well. On that particular afternoon, however, my mother was proud of her new sewing machine and was looking forward to making extra money for the family.

'Nevertheless, mother didn't make much money, since custom dictated that women do their own embroidery by hand. She did get orders for men's shirts and qumbaz (overcoats). In those days, people would pay in kind with soap, olive oil, wheat or eggs. Mother saved the eggs to sell on market days in order to buy embroidery thread which she saved for my trousseau.

'At the age of 17, I got engaged to Boutros, who was 20. Of all the young men in the village, he always stood out for me. My parents' house was on the path to the springs in a green valley, and everyone in

Ramallah

Above Nour's mother linen dress showing the geometric embroidery patterns (circa 1880)

Threads of Identity

When the Turkish officers arrived in our area to enlist new soldiers, Boutros's mother hid him in their wheat bin and saved him from army duty

Above Nour Samara and her husband, Boutros Saleh, 1960

the village of Aboud had to pass our house on their daily walk to the springs to fetch water. Watching the young men go by was a pastime for my girlfriends and me. One day Boutros passed by. He was the most handsome young man in the village and one of the privileged few to attend school in Ramallah. That morning he looked straight at me and said to his friend in a loud voice, "Nour has lit up our day." [Nour, in Arabic, means light.] I blushed and turned my back upon hearing him speak from his heart like this. From that day on, our daily exchange of glances took on a new meaning.

'This was during World War I, which was an extremely difficult time for us. Most of the young men were conscripted into the Turkish army; few were left behind to farm the land. When the Turkish officers arrived in our area to enlist new soldiers, Boutros's mother hid him in their wheat bin and saved him from army duty. Later, we often referred to his good luck as "the little miracle in the bin".

Ramallah

Above 19th century style Ramallah *saffeh* (headdress)

'Boutros and I were not related, but his mother and mine were friends. Eventually, his family asked for my hand in marriage. During the two-year engagement which followed, my mother and aunts helped me complete my trousseau. Meanwhile, World War I ended and Palestine came under the British Mandate. Boutros joined the Palestine Police Force and was to be stationed in Ramallah. We were finally able to set our wedding date.

'Preparing my trousseau was a project which involved all the members of my family. Father bought cloth and silk thread for my dresses from Lydda, which was a major market centre at the time. Mother and I divided the embroidery between us. She did the chest panels and I did the back and side panels of the dresses. The highlight of our handwork was when Im Musa, a specialist in traditional headdresses, embroidered my *weqaya* (wedding headdress) and the band onto which coins would be attached when I got engaged.

Threads of Identity

I rode from my home to the church on a decorated horse sent by the bridegroom and led by my father

Above Ramallah bride riding to her wedding, 1915

Right Samples of coins from different areas of Palestine prepared to be attached to headdresses (1850-1915)

The Wedding

'There was a week of celebrations in the village before the wedding at Boutros's family home. On the night before the big day, the celebrations moved to our house where all the girls and women gathered to decorate their hands and feet with henna designs.

'On the wedding day itself, I wore an off-white, handwoven linen dress, embroidered in red. Under it I wore a plain white linen dress, which also served as my nightgown. The **weqaya** was placed on my head and an **asbeh** (sheer silk scarf) was tied across my forehead. My jewellery consisted of a silver choker, silver and glass bracelets, and a necklace of cloves and coral beads. I was then wrapped in a red cloak, the banner of the people of Aboud, who consider themselves as belonging to the Qais tribe. By tradition Arabs trace their lineage to either the Qais or Yemen tribes that migrated from the Arabian Peninsula as Islam spread to the Fertile Crescent. Red was the colour for Qais, and white was for Yemen.

'The wedding was held in the old Greek Orthodox Church (which dates back to Byzantine times). I rode from my home to the church on a decorated horse sent by the bridegroom and led by my father. I will never forget the rainbow of colours on that day. My grandmother wore her own wedding dress known as the **tubsi**. Mother wore a **jellayeh**, a costume with a slit down the skirt front, worn over trousers. The older women wore black linen dresses, while the younger ones were attired in white linen. My mother and aunts all wore headdresses, with rows of coins arching across their heads. They were the last generation to wear this style.

'Boutros's father invited many people from seven nearby villages for the wedding. Boutros and I were seated on a raised platform. His mother presented me with a necklace of black ribbon with 20 gold coins sewn onto it. Several groups of young people performed the **dabkeh**, the traditional folkdance. At sunset, the traditional dish of **fatteh** (rice, meat, yogurt and toasted bread) was served. Afterwards, the dancing resumed and continued until midnight.

'The following morning I wore a white linen costume to receive congratulations and gifts of money from the people of the village. This continued for a week. Then our two families attended the Sunday church

Ramallah

THREADS OF IDENTITY

Sarah and Najwa Shibley were well known for their craft, and women came to them from the entire area to have their pottery decorated

Above Ramallah women making pottery, 1905

Right Typical Ramallah *hishey* jar decorated with henna or soil called *mughra*, 1935

service together, and my father gave a luncheon. I wore my wedding costume. My father presented me with 10 gold Ottoman pounds and 50 silver Maria Theresa coins. After spending two more months in Aboud, we moved to Ramallah where Boutros was stationed as a policeman. At the end of the following summer, I gave birth to a baby girl, at home with my mother attending to me. A year later I had a baby boy.

Life in Ramallah

'Today, Ramallah seems very close to Aboud, but when I moved there with Boutros, I was lonely and homesick at first. Fortunately, our landlady, Zarifa, soon introduced me to new people. Among those I got to know were Sarah Shibley and her daughter, Najwa, who made and decorated pottery jars for storing oil and water. First they collected old pottery and crushed it in a mill. Then they added special soil and water. Taking a portion of this mixture, they moulded a jar by hand. Finally, they made the cover of the jar and the dipper that went with it. These pieces were fired in a kiln, a hole dug in the ground with a fire built around the outer edge. Sometimes the jars were sent to specialised artisans to be decorated. Sarah and Najwa were well known for their craft, and women came to them from the entire area to have their pottery [7] *decorated.*

[7] The pottery made in this way was called *hishey*, and Ramallah was famous for it. Similar pottery is made in southern Jordan. Some women specialised in making the pieces with the coiling or slab technique, while others decorated the jars with a locally produced brownish paint.

Threads of Identity

Above Im Ghazi wearing her headdress with gold coins

Right Ramallah-area shawl, 19th century

'Ramallah costumes were different from the ones of my village. Few women still wore the jellayeh and there were embroidery patterns I had never seen before. My embroidered shawl was much simpler than those of Ramallah, which was a centre for trade, linen weaving and other handicrafts. Everything was highly specialised. For example, when I wanted a shawl of the new style, I bought the material and took it to an embroiderer to make the floral decorations. Then I went to another woman who made the knotted fringes. One woman specialised in making headdresses and another fastened the coins on them. This was so different from my village where people embroidered for themselves or were helped by family members.

'Every Ramallah costume had an inverted arch called the rainbow which was embroidered on the chest panel. After 1925, this was replaced with gold-threaded embroidery in the Bethlehem style. Women in Ramallah bought sleeves for their black dresses from Bethlehem, and many inserted beautiful gold couching embroidery on the chest panel and back. Some women specialised in doing the connecting stitch over all the seams.

'Living in Ramallah, I wanted to blend in better and so I started with my clothes. With the help of Zarifa, my new friend and landlady, and my mother-in-law who was visiting me at the time, I began this endeavour by purchasing white linen. We took it to Im Mariam who was the best local dyer. In order to get the shade of black I wanted, she first dyed the fabric with indigo nine times, then soaked it in a solution of boiled oak bark, fenugreek and vinegar for two or three days.

'Afterwards, I wanted the Bethlehem sleeves which were becoming so fashionable and were worn by the elegant women in the church. These sleeves had golden couching. (see chapter 6 on Bethlehem) So, off I went with my husband, children and my landlady, on a trip to Bethlehem, especially to purchase these sleeves. In Bethlehem, we attended the service at the Church of the Nativity and asked the priest to bless our children. Then, finally, we reached the house of the famous embroiderer, Jamila Freij. She sold the sleeves to us and insisted that we stay for lunch. It was such a memorable trip and I still wear this dress on special occasions.

In the evening my mother-in-law would invite the village people and we would all enjoy folktales, songs or poetry

Above Helaneh Saleh, Nour's mother-in-law, 1940

'Our family was growing. I had two more children, a boy and a girl. Later, I had two more girls. My mother-in-law would send us provisions from Aboud – olive oil, flour, dried figs, raisins, dried vegetables, cheese, soap, etc. That was a big help and I was able to save money and buy what I wanted in order to follow the new Ramallah dress style.

'Every summer we left Boutros behind in Ramallah and spent the holiday in Aboud. He would join us every other week. Most of the village weddings were held during the summer, and we joined in the festivities. Christian weddings were on Sunday and Muslim weddings on Friday, so we attended both. My new costumes were highly admired by the women in Aboud, and young brides copied some of the Ramallah patterns from them. However, they found the Bethlehem sleeves rather funny.

'In the village, I helped my mother-in-law with food preservation. In the summer we made soap from olive oil. We also gathered carob to make molasses. Some of the carob was dried to make a special tea, and the remains of this were boiled into a jelly from which we made pudding. We dried vegetables and herbs, such as sage and thyme, for medicinal use.

> 'We were on holiday in Aboud in May 1948 when war broke out. In a very short time we lost the larger part of Palestine. Our Jerusalem home was occupied by Jews, so we lost our house and possessions, including my precious costumes

'My mother-in-law was a very special person – tall and slender, with beautiful green eyes, long, thick hair and a sharp sense of humour. She worked hard all day, but in the evening she would invite the village people and we would all enjoy folktales, songs or poetry.

'My children loved the village and never wanted to leave at the end of the summer holidays. Usually our departure created a fuss, with all our friends and relatives coming to bid us farewell, even though Ramallah was only a few kilometres away. Many brought us gifts of dried figs, thyme or other herbs.

1948: War breaks out

'By the mid-1930s, my husband had become increasingly uncomfortable about his job with the British administration's police force. Protesting against the large numbers of Jewish immigrants arriving in Palestine, the Palestinians were often on strike and he was expected to break the strikes. This he found difficult as he was usually in agreement with the strikers. In the midst of it all, he was transferred to Jerusalem.

'When we moved there, we lived in the Musrara quarter, not far from the Arab Anglican church and the school that my children attended. Some of my neighbours were native Jerusalemites; others had moved there from surrounding villages, like Lifta, Silwan and Malha. The dresses women wore for special occasions were made of striped silk with couching, but the new style was the rosa, a silk costume with embroidered rose branches. My former landlady, Zarifa, came to visit us from Ramallah. We bought rosa fabric and she cut out a dress for me. My neighbours helped me embroider it, and Zarifa did the chest panel.

'We were on holiday in Aboud in May 1948 when war broke out. In a very short time the larger part of Palestine was occupied by Israelis, including our Jerusalem home, so we lost our house and possessions, including my precious costumes. We were never allowed to return to retrieve our belongings. We went back to Ramallah which was now considered to be part of the West Bank of Jordan. The Jordanian government issued passports for us so we could travel, but I found that the city had changed. It was accommodating refugees from Lydda, Ramla and many other villages. Even Aboud had changed. Refugees had come there also, and some of them had to live in the caves.

Threads of Identity

'During these difficult years my two sons finished school, but found no jobs. Together with my son-in-law, who was also unemployed, they emigrated to the United States. I was losing not only a homeland but also my children.

'After my mother-in-law died, Boutros and I moved into the old family home in Aboud in order to live with his father. Readjusting to village life was not easy for us. War broke out again in 1967, and all of Palestine fell under Israeli occupation. There was another influx of refugees into Aboud and Ramallah. Our economy was badly hit. Villages like Aboud had for centuries depended on cultivating olives and selling the oil. Each tree produced at least $200 worth of oil annually, but now there was no market for it.

'With conditions like that, Boutros and I decided to visit our children in the US who were becoming successful. I packed my best dresses and wore my complete Ramallah attire when I travelled by plane for the first time in my life. On the long journey, with stops in several airports, I attracted a lot of attention. Unfortunately, when I reached New York, my suitcase was lost, and I had to wait two months for it to arrive. While I waited for my luggage, I hardly left the house. I did not want to wear my only precious dress every day and I did not want to wear Western-style clothes.

'Life in America was strange for me. My sons and their families were busy, so Boutros and I were left at home. There were so many modern conveniences and everything was bought from the store. I had so much free time. I did not have to wash the clothes, wash dishes, make bread or preserve food. Yet I longed to go back to Aboud.

Autumn Years in Aboud

'While we were in the US, things in Palestine had deteriorated as the Israeli occupation tightened its grip. The first shock was to find that two Israeli settlements had been built on Aboud's land where there had once been olive groves. Hundreds of acres had been confiscated without any compensation given to the owners. Aboud had also lost its water sources, including a spring on our land that had previously been accessible to the public. The water had been diverted to the settlements, restricting what was available to the village.

Life under occupation has become more and more burdensome, but I am lucky because my family and friends are around me and I still live in our family home

Left Nour and her daughter crushing olives, 1975

Above The author with Sab'ah (right) and Ghazaleh (left) wearing new Ramallah dresses, 1985

'We had been unable to adjust to life in America, but now life in Aboud had become foreign to us too. Our younger children were finishing school and we began looking for job opportunities for them. The girls wanted to go into nursing and inquired at St John's Hospital in Jerusalem about being trained there. This meant they had to live in Jerusalem, so we did not see them often, as travelling through all the road blocks was difficult.

'Life under occupation has become more and more burdensome, but I am lucky because my family and friends are around me and I still live in our family home. I have enough embroidered dresses so I have started embroidering wall hangings of the Lord's Prayer - one for each of my children. I brought the samplers from the US.'

That was the story that Nour told me. Later in her life, as a widow, she continued to live in the old family home surrounded by family who would always visit from abroad. On her birthday, 5 May 2006, Nour, died peacefully in Aboud at the age of 99. She continued to embroider until the last year of her life.

Collection *Ramallah Area*

RAMALLAH

Left Chest panel from a Ramallah costume, showing the Bethlehem couching embroidery in gold cord (circa 1925)

Above Ramallah linen costume typical of the end of the 19th century when new embroidery patterns were introduced (circa 1900)

THREADS OF IDENTITY

Left *Khirqa*, head shawl from the early 20th century when bird and duck patterns were introduced

Above Floral shawls (circa 1935)

Right above Cushions with typical Ramallah patterns

Right Silver choker with Ramallah chin-chain from 1930s

Far right Golden wedding pin with Ottoman coins, from Ramallah and Bireh

Ramallah

Chapter 4
Jericho

Due to its exceptionally warm climate, as it is the lowest city on earth, Jericho is a centre for agriculture. The bananas and oranges of Jericho are said to have a special taste and scent. Flame trees, resplendent with bright red blossoms, line the city streets. As the last Palestinian town before crossing the Allenby Bridge to Jordan, it has always had many rest houses and restaurants.

Left City of Jericho (circa 1930)

Above Necklace of ancient beads collected over the centuries from the layers of the city of Jericho

THREADS OF IDENTITY

Above Amulet with silver pendant, Palestine Mandate coin and ancient beads

Jericho also has a rich archaeological history. According to some experts, such as the late British archaeologist, Dame Kathleen Kenyon,[8] it is the oldest continuously inhabited city in the world. Nearby is the beautiful Qasr Hisham, an Umayyad palace, built in the 7th century.

Jericho's large plantations were predominantly owned by wealthy families from Jerusalem, Bethlehem or Ramallah. To avoid the cold weather, these families would usually spend the winters in Jericho. Given the steamy climate, Jericho developed a reputation as a winter resort for all those who could afford to escape the cold of the neighbouring cities. The plantations were managed and worked by local farmers and Bedouin who lived in Jericho all year round.

[8] Dame Kathleen Kenyon (1906 – 1978), a leading archaeologist who specialised in Neolithic archaeology in Palestine and nearby countries, and excavated an area of Jericho proving it to be the oldest known, continuously occupied settlement, described her work there in *Digging Up Jericho*, London, 1957.

JERICHO

Above Jericho women in traditional dress (circa 1935)

Below Family of Mahmoud Radif, from Jericho, 1946

THREADS OF IDENTITY

JERICHO

Jericho was flooded with refugees from towns and villages that had been occupied by Israel. During the June 1967 war, the camp was attacked by Israel, and they became refugees again, fleeing to Jordan

Left Kohl holder made of felt material decorated with coins and beads. The kohl bottles are made of carved wood (circa 1920)

Above Women in Aqabat Jaber Refugee Camp, wearing dresses typical of the 1950s

Alya (Im Suleiman)
'The land belongs to God'

I met Alya on one of my many trips to visit my parents before 1967, when I would travel freely back and forth between Amman and Bethlehem. During those years, Jericho was flooded with refugees from towns and villages that had been occupied by Israel.[9] Therefore, the YWCA had established a sewing and embroidery centre to enable women to earn money, and I would often stop at this centre as part of my involvement in projects that promoted embroidery to help Palestinian women survive. Alya was one of the active women at the centre and we established a long-standing friendship. I interviewed Alya on different occasions in the 1950s and 60s. Besides shedding light on how she lived, her account reveals the close relationship between her Bedouin family and their urban-based landlords – a situation that was radically altered after the Israeli army occupied the West Bank. Her story also exemplifies how traditional dress styles specific to different areas of Palestine began to intermingle, especially as war and occupation pushed people into new locations and ways of life.

Alya's family worked on the banana plantation of Abu Kamel who lived in Ramallah. She gave birth to her first son and named him Suleiman, and she became known as Im Suleiman and her husband as Abu Suleiman.

Alya called the costume she wore a *thob ibb* (pocket dress). It had a very long skirt that was doubled over a handwoven belt to form a big front pocket in which to carry the items needed for the day. The same style of gown was worn by women of the Adwan tribe across the river in Jordan. The dress was decorated with lengthwise stripes of running stitch embroidery done in white cotton thread. Along the hem was a four-inch navy-blue band intended to protect the wearer from the evil eye. Wound around her head, she wore a red

[9] Aqabat Jaber Refugee Camp was established on the outskirts of Jericho in 1948, housing more than 35,000 Palestinians. During the June 1967 war, the camp was attacked by Israel, and they became refugees again, fleeing to Jordan.

JERICHO

Above Alya's costume showing the new cross stitch embroidery patterns (circa 1940)

99

Left Detail of Alya's dress showing the blue cotton band attached to the hem to protect the woman from the evil eye, and protect the hem from wearing out

Below Farmers working in the fields, 1930s

cotton *asbeh* (scarf) with white dots. At the time I met Im Suleiman, this type of dress was being replaced by a single-length costume with the same embroidery and blue band on the hem.

Abu Kamel's family came every winter and stayed in the large house next to Im Suleiman's modest one. She ran errands for them, and a special relationship developed between her and Im Kamel, the wife of Abu Kamel, that would last many decades. Coming from Ramallah, Im Kamel was very proud of her town attire, and one winter she taught Im Suleiman how to sew and embroider in the Ramallah style.

The following winter, as Im Kamel arrived with her family for their annual stay, she was pleasantly surprised to see the Ramallah rose branch embroidery pattern on Alya's dress. That same afternoon, other farmer women came to welcome Im Kamel, all wearing their Jericho-style costumes decorated in the same Ramallah pattern. The white running stitch had disappeared, but the blue band at the hem had been retained as it was thought to protect the wearer from evil. Im Kamel was happy to see how the embroidery patterns she had taught Im Suleiman were spreading across Jericho.

Alya's life was hard. She worked alongside her husband on the banana and vegetable plantation. In addition, she took care of her large family, waking up at dawn and baking bread, preparing the day's food and ensuring that the children were ready for school. During the harvest season more workers were usually needed. One of these seasonal labourers was Mariam, an attractive widow with five children, who caused some trouble to Alya and her family life. The following is in Alya's words:

'I always noticed that Abu Suleiman was especially sympathetic towards Mariam. He would help her more than he helped the others. Then he would give her a portion of the vegetables, saying, "These are for your fatherless children." I knew it was not the children but Mariam that he was interested in. I decided not to say anything about it to him. I knew that his feelings were like a passing cloud, and that a man's nest is his home. The looks he gave her cut me like knives, but I kept everything in my heart.

'Two years later, he couldn't stand her or her children whom she always sent to us, asking for favours. One day as we were going to the fields, we passed Mariam's house. Abu Suleiman turned to me and said, "Im Suleiman, you are a queen, you are my queen." I turned my face away to hide the tears. He knew that I knew about his affair with Mariam, and I knew then that it was over.'

On one of my visits, some years later, I learned about the engagement of Suleiman, her eldest son, to a distant relative. There was some tension over what would be the proper trousseau for the bride. Some wanted to stick to Bedouin traditions, while others were influenced by the refugees or urban landlords. The two families planned to go to Jerusalem to buy the trousseau. Alya put conditions on her husband. Before buying anything for his son's future wife, he had to buy Alya a gold coin pin and coin earrings like the ones her landlady Im Kamel, from Ramallah, had. Abu Suleiman did not refuse.

Hamdeh, Suleiman's fiancée, lived next to the refugee camp and went to the same school as the refugee children. Here, in addition to their regular lessons, the girls learned embroidery. Hamdeh told Suleiman's family that she wanted the dresses for her wedding to be like the ones the girls in the camps wore. This was a totally new style based on a mix of traditional peasant patterns from different villages, combined with new patterns copied from Western magazines.

Left Handwoven woollen belts worn by women in Jericho and the Jordan Valley, early 20th century

Above Women take a milk break during their sewing class in Aqabat Jaber Camp

Threads of Identity

Above Jericho handkerchiefs trimmed with beads, made by the bride for the bridegroom to wave while dancing (circa 1940)

Suleiman's family was opposed to this as it meant denying their Bedouin heritage, but they reached a compromise. They decided that her trousseau would be half-Bedouin, half-peasant. Thus, her new dresses were a combination of the two styles. The colourful scarves worn by the Jericho Bedouin were bought for her head, but her jewellery consisted of the gold coin bracelets and necklaces favoured by the peasants. Two of her dresses were machine-embroidered in the refugee camp.

A mud-brick room was added to the family home for the new couple, but they took their meals with Im and Abu Suleiman. Abu Kamel, the landlord, and his family attended the wedding and paid for the additional room, plus its furnishings, as a wedding present. For 40 days, the bride was treated royally with plenty of rest and no work. After that, she had to get up early like the others and accompany Suleiman to the fields.

Im Suleiman then had more free time. She made costumes for herself and her daughters cut in the Jericho way but embroidered with the Ramallah branch pattern. Every winter, Im Kamel came from Ramallah, bringing new embroidery patterns to share with her. At this time, the YWCA centre in the refugee camp taught women how to make dolls dressed in traditional costumes. These were then marketed in cities, sometimes to tourists. Soon, Im Suleiman was making these Jericho dolls and earning extra money.

One day in June 1967, Im Kamel arrived unexpectedly in Jericho, saying that there was trouble, but Jericho was safe for the time being. Abu Kamel was in the United States and Kamel, their eldest son, was living in Amman. The 'trouble' was the 1967 Arab-Israeli war which had just begun. Jericho became a living hell with refugees in their thousands converging on the city as they made their way to Jordan. Three days later, Kamel arrived from Amman in a rented car and urged his mother to leave with him. She resisted the

idea, saying she would rather die where she was. Kamel told horrible stories of how Israeli planes were dropping napalm bombs on the refugees. He convinced her that she should head for Jordan in the company of a Red Cross convoy. He assured his mother that she would be gone for only two weeks or so. Im Kamel went into her bedroom and took her time putting on her complete white Ramallah attire, including the headdress and red shawl. Reluctantly, she went to the car with tears in her eyes.

Im Suleiman spoke about the aftermath of the war:

'A month later, we went to deliver the dolls we had made to the centre. The camp was like a ghost town, nearly empty. The embroidery centre had been turned into an Israeli army office. Two years later, Abu Kamel obtained a special permit to come back. Standing at our door, crying, he told us that Im Kamel had died a few months after leaving Jericho. The rest of the family were not allowed to come back to their homes in Ramallah or Jericho, and had to remain in Jordan.'

The Israeli authorities confiscated Abu Kamel's family land under the Absentee Property Law,[10] and classified it as belonging to the Jewish National Fund.[11] Im Suleiman's family had to pay rent to them, and water rights were restricted. When I saw her years later, I asked her who owned the land. She replied: 'The land belongs to God.'

[10] In 1950, Israel passed the Absentee Property Law and confiscated the land of Palestinians who fled or were forced to leave their property during the 1948 war. The same law was applied in the West Bank and Gaza Strip after the 1967 war. Property rights were transferred to the Custodian of Absentee Property without compensation to the property owner or provision for an appeal.

[11] The Jewish National Fund was founded in 1901 at the Fifth Zionist Congress in Basel, Switzerland, as a tool for purchasing lands in the Ottoman Empire territories. After the founding of the State of Israel, the Fund was allotted a large portion of the confiscated Palestinian land which was then reserved for use by Jews only.

Chapter 5

Hebron

Another very old city of Palestine is Hebron, known as al-Khalil in Arabic. Its history dates back to the Amorites and Hittites. The town itself, with its tall stone houses, narrow streets and picturesque bazaars, is a typical example of an old Arab city. The name, al-Khalil, derives from Khalil al-Rahman, meaning the friend of God, and refers to the Prophet Abraham, revered by Jews, Christians and Muslims, who is buried there in the al-Haram al-Ibrahimi Mosque.

Left City of Hebron in the early 20th century, with al-Haram al-Ibrahimi Mosque in the background

Above Detail of silk *shambar* (head shawl) made in Hebron area (circa 1920)

THREADS OF IDENTITY

Above Fatma Musa modelling a silver *kirdan* (choker) and *jellayeh* costume displaying silk patchwork on the front and sleeves (circa 1928)

Hebron

Above Hebron market, 1930s

Located south of Jerusalem, the Hebron region covers approximately 2,100 square kilometres. From ancient times, its hilly landscape has supported an agricultural community renowned for their vineyards and the grapes they grow. In 1946, this community numbered 100,000 Arabs living in 83 towns and villages.

Hebron has a rich cultural heritage, and its craftsmen have for centuries worked in a range of media, including glass, ceramics, leather and fabrics. The cotton fabric called *karawy* was handwoven in large quantities and dyed with indigo for village costumes. Silk was woven for the characteristic black bridal shawl embroidered in red, known as the *shambar*.

HEBRON

Left Detail of the back of a dress with the wave motif (lower half) and the square-shaped 'Tent of the Pasha' motif, 1925

Above A copy of a traditional *weqaya* (bridal headdress) from Deir Samet 1968

Above Right *Meklab* (a bridal ornament) worn on the back, consisting of a piece of fabric covered with coins, amulets and glass beads, and fringed with silk (circa 1900)

Friday was market day in Hebron, and villagers came from all around to shop and buy fabrics. While city women wore a simple indigo-blue dress with no embroidery, the costumes of village women were distinguished by profuse, colourful cross stitch. This painstaking type of embroidery can be seen in a great variety of patterns and colours, all done with silk thread. There is a primary pattern called the 'Tent of the Pasha', which is evident in village dresses throughout the area, with variations specific to each village. Hebron women were also known for attaching patchwork to their dresses.

HEBRON

On the al-Auneh Day all the villagers, men and women, gather to help and celebrate the roof construction of a fellow villager

Left Back of a boy's circumcision vest worn in Hebron villages, made of *dandaky* cotton, covered with coins and a beaded amulet; the front is made of *atlas* silk (circa 1930)

Above al-Auneh Day

Threads of Identity

Fatma Musa
from Qubayba: Selling eggs to buy colourful threads

Above Fatma Musa in Amman

Right One of the rare *jellayeh* costumes of Qubayba, linen with heavy silk embroidery (circa 1900)

I met Fatma Musa in 1968 through the Near East Council of Churches office in Amman, where I had volunteered to help with an embroidery project. I invited her home to help me document the dresses I had in my collection from the Hebron area. At the time I met her, Fatma was constantly embroidering in order to make ends meet. I interviewed her on several occasions over an extended period, and we kept in touch throughout the 1970s. Below is the story of her life as she related it to me over several meetings:

'I was the eldest child and my father's favourite. Qubayba, the village I come from, lies between the Hebron hills and the plains. We had access to two big markets, Faluja and Hebron. My mother made me a straw basket which during the week, I would fill with eggs. Thursday was market day in Faluja; we would get up before the morning call to prayer. Then friends and relatives got together to go to Faluja as soon as the morning prayers were over. Clutching my egg basket, I rode behind my father on his donkey. All the way he talked to me or sang. My mother usually rode on a different donkey.

'In Faluja, our group would disperse after arranging where to meet in the afternoon to go home. At the market, my mother and I traded eggs for spools of silk thread and sometimes for cloth. My father sold wheat, barley and other grains which he had grown on his land. He grew vegetables as well, some of which were dried to be used during the winter and the rest would be given to others in the village.

'I never went to school. Instead, I helped my mother with whatever she was doing. When I was 10, she taught me how to embroider, and I was always anxious to finish my household tasks in order to sit and embroider. By the time I was 12, I was making my own pieces. I started with an everyday dress, then a big red **jellayeh**, *then a* **ghudfeh** *(head shawl). My mother and sisters helped me and also worked on their own costumes.*

'At the Faluja market, my mother would point out the many different types of costumes worn by women from other villages. We laughed at the big Faluja patterns and at how many colours were used in the Gaza dresses. Ours were the best, she always said. I also

HEBRON

Above Tobacco bag made by the bride to give to the bridegroom during the engagement (shown in actual size) (circa 1935)

Right Hebron-area *ghudfeh* (shawl), linen with silk cross stitch; by tradition, the bride does the embroidery while the fringe is provided by the bridegroom (circa 1925)

went with my parents to the Hebron and Bethlehem markets. In both places, costumes and accessories were sold ready-made. But people from our village never bought ready-made dresses. It had to be "the work of the soul for the soul", i.e., handmade for yourself.

'One day, when I was nearly 15, I was going to the Faluja market with my father as usual, but I noticed that he was very quiet. Midway there he said, "Fatma, I have promised you to Ali Salameh. Yesterday, his family asked for your hand and I accepted. This is your destiny." I was shocked and confused. Ali was the age of my father, a widower with three children. Moreover, he was a big landowner and chief of the town. I loved and respected my father totally so I had faith in him and believed that whatever he did was for my own good, so I said nothing. We were silent for a long time.

'Back home, we got busy preparing my **jehaz** (trousseau). Being the eldest, I had the advantage that all my sisters and aunts helped me. As we worked, my mother constantly compared every item in my trousseau with what had been made for hers.

'One day, my family went with my fiancé's family to the Faluja market to do the **kisweh** (wedding shopping). My fiancé bought presents of cloth for all my aunts and uncles, fabric for my bridal costumes, as well as jewellery, henna, rosewater, cloves and a variety of sweets.

Threads of Identity

Above *Kirdan* (silver choker), part of the bridal dowry made in Hebron and in Kerak, Jordan

The third day after the wedding, as was the tradition, I went with my girlfriends to the water springs where the whole village – men and women – met and socialised

Above *Mashkhas*: Venetian gold coin found in archaeological digs, used as an amulet

'Our village sheikh would not preside over the marriage contract because I was underage. So we had to go to Hebron and lie about my age. Four months after signing the contract, the wedding took place. I wore the red **jellayeh** which I had embroidered, and on my head I wore a headdress encircled with a ring of 40 Maria Theresa coins, and over it, a white embroidered shawl.

'My father arranged two henna parties on two successive nights. The first night all the women tinted their hair with henna. The second night we painted henna designs of palm trees on our hands and feet. After that, the whole town was invited to the bridegroom's home for a dinner of **fatteh**. To make this dish, thin, flat **taboon** bread was cut in pieces and placed in large wooden bowls. Broth was poured on top, then meat and hot butter. After the meal, the guests presented gifts of money.

'The third day after the wedding, as was the tradition, I went with my girlfriends to the water springs where the whole village – men and women – met and socialised. When we got there, my husband passed around the customary sweets.

'I did not get to know my husband before our marriage, but he treated me with respect and I did likewise. We lived happily for five years until 1948 when Jewish militias came and attacked our village while we were sleeping. We gathered our sheep and went south to the village of Dawayima,[12] where we lived in a cave. Again we were attacked, this time by the Israeli army. This forced us to move to the village of Deir Samet, then to Dura, where we sold our cattle and moved north to Halhul. In all this moving about, two of my children died, and I was left with one.

'In Halhul, we lived in a garage, and in the summer we rented a vineyard where my husband and I worked all day. While working in the vineyard, I gave birth to a baby girl. At the end of the summer, we moved to Tarqumiya, another large village, where we worked on a farm. After that, our situation worsened as there was no work available. We decided to move to the refugee camp known as Fawwar, near Bethlehem.

[12] The site of a massacre in 1948 where Israeli forces killed around 100 unarmed Palestinians in the village and surrounding caves.

'We were given a tent and a card with a number. My husband, who had been the head of his village, was reduced to being a refugee identified by a number. He had to look for work and found a job harvesting in Yatta village. His hope of returning to our own village began to wane, and his whole personality changed. He just could not adapt to all these changes and his spirits were very low.

'Once, he went to join a queue for our food rations and he came back so dejected that I never let him go again; I went instead. He also became very sarcastic. I remember asking him once where he was taking the children. "To bathe them in the Qubayba springs," he replied. Another time, when his brother, who lived in the Jericho refugee camp, came to visit us after many years of separation, my husband shouted, "Go kill our largest sheep. Roast it and invite all the people of Qubayba to join in our victory celebration. We are back in Qubayba."

'While living in Fawwar camp, I had a baby boy and girl, so we became a larger family. I had to sell some of my old embroidered dresses and cushions, and I began doing paid embroidery work for women's organisations. We hardly felt that we had settled down when the 1967 war started and there was a new stream of refugees. We decided not to leave, but the napalm bombing pushed us towards Jericho. There we found Aqabat Jaber Camp emptied by the Israeli attacks, and we joined the thousands fleeing across the border to Jordan.

Above Refugees living in a cave, Hebron area, in the 1950s

"Go kill our largest sheep. Roast it and invite all the people of Qubayba to join in our victory celebration. We are back in Qubayba"

'In Amman, we rented a room in Jabal Nazif. We were registered as refugees to get rations, and I also registered at a welfare organisation to do embroidery work. In order to help my family survive, I sold my silver jewellery and more costumes. During all of this upheaval, my husband got sick and died, leaving me to manage alone with the children. I took my eldest son out of school so he could work. Every day I prepared turmos (lupines) for him to sell on the street. The main staple of our diet was the flour ration I got from UNRWA. I baked it into bread with za'tar (thyme) in the morning, and a little sugar and sesame seeds at night. Sometimes we would go to the market at the end of the day and buy the leftover vegetables because they were cheaper. Our life was difficult but my children were bright and helpful. We survived by my son's work and my embroidery.'

For a few years I lost contact with Fatma, but I met her again in 1985. She looked well and was satisfied with her life. One of her sons had become an engineer. He had married and built a house. He asked her and her remaining children to live there too. He wanted her to be in charge of the household and he said he would turn his salary over to her, but she felt too weary after all of the trauma she went through to take on this role. Her eyes had grown weak, and she could not embroider as she had before. Still, she made a new-style dress for her daughter-in-law, embroidered with rose branches, the type preferred by those Palestinian women who still wore traditional clothing during the 1980s.

Again I did not see Fatma for many years, but I looked her up in April 2003 and was pleased to learn that she was in good health and living with her son who is now a successful engineer. We talked on the phone and she still remembered all the questions I asked her in our earlier interviews. Since I had last seen her, she had embroidered costumes in the traditional Qubayba style for her daughter, daughters-in-law and granddaughters. She also taught all of them embroidery, particularly the patterns of Qubayba. She said that while they all wear modern clothes, they put on their traditional costume on festive occasions.

Sabeeha
from Deir Samet: Embroidering in spare moments

Above Ishaq, Abu Iyad

Right Sabeeha's costume from Deir Samet, Dura, linen with *heremzy* (taffeta) silk side panels, patchwork and cross stitch in the centre (circa 1928)

I first met Sabeeha's son, Ishaq, around 1980 in Jerusalem's Old City *suq* and was impressed by his knowledge of Palestinian folklore. He told me he was a teacher and Palestinian folklore was his hobby. He bought traditional items, such as old headdresses, jackets and agricultural tools from different parts of the West Bank, selling some of them and keeping what he thought was rare. He gathered information about these pieces, but what distinguished him from other collectors and traders was that he also traced their linguistic roots. He was interested in what the piece had been called, the connections and associations of its name, and where it had been mentioned in literature, poetry and proverbs. He also collected popular songs, those sung on particular occasions, rather than just the well-known wedding songs. He recorded the lyrics of the songs people sang for rain, for a family member who was leaving home to go abroad, and so on.

When he invited me to meet his mother in his hometown of Deir Samet, I readily agreed. Deir Samet lies south of Hebron, one of a cluster of 95 small villages called *khirbet*, meaning they were built on the sites of ancient ruins. Together, these *khirbets* make up the village of Dura. In 1948, Dura's population stood at 11,000, most of whom were peasants. Deir Samet, with a population of 900, was the largest *khirbet*.

In the 1948 war, some of Dura's small villages were completely emptied of their population. But Deir Samet was among the half-lucky ones. While many people remained in their homes, they lost most of the land which extended beyond their village. Only a little land remained close to the village. In 1949, 10 men crossed the newly-created Israeli border to plant their land and live in their farmhouses there. After they finished planting, they were killed by Israeli forces, and the harvest was reaped by Israelis. Many others tried the same thing, but they met the same fate.

HEBRON

Threads of Identity

Sabeeha always carried her embroidery with her in a deep pocket hidden underneath the chest panel of her dress, for whenever there was a spare moment

Above *She'arieh* necklace worn by women in Hebron area

Right Detail from the back of Sabeeha's dress; the off-white stitching is an intentional mistake made to ward off the evil eye (circa 1928)

Sabeeha, Ishaq's mother, was a large woman with a beautiful face and green eyes, and one of the few still wearing the traditional cap with silver coins, embroidered costume and shawl particular to the area. Sabeeha's village was prosperous before 1948, with land extending south to the Naqab desert. The villagers had access to the markets of both Hebron and Bethlehem.

She related her daily schedule in great detail. Every evening she would prepare bread dough and leave it for the next morning. She would wake up at around five o'clock and take the dough to be baked at the local *taboon* (communal oven) where she waited her turn among the other village women. When the loaves were done, she would spread them out to cool and then take her jug to fetch water from the nearest spring. Back home, she would milk the sheep, then prepare lunch for the shepherds who worked for her family before they took the sheep out to pasture. During the planting and harvesting seasons, she would take a lunch of fresh bread, raw or fried vegetables, olives, onions and cheese to the men working in the fields, before returning home to make lunch for her family. The lunches had to be good. 'You know how men eat,' she said.

Threads of Identity

She would wake up at around five o'clock and take the dough to be baked at the local taboon (communal oven) where she waited her turn among the other village women

Above Village oven in Hebron area, 1900s

Her mother-in-law helped with the housework, but Sabeeha shouldered all the tasks outside the house alone. Friday was the day off, and she received guests, her women friends from the village who came to sit and chat, bringing with them their embroidery. On that day, some of the dough she had prepared would be turned into *zalabya* (fried bread balls dipped in sweet syrup) for her guests.

Sabeeha always carried her embroidery with her in a deep pocket hidden underneath the chest panel of her dress, for whenever there was a spare moment between childcare, cleaning, washing and cooking, she would work on it. She helped with the farm work when needed, moving to a summer shelter near the fields of wheat, barley and lentils. Another task she was responsible for was making yoghurt and cheese from sheep's milk.

However, in 1948, her life radically changed. Hearing of the approaching war, families sent their women and children to the small farmhouses they had on their land outside the village, thinking they would be safer there; but a few months later, the Israeli forces expelled them from these houses and farms, and confiscated the land. So they had to return to the village where they became landless farmers. Sabeeha had to sell all the gold coins on her cap to send Ishaq to a teacher training college in Hebron.

Above Detail of a shawl from the Hebron hills, mainly Yatta village, made of linen with reversible Moroccan stitch embroidery and drawn thread work (circa 1925)

Ishaq was a school teacher until 1980 when he decided to follow his passion and opened a shop in Bethlehem selling antiques and souvenirs, as the income from his shop would enable his children to go on to higher education. He is a valuable source of information on folklore and has broad knowledge of the traditional agricultural tools and village rites related to rain and the harvest, and many researchers, students, journalists and museums seek him out. He has also written a book on the folklore of Hebron, but has not yet been able to publish it. My friendship with Ishaq continues to this day, and whenever he is in Amman, we lose ourselves discussing various anecdotes or recent discoveries regarding Palestinian folklore.

Collection *Hebron Area*

HEBRON

Left Detail of a *meklab*, bridal accessory (circa 1900)

Above Costume from Taffuh village, Hebron area, cotton with centre silk panel on skirt and sleeves, patchwork around hem and pointed sleeves of *malak* fabric (circa 1925)

Left Silk *shambar* (head shawl) with reversible silk embroidery (circa 1920)

Below Hebron-area *araqiyeh* (headdress) with cross stitch embroidery and circle of Maria Theresa coins, plus some Ottoman coins; the embroidered *lafayef* (bands) are wrapped around the woman's braids

Right *Jellayeh* festive costume of Zakariya village, north-west of Hebron, made of cotton with silk panels on front and sleeves, and decorated with cross stitch and patchwork (circa 1930)

Next page Collection of silk cushions from the Hebron area, decorated with cross stitch and patchwork; a bride usually prepared 6 to 12 cushions for her new home (circa 1925)

HEBRON

Chapter 6
Bethlehem

Bethlehem, my hometown, has been the weaving and embroidery centre for the villages of central and Southern Palestine for many years. Because of the city's religious significance, many churches, monasteries and schools of different affiliations were founded there over the centuries. Bethlehem's heritage is a product of Arab culture and Byzantine influence and this cultural mix is apparent in the city's architecture.

Left A view of Bethlehem from the north (circa 1930)

Above Bethlehem *shatweh* (bridal headdress) of felt and cotton, embroidered with cross stitch, couching and *sabaleh* (herringbone) stitch. Front covered with silver or gold coins and rows of coral beads (circa 1920)

THREADS OF IDENTITY

Above Procession near the Church of the Nativity (circa 1925)

Religious orders, like the Franciscans and Benedictines, have had a presence in Bethlehem for centuries. The Franciscans introduced many crafts and skills in their schools, while the Benedictines stressed research, and later opened Bethlehem University.

Before the occupation, walking in the streets of Bethlehem, especially on Sunday mornings, you would be struck by the rainbow of colours on the women's *malak* (royal) costumes. The Bethlehem costume is called royal because it is so rich that it is described as 'the queen of dresses' in Palestine. Indeed, it is made of a blend of silk and linen, woven in bright multi-coloured stripes. Over the dress comes a short-sleeved jacket which glistens with embroidery. With this costume, women wear high, fez-like headdresses bearing the glinting coins of their dowry, crowned by a sheer silk shawl.

Religious harmony was demonstrated by the fact that both Christians and Muslims wore the same style, with the Christian women adding a small cross on the chest panel of the costume

Above Bethlehem couple, 1920s

Threads of Identity

BETHLEHEM

Left *Khedary* (festive dress) of handwoven linen with red and green silk stripes on sides and sleeves (circa 1880)

Above Bethlehem woman from the Bendak family in full traditional attire, 1916

The *malak* is a glamorous costume decorated with couching *(tahriry)* stitch which started in Bethlehem and nearby Beit Jala and spread to Beit Sahour and villages around Jerusalem. It is unlike the embroidery of any other part of Palestine with floral and geometric patterns outlined in gold or silver cording on panels of green, orange or red Syrian silk. The space between the cording is filled in with satin stitch in many colours of silk thread, and the couching panels are then sewn onto the locally-produced *malak* fabric of the dress.

The costumes were costly, as befitted a prosperous town. The wealth of Bethlehem was due to several factors. The population was relatively well educated, as many had attended the numerous church schools there. Historically, the town had benefited significantly from tourism and pilgrimages and this meant that the handicrafts market was vibrant as well. Bethlehem was also the commercial centre for all the surrounding villages. And being entrepreneurial, many Bethlehem families emigrated, especially to the United States and Latin America, and sent back a significant part of their income to invest in their town.

Threads of Identity

Above Cuff of sleeve from *malak* costume; the round pattern is called "the watch" with crosses on each end and a bird at top (circa 1920)

Right Main street in Bethlehem 1940s

This prosperity created a wealthy elite, and the refinement and extravagance of the *malak* dress reflected the high standard of living. Religious harmony was demonstrated by the fact that both Christians and Muslims wore the same style, with the Christian women adding a small cross on the chest panel of the costume.

Bethlehem women set the fashion trends and village women throughout the surrounding area chose the *malak* costume as their wedding dress. Variations on this costume were worn by brides in Beit Jala, Beit Sahour, En Karem, Malha, Artas, Silwan, Deir Yasin, Ezariya and Lifta. Townswomen kept their costumes more classical by limiting the amount of embroidery on the sides and sleeves, whereas villagers' versions of the *malak* dress were heavily embroidered.

Above Qaser Jacir, built as a residence by Suleiman Jacir and his brother in 1914

After 1920, making the *malak* costume became a business, and many Bethlehem women became famous as seamstresses and embroiderers, sending their dresses to other parts of Palestine. In fact, it became a status symbol for women from other towns to order their trousseaux from Bethlehem. It is interesting to notice how parts of Bethlehem sleeves or chest panels appear on Ramallah or Jaffa dresses.

Many women in Bethlehem became professional costume makers, such as Manneh Hazboun, Wardeh Giacaman, Helweh Jrady, Jamila Hazboun Mahyub, Afifa Hazboun, Manneh Saba, and others were responsible for 'exporting' whole or parts of the 'queen of dresses'. They were also the first generation of professional working women who enjoyed the prestige that their knowledge and skills brought them.

BETHLEHEM

Above Bethlehem *taksiri* (festive jacket) in gold thread couching on cotton velvet (circa 1935)

143

Threads of Identity

Bethlehem

Just as it was customary to be married in this dress, so also a woman saved one of her *malak* costumes to be buried in. As a result, many of the best ones have been lost forever. Since the *malak* was so lavish, a different type of dress was made for everyday wear. This was called the *khaddameh*, meaning service, and was made of handwoven linen and embroidered with cross stitch on the chest panel and sides with patterns particular to the area, using threads in pale hues of pink, green and white. Women in En Karem and Malha villages wore this dress as well.

The Naser factory was established in 1832 and produced the red and black striped *malak* fabric, a blend of silk and linen, for Bethlehem women, and other fabrics for those in the surrounding area. Previously, the *malak* fabric had been imported from Egypt and Syria. Subsequent generations of the Naser family continued running the factory and expanded their business. In the 1930s, in addition to weaving, Khalil Naser began selling embroidered costumes as well as individual pieces of embroidery to be used for costumes.

Left above Qattan-Dabdub family wedding: a mixture of dress – European and traditional styles (circa 1930)

Left below Atallah wedding at Beit Jala (circa 1945)

Right Trademarks of the Naser family weaving factory for woollen belts

THREADS OF IDENTITY

Bethlehem had been a weaving centre for centuries. The Naser factory, for example, was established in 1832, producing the red and black striped malak *fabric*

Above Alice Mushabak in uniform of the Russian School, Beit Jala, 1916

Right Detail of *malek abu wardeh* fabric, so called because of the rose stripes. Woven in Bethlehem

In the early 20th century, Najib Naser was the proprietor of the factory. In 1928, when his son was to marry, velvet was new on the market. Najib sent a piece of the *malak* cloth to Krefeld, Germany, to have the same striped design produced in velvet. This was the first velvet costume in Bethlehem and soon other brides wanted this style too, and he continued importing velvet for bridal gowns until 1948.

At its height, the Naser factory employed 400 workers and produced textiles for villages all over Palestine. It also made white silk scarves to be worn over caps, the plain shawls worn in Bethlehem, and those with embroidered floral patterns that were worn in villages. Naser imported thread from Syria and Egypt, and later from Germany and France. After the Arab-Israeli war of 1948, his work slowly dwindled, and he later produced fabric for school uniforms.

The population was relatively well educated, as many had attended the numerous church schools there. Historically, the town had benefited significantly from tourism and pilgrimages and this meant that the handicrafts market was vibrant as well

Left Back panel of jacket made in Bethlehem for villages around Jerusalem, e.g. Malha, En Karem, Lifta (circa 1925)

Above Murcos Nassar's family in Bethlehem; he was an architect specialising in monasteries; his wife, Hilweh, is seen in her *malak* dress, 1940

THREADS OF IDENTITY

Habiba
one of the the last to wear the malak *dress*

Above Habiba

I always loved going to the Church of the Nativity when I visited Bethlehem as I have so many fond childhood memories of it. I especially loved watching the congregation during the services in this Greek Orthodox Church, which was a mixture of local Palestinians from other villages and towns, and tourists. In the 1950s and 60s, many of the local women attended the service wearing their traditional Bethlehem costume with all its splendour and *shatweh* (high headdresses).

On one of these visits, in 1982, I was surprised to see only three women wearing complete *malak* costumes. I spoke to them after the service and they told me that they were indeed the only three left in the whole of Bethlehem who still dressed that way. On a subsequent visit to the Church of the Nativity in 1986, I did not see these three ladies and was informed by the priest that two had died and the third, Habiba, no longer came to church. After the service, I went off on a mission looking for Habiba, or Im Bishara as she was called. It was not difficult to locate her house which was in one of the oldest areas of Bethlehem, adjacent to the church.

She was happy to welcome me into her home and told me that her knees no longer allowed her to attend church and that she greatly missed it. She was aware that for the past two years she had been the only one still wearing the complete Bethlehem costume. When she was in the street, she said, tourists often asked to photograph her.

Since I had not known Habiba before, I asked if she would tell me her life story and she was more than happy to relate to me all the vivid details both sad and joyous, sometimes in sadness and tears, at other times in laughter.

Habiba was just 15 in 1914 when her family rushed her into preparations for her wedding. Salim, a distant cousin, was to be the bridegroom. If they delayed the marriage, he would be conscripted into the Ottoman army, because at the beginning of the First World War young men were not called up if they were married. During that time, 10 other marriages were being rushed through to avoid conscription.

BETHLEHEM

Above Habiba's *malak* costume (circa 1920)

Although the wedding was prepared in a rush, this did not mean that I would not have a full trousseau as traditions required

Manneh, her older sister, did embroidery work for sale, so she gave Habiba the finished pieces she had at hand. They bought fabric to which they attached these pieces, thereby quickly producing three *malak* costumes, one red and black striped and two green and black. Habiba told me how the women of both families worked together:

'Although the wedding was prepared in a rush, this did not mean that I would not have a full trousseau as tradition required. Salim's aunts and mine were all busy sewing the costumes, making bedding and quilts, and crocheting fringes on sheets and pillowcases. There was a deadline if we were to save Salim from the army. I went with my mother and sister as well as Salim's mother and sisters to buy the other items I needed. From the Naser shop, we bought a pink belt and white silk headscarf.'

Getting the *shatweh* (headdress) made was a rather complicated procedure. It had to pass through a number of expert hands. Habiba's sister, Manneh, did the needed embroidery pieces. She then took it to Rahmeh Mussalam to be shaped, quilted and hardened. Next, a woman of the Dahbora family sewed on the coins and coral beads.

Left *Qabeh* (chest panel) from Habiba's *malak* costume; notice the little cross below the slit (circa 1920)

Above Two brides covered in white silk riding to their weddings, Bethlehem-area village

Habiba's husband owned and ran an olive oil press. When she was 25, he died and his family took over running it

Above Old olive oil press, 1915

Her sister, Manneh, embroidered two velvet jackets for Habiba. Reminiscing about everything that Manneh had done to help prepare Habiba's trousseau was particularly emotional for Habiba, because Manneh, who had emigrated to Chile, had recently passed away.

In the first few years of her marriage, Habiba had two boys and two girls. Her husband owned and ran an olive oil press. When she was 25, he died, so his family took over running the press, and she and her sister opened a sewing centre at home, making traditional menswear from Syrian silk. At this point in her narrative, Habiba began to laugh. She recalled how much she and her sister had enjoyed sewing for men because they were always pleased with the result, whereas women customers were always so much more demanding.

Habiba's children grew up and acquired a good education in Bethlehem schools run by priests and nuns. During the 1930s and 40s, life was good. Many tourists came to Bethlehem and souvenir shops flourished, however, after the war in 1948, the business boom vanished. Habiba was forced to send her sons to Chile with their uncles to find work. A few years later, she and her sister followed and for three years

Above Habiba
in her everyday dress

she lived with her sons and their families. Then she returned to Bethlehem to take care of the family property, while her sister stayed behind.

At this point in her story, Habiba brought out her silver jewellery which had been a wedding gift from her beloved husband, Salim. Her sons had added gold coins to the *znag* (chin-chain) and given her gold bracelets. While showing these pieces, she repeated an Arab poem which goes like this:

For whom shall I wear all this (finery) since my beloved has left me?
For the stone walls of my home or for the wooden furniture?

Three years later, I went to visit Habiba again. She had hung her *malak* costume with the embroidered jacket outside the cupboard on display. 'You see, I took them to church and had them blessed,' she told me. 'Now they are ready for my "departure". I shall look beautiful when the women dress me and sit around to bid me farewell,' a reference to the custom of gathering around the deceased's coffin at home for some time before the burial.

That was the last time I saw Habiba.

Manneh Hazboun
the first to blend Bethlehem and Beit Dajan styles

Above Manneh Hazboun, 1930s

Right Sleeve of a Beit Dajan dress showing Bethlehem couching applied by Manneh Hazboun (circa 1938)

I first heard about Manneh Hazboun from several Beit Dajan women who were refugees in Amman. To them, Manneh was the expert on embroidery, and they talked about the couching embroidery which she taught them in her family's orange groves in the 1930s and 40s. I followed this trail on one of my visits to Bethlehem in 1975. All I had to do was go to the Hazboun family block in the old town and inquire about her. And there she was in her full Bethlehem attire, smiling warmly, ready to reminisce about her Beit Dajan days.

Manneh was a born artist with an entrepreneurial twist. She spent many of her younger years in the village of Beit Dajan near Jaffa in the north of Palestine where she introduced Bethlehem-style embroidery, making a connection between town and village that resulted in a new style of costume altogether. Manneh was full of stories of her days in Beit Dajan. She spoke of the weddings, the competition for having the most beautiful costume, the work of the weavers and dyers, the orange-picking season, and parties held under the orange blossoms when her brother would bring the Haj Jum'a music group from Jaffa to entertain them. From time to time, when she remembered her brother's family who had all been killed in the 1948 war, she would cry silently, tears streaming down her face.

The Hazbouns of Bethlehem owned a large orange grove next to Beit Dajan. Prior to World War I, Manneh went with her mother to stay there with her brother's family. She already had three years of experience embroidering in the Bethlehem workshop of Nasra Hazboun. In Beit Dajan, she socialised with the girls whose fathers and husbands worked in the orange groves.

When Aziza, her friend in Beit Dajan, was getting married, she brought her embroidery to show Manneh. The pieces, nearly finished, were all in cross stitch. Manneh had a bright idea: she suggested adding the Bethlehem couching to Aziza's embroidered pieces. Together, the two women bought silver thread from Jaffa, and Manneh added the Bethlehem

BETHLEHEM

THREADS OF IDENTITY

The Israeli army forced Manneh and her 90-year-old mother out of their house. They left for Jaffa, where they had a house adjacent to their orange-exporting office

Above Helweh Jaradeh, another embroiderer from Bethlehem, competed with Manneh

couching to Aziza's wedding costume. This set a brand new trend that spread not only through Beit Dajan, but also to villages in the Jaffa area, like Safiriyya, Sarafand, Yazur, Salama, Deir Tarif and Saqiya.

Girls came to Manneh to learn couching. In the 1930s, the demand for this new style was so great that she started her own business. She would take the Beit Dajan embroidery pieces to Bethlehem to be embellished by Jamila Hazboun Mahyub or at the workshops run by the Hazbouns. At first, the work added in Bethlehem consisted only of rose branches on the skirt, but then some wanted it on the chest panel too. Later on, Manneh's mother and brother helped her start a workshop where she taught Beit Dajan girls Bethlehem-style embroidery, including new connecting stitches, couching and appliqué.

The Beit Dajan orange grove owners sold their produce to Europe via traders in Jaffa. They were becoming prosperous and it showed in the women's costumes. Instead of using only linen for wedding dresses, some now had velvet costumes, as well as the Bethlehem *malak* dress with silver couching.

There were other connections between Bethlehem and Beit Dajan. For example, a Bethlehem embroiderer, Helweh Jaradeh, became a competitor to Manneh. She went from village to village, selling her work. Every Wednesday, market day, she came to Beit Dajan to deliver embroidery pieces and take new orders.

While the Hazboun family had a thriving 125-acre orange grove, Manneh's embroidery workshop was also growing. This, however, was to change drastically when, in the spring of 1948, the homes and orange groves of Beit Dajan were attacked by Israeli forces. Manneh's brother and his family were killed and the rest of the family left for Bethlehem, but Manneh and her mother remained in Beit Dajan.

Bethlehem

Above *Kaffat*, a chain used on the headdress of Ta'amreh tribal women in Bethlehem

However, the Israeli army forced Manneh and her 90-year-old mother out of their house and they left for Jaffa, where they had a house adjacent to their orange-exporting office in Fuad Street. There they lived for four years until being evicted again by the Israeli authorities. They were told that they could stay on the condition they agreed to share their house with three Jewish families who had emigrated from Eastern Europe, which was unacceptable for them so they decided to return to their family home in Bethlehem. They each were allowed to take only one suitcase and a quilt. Five months after they returned to Bethlehem, Manneh's mother died and Manneh lived with her brother's family for the rest of her life, and although she stopped working, she remained a source of reference on embroidery until the end.

Two years after my first visit I went again to see Manneh, this time taking with me photos of some of the Beit Dajan women whom she knew. I arrived too late; her brother told me she had died two months earlier and he gave me her wooden spool with the silk threads wound around it.

THREADS OF IDENTITY

Jamila Hazboun Mahyub
creative embroiderer

Above Jamila Hazboun Mahyub

Right Detail of a priest's robe that inspired Jamila Hazboun Mahyub and others in their embroidery

Hanna Naser, the owner of a weaving factory in Bethlehem, also sold Bethlehem embroidery pieces which could be sewn on dresses. During one of my visits in 1972, I asked him to direct me to the women who supplied him with these pieces. He took me to the home of Jamila Hazboun Mahyub where we all enjoyed a cup of coffee and lively chat about the 'old days'. This was followed by many other visits to her house.

Jamila Hazboun Mahyub was a shrewd, determined and energetic woman. She was small in stature, with bright eyes and a sharp sense of humour. She never married, and for over 40 years (1915-58) embroidery had been her full-time vocation. She studied in a convent school and on her way to school she would pass an embroidery centre run by Afifa Hazboun and stop and talk to the girls working there. As her studies became more and more difficult, she made up her mind to leave school and pursue embroidery. This led to a big fight with her parents, but in the end they relented and she was soon earning a living, and not just for herself.

After her father died, Jamila's income from embroidery work sustained the family. She opened her own centre specialising in preparing bridal trousseaux, and eventually employing 40 girls. Brides from many villages such as En Karem, Malha, Beit Jala, Artas, Ezariya, Imwas, and Lifta were attracted to the centre. In the 1920s, many women from the Ramallah area who had discovered the beauty of the couching embroidery visited her and bought Bethlehem sleeves to attach to their costumes. Jamila found this amusing. [See Nour's story from Aboud/Ramallah, Chapter 3]

Jamila was also innovative. She laughingly described how she had been sitting behind a Franciscan priest in church one Sunday and studied the large embroidered pattern on the back of his robe. She then went home and embroidered the same pattern on her jacket, experimenting with different colours. Within a few months, this had become the most fashionable pattern on Bethlehem jackets.

Above Jamila Hazboun Mahyub far right, in her parents' house, 1930s

Below Chest panel showing the first stage of work when *sabaleh* (herringbone stitch) is placed as a border for couching

After ensuring her brothers had finished their education and paying for their weddings, she had a house built for all the family. 'I made wedding dresses for everyone but myself. I don't even wear a *shatweh*,' she remarked, laughing, referring to the headdress reserved for married women. 'Do you see what I have on my head? A small embroidered cap without coins on it, just a simple cap for a single woman.' There were those who were interested in marrying her, but these suitors were either from Beit Sahour or Beit Jala, and she would not accept anyone who was not from Bethlehem.

During my visit, she opened her cupboard and brought out embroidery samples to show how the chest piece was done. She recalled with a chuckle how she had sometimes introduced new patterns and given them names like raisins, sugar cubes, nuts, apple blossoms and so forth. She obviously relished the fact that her patterns and the names she invented for them had become so popular.

BETHLEHEM

Above Silk thread and wooden spools donated by Jamila Hazboun Mahyub to the Kawar Collection, shown next to rolls of *heremzy* fabric woven by Amin Haffar in Damascus

In the 1930s and 40s, Jamila was very successful and made a good income, but after the war in 1948, economic depression set in. Work was never the same. The brides who had come to her from the villages disappeared into refugee camps. With business steadily decreasing, she finally closed her workshop in 1956. On the one hand she felt that she had done enough in her life; on the other, she felt sad that the tradition of handmade costumes was being discontinued. She had hoped that some of the clever girls she had trained would carry on, but there was little demand for the couching embroidery. On one of my last visits, as I was getting ready to leave, I was very touched when Jamila gave me her last remaining embroidery samples showing the steps for making a pattern, her wooden spool with silk thread, and her photo. *'These are for your museum,'* she said.

Helaneh Silhy
and her treasured Singer sewing machine

Above Helaneh Silhy in 1987

Opposite our home in Bethlehem was a beautiful villa which belonged to Helweh Bendak. She had two daughters, one of whom was Helaneh, and two sons living in El Salvador who had sent her the money to build the villa, in which they planned to live on their return. These neighbours were part of our lives as I was growing up.

Helweh had to embroider for a living because she was raising her children alone after her husband had been conscripted by the Turkish army and never returned. Helweh had one of the most beautiful costumes in Bethlehem, complete with jacket and headdress. Her grandmother had taught her the couching stitch before World War I and Helweh recalled that the Christian Orthodox pilgrims coming to Bethlehem from Syria, Turkey, Bulgaria and Russia had the same stitch on their clothes. She would proudly tell me about who made her clothing. Rosa Bendak made her beautiful jackets. Maria Salem helped her embroider her costumes, as did Maria Jeryes and Helweh Ghneim.

Helaneh Silhy sometimes helped her mother with embroidery, but her real claim to fame was having introduced the sewing machine into villages of the area. In 1928, the Singer Sewing Machine Company opened a branch in Bethlehem, and Helaneh registered for the first embroidery course to be offered on the machines. She did so well that the company asked her to stay on and teach machine embroidery as part of a sales promotion. Then the company sent her to nearby villages to do demonstrations. Helaneh was faithful to the traditional patterns and used them in machine embroidery, but some women objected to her work because it would make their handiwork redundant. Some embroiderers saw this as a threat to their own business.

In the villages the sewing machine was catching on and villagers started expanding their output from dresses to tablecloths, bed sheets, children's clothes, etc. Helaneh taught them how to copy the design on paper and then embroider over it.

BETHLEHEM

Helaneh told me that her mother had never liked machine embroidery. She felt that machines were for sewing only, whereas embroidery should be done by hand

Above The famous Singer sewing machine on which machine embroidery was introduced in Palestine (circa 1925)

Below Sewing machine cover with embroidery inspired by part of the royal British insignia

165

Helaneh told me that her grandmother had taught her the couching stitch before World War I

One village, Dura, in the Hebron area, asked the Singer Company to start sewing and embroidery classes for women there. A centre was established, and Helaneh went with the company directors for the opening. Such importance was attached to the centre that all the notables of Dura, women and men, including the *mukhtar*,[13] met them at the entrance to the village before accompanying them to the centre for the opening ceremony.

Other sewing centres opened around Bethlehem and Jerusalem. Every year they competed in a machine embroidery competition. Helaneh was on the committee of judges. She stayed with the company until the 1948 war, which caused the destruction of some of the centres and the evacuation of the villages where they were located.

Helaneh told me that her mother had never liked machine embroidery. She felt that machines were for sewing only, whereas embroidery should be done by hand. Years later, I met Helaneh in Bethlehem. Her mother had died, and they had dressed her in her best Bethlehem costume and silver jewellery, just as she had wanted. All her friends had admired her, saying she looked like a queen.

These women's lives give an impression of what was happening to costume-making and embroidery in Bethlehem in the first half of the 20th century. I had the chance to meet many other women whose work is also worth mentioning. Hanneh Banayot specialised in embroidery for head shawls, as did Jamila and Dahabeya Freij. Mariam Dahbora and Maria Bendak worked on the tall Bethlehem *shatweh* (headdresses). Nasra and Hanneh Hazboun were embroidery teachers, as were Wardeh Giacaman and Helaneh Silhy. I feel an obligation to mention all these names because when these women left our world they took with them great knowledge and expertise, and it is important to honour them.

Right Helweh Bendak, Helaneh's mother, with author in Bethlehem (circa 1958)

[13] *Mukhtar* means 'chosen one' in Arabic, and here refers to the village leader, chosen on the basis of seniority.

BETHLEHEM

Collection *Bethlehem Area*

BETHLEHEM

Left *Bughmeh* (old-style wedding choker) worn in rural areas around Bethlehem with Ottoman coins and glass Venetian beads (circa 1880)

Above Front and back of Bethlehem felt jacket embroidered in silk and couching, probably for women of Jerusalem villages, as Bethlehem women preferred velvet jackets (circa 1920)

169

THREADS OF IDENTITY

Above Costume of *malak* fabric reproduced in velvet by Naser for his son's bride (circa 1930)

Above *Khaddameh,* everyday dress worn in Bethlehem and surrounding areas (circa 1925)

THREADS OF IDENTITY

Above Festive *khedary* dress
with patchwork, worn in villages
around Bethlehem and Hebron
(circa 1900)

Right Bethlehem linen shawl
with stem stitch and cross stitch
(circa 1880)

172

Bethlehem

Left *Znag* silver chin-chain to hold headdress in place, made in Bethlehem by Sammur family

Above Front and back of *shatweh* (headdress) worn by married women in Bethlehem, with silver or gold coins given by the bridegroom as dowry (circa 1925)

Below left *Qurs*, a cap worn by Jerusalem village women and unmarried Bethlehem women, embroidered in couching and trimmed with Ottoman coins (circa 1930)

Below right Silver crucifix from Bethlehem

Chapter 7
Jerusalem

Early in the 20th century, the attire of Jerusalem reflected multiple co-existing worlds. Late-Ottoman styles were still prevalent, although increasingly influenced by Western fashion, which gained more presence through the British Mandate after World War I and the arrival of European pilgrims, tourists and Jewish refugees.

Left David Street near *Bab al-Khalil* (Jaffa Gate), 1910s

Above *Sarma* wedding dress, gold-thread embroidery on cotton velvet, ordered in Damascus, Ottoman style worn by urban Arab women in the early 20th century

THREADS OF IDENTITY

Above Jerusalem from *Bab al-Amud* (Damascus Gate), 1930s

JERUSALEM

There was a gradual move towards European dress, especially among upper-class Jerusalem families

Above Stelios Awad and Julia Harami at their engagement; note the couching embroidery on her dress, 1926

This was a period of relative economic prosperity and lively social and cultural activities, as well as greater educational opportunities for women. It was a period that witnessed the birth of the Palestinian anti-colonial movement, the formation of nationalist political parties and women's associations. Fashions changed along with the improved economy. There was a gradual move towards European dress, especially among upper-class Jerusalem families. On the other hand, daily life in the villages surrounding Jerusalem remained relatively unchanged, even though the villagers' livelihoods were intertwined with the city.

THREADS OF IDENTITY

JERUSALEM

Left *Qabeh* (chest panel) typical for Jerusalem area villages like Lifta and Deir Yasin (circa 1905)

Above left Weekly market in Jerusalem where villagers came to sell their goods, 1930s

Above right *Bab al-Amud* (Damascus Gate), Jerusalem, where women came daily to sell their products, 1965

The intermingling of urban and rural societies was readily apparent on a daily basis. At dawn, Jerusalem would be bustling with activity as villagers descended on the city, in traditional dress, going about their business in the various Old City markets. At the entrances to the city, such as *Bab al-Khalil* (Jaffa Gate), the contrast was most obvious. There would be groups of men, women and children from neighbouring villages hauling their agricultural produce for sale or buying necessities from the city market. Peasant women dressed in brightly coloured, intricately embroidered dresses and thin, white head coverings found a spot in the narrow lanes of the market and began to sell their farm produce while urban women strolled by in European-style dresses and hats, or covered with the traditional silk or cotton cloaks.

THREADS OF IDENTITY

Above People gathering in Jerusalem for the procession down the Jericho Road to the Nabi Musa Shrine, 1900-1920

The urban and rural populations also gathered for annual pilgrimages to the shrines of Nabi Musa (the Prophet Moses) and St Elias in Jerusalem and Haifa. These were indigenous celebrations, particular to Palestinian society, in contrast to the rituals of Palm Sunday, Holy Week and Easter, which attracted many European pilgrims. People marched towards the shrines of these holy men and, once there, prayed, danced, cooked and enjoyed sports, such as horse racing. With everyone wearing their finest clothes, one can imagine the mingling of colours and styles.

JERUSALEM

The urban and rural populations also gathered for annual pilgrimages to the shrines of Nabi Musa (the Prophet Moses) and St Elias in Jerusalem and Haifa

Above Church of the Holy Sepulcher at Easter, 1930s

Below Easter procession carrying the cross from *Bab al-Asbat* (St Stephen's Gate) along the Via Dolorosa, 1930s

THREADS OF IDENTITY

184

The cotton-weaving and marketing centre in Jerusalem was Suq al-Qatateen

Left Pink *sarma* dress made in Turkey for a Jerusalemite bride (circa 1920)

Above Suq al-Qatateen, cotton weaving centre, 1900-1915

The cloth used to make the Jerusalemites' garments was mostly locally handwoven cotton and silk, as well as cloth imported from Syria and Egypt. Bethlehem, Ramallah and Majdal were all well known weaving centres and Jerusalem itself had 65 weaving workshops at the time of the British Mandate. The workshops were located in certain areas such as Suq al-Qatateen and Suq Sabra where the weavers and dyers had formed unions to protect their rights. However from the beginning of the British Mandate, there was an increase in imported textiles as well as the introduction of mechanised looms by the Jewish immigrants, and the local weaving industry declined as a result. In the wake of World War II, the Red Cross made efforts to support the 65 weaving workshops of Suq al-Qatateen, as did the Friends of Jerusalem society, but eventually the falling demand for locally woven textiles took its toll. Many of the weavers ceased production and instead opened shops selling imported cloth. Others were able to keep going mainly because villagers still demanded handwoven cotton and linen which, being loosely woven, were more suitable for embroidery, since women could more easily count their stitches. By the end of the British Mandate in 1948, handweaving was done only by some individuals in Suq al-Qatateen, such as Abu Feras.

Threads of Identity

Urban Jerusalem
Marketplaces, Diversity and Elegance

Costumes worn in Jerusalem in the early part of the 20th century can be divided into traditional attire and a more modern blend of Ottoman and European styles. The exact blend would depend on the specific family and the degree to which they were embracing change.

A typical traditional attire for women was a basic dress with a gathered waist and long, narrow, cuffed sleeves. Dresses for special occasions were sometimes trimmed with handmade lace. On her head, the traditionally dressed woman tied a *mandeel* (light scarf), bordered with beautiful needlework called *oya*, which appeared in the 19th century in Turkey, Greece and cities of Palestine. *Oya* is made with only needle and thread, and fastened to the edge of the fabric. There was ongoing competition between Jerusalem and Nazareth as to who could make the best *oya*. In Nazareth, many colours were used to make a heavy design, whereas the Jerusalem *oya* was less colourful and made in geometric and floral designs.

When going out, the traditionally dressed woman wrapped herself in a *mlaya*, usually made of coloured cotton or light silk, which fell like a drape from the head to the ankles, with a silk belt around the waist; the hands appeared from the front opening. An alternative to this was the black silk *habra*, which came in two pieces; one part made of very light silk covered the woman's face and fell to her waist; the other was a gathered skirt.

Left (1) Mansour Family, 1920
(2) Shukri and Katrina Deeb, 1911
(3) Faidi al-Alami, his wife, Zleikha Ansari, and son, Musa al-Alami
(4) Jerusalem man, 1915, in urban attire combining modern and traditional styles

Above Diamond brooch, Ottoman style, made in Damascus and worn in cities all over the Arab world

THREADS OF IDENTITY

Above Silver belt made in Aleppo for urban women

Below Silver filigree fish showing the crucifix, made by Jerusalem jewellers

Right Modelled *sarma* bridal dress made in Aleppo, worn in Jerusalem; silver belt made in Syria; head shawl embroidered with hammered silver made in Ba'albek, Lebanon, 1930

An especially attractive item in city wear was the silk *abaya* (cloak) that covered the shoulders and fell to the ankles. These cloaks were handwoven in Aleppo (Syria), Lebanon or Mosul (Iraq), and came in light colours. Geometric patterns were woven on the upper back and front, using the brocade technique and silver or gold thread.

The Jerusalem women who wore more modern dress, like their counterparts in other cities of Palestine, favoured simply-cut dresses for everyday wear, similar to those worn by women in other Mediterranean countries at the turn of the century. For their trousseaux, ladies from Jerusalem would often go to Damascus to order the famed embroidered brocades or the Ottoman-style *sarma* costume, usually made of velvet or shiny silk. *Sarma* is an embroidery technique that was common in Syria and Turkey, whereby fine, metallic gold or silver thread is worked over a cardboard foundation to form floral and arabesque patterns that are sewn onto the fabric. Many wedding dresses worn in Jerusalem in the late 1800s and early 1900s were of this type.

Mariam Husseini from Jerusalem's Old City showed me her mother's wine-red velvet *sarma* wedding dress that had been made in Damascus in 1920. Women's costumes exhibited at the Islamic Museum in the al-Haram al-Sharif (Noble Sanctuary, site of al-Aqsa Mosque and the Dome of the Rock) in Jerusalem display a variety of fine embroidery made in Damascus. These pieces are from the Khalidi family, who inherited them from their grandmother.

JERUSALEM

Threads of Identity

190

JERUSALEM

Women's costumes exhibited at the Islamic Museum in al-Haram al-Sharif (Noble Sanctuary, site of al-Aqsa Mosque and the Dome of the Rock) in Jerusalem display a variety of fine embroidery made in Damascus

Left An embroidered silk *abaya* and head shawl, decorated with hammered silver (circa 1925)

Above Jerusalem, Dome of the Rock, 1980s

A simpler style than the *sarma* was the *yalak*. This dress, usually of velvet, had a slim cut, with slits on both sides. The sleeves were narrow but widened with a slit at the cuffs. The front opening in the narrow yoke was fastened with a row of small buttons and loops. Under this coat-like costume a long underskirt or slip was worn.

As European fashion found its way to the cities of Palestine after World War I, entrepreneurial and talented dressmakers, such as Rabeeha Salem, Kukon Tlel and Badia Hallaq, opened workshops in Jerusalem to meet a growing demand. Other dressmakers, among them Arabs, Armenians and Jews, would go to the home of a family and sew for them by the day, often returning year after year. This was the time when Michel Manneh opened his fabric shop for the elite in Mamilla Road, as did Awwa and Barakat. Jerusalem women came to these shops to buy a 'coupon', the name given to a three-metre piece of high quality fabric, unique in design, to be made into a dress.

THREADS OF IDENTITY

The Jerusalem women who wore more modern dress, like their counterparts in other cities of Palestine, favoured simply-cut dresses for everyday wear, similar to those worn by women in other Mediterranean countries at the turn of the century

Left Back of a silk *abaya* worn by urban women in most Arab cities, early 20th century

Above Women's meeting in Jerusalem, 1924.
Back row from left: Unknown, Unknown, Samia Awad, Na'ima Salameh, Lydia Shahla, Kukon Tlel, Na'ima Atallah, Unknown, Aziza Mansour, Mary Aboud, Nabiha Halabi, Julia Harami Awad, Unknown, Unknown.
Middle row: Sarah Deeb, Olga Demyani, Jamileh Ghori, Unknown, Mrs Bertram, Katy Siksik, Badi'a Harami, Unknown, Unknown.
Front row: Katrina Farraj, Najla Khawli, Evelyn Ghori, Salma Harami, Mariam Kurd, Sultaneh Halabi, Milly Halabi Atallah

Tayseer al-Asmar
life in the Old City

Tayseer al-Asmar's family lived in Haret al-Qirami, a quarter of Jerusalem's Old City. When she reached puberty, her mother started taking her to the dressmaker, Fatma Awwa, to make dresses to be worn on *yom al-istikbal* (reception day) in their house. This was a day set aside for a woman to receive her female friends in the afternoon, a very common custom in Jerusalem and other Arab cities, which continued into the 1950s. Tayseer recalled these occasions:

'My mother held yom al-istikbal *on the last two days of every month. We prepared coffee, anis, mint and sage tea, date cakes and rice pudding. We invited relatives, neighbours and friends who all arrived wearing their best clothes and everyone would spend a pleasant day playing dice or cards, listening to the* oud *(lute), making necklaces from flower blossoms and smoking hubble-bubbles. When I was a young woman, the famous dressmakers were Fawzia Habbiromman and Jamila Khalaf, who tried their best not to repeat the same style twice, for they knew that their customers would meet at the istikbal and notice each others' dresses.'*

As the years passed, the more Westernised and affluent Jerusalem families started to move outside the Old City walls to new neighbourhoods. Tayseer's family could not afford to live there, and when the families of her friends at school moved out it became clear to her how traditional her own family was:

'My father wore a qumbaz *(overcoat) of white silk called* rosa, *a red* tarboosh *(fez) on his head and a long chain across his chest for his pocket watch. He did the shopping himself because he thought it inappropriate for my mother to do so. He would tie the shopping basket to a rope which was attached to our window and my mother would pull the basket up. Each time she would find a rose or other flower at the top on the basket, which she put in her hair.'*

The silk *qumbaz*, worn over baggy trousers, a linen shirt and a vest, had long been typical of urban men's attire in Jerusalem.

Above Tayseer al-Asmar, 2009

JERUSALEM

Above Man's silk *ghabany qumbaz* (circa 1900)

The bride's mother packed all the bath items, as well as embroidered handkerchiefs to be given as gifts to all the women attending

Above Embroidered towels used in public baths, early 20th century

The Hammam: Women's sanctuary

There were about 13 public baths in Jerusalem at the beginning of the 20th century. Some belonged to the *waqf* (Islamic charitable foundation) or to churches which rented them out to specific families who ran them for generations. Not until the 1930s did their use decline, as more homes became equipped with modern plumbing.

Every woman using a public bath would prepare a *bukjeh* (square piece of silk), elaborately embroidered with silver and gold silk thread. In this she wrapped her bath items, including soap, a comb, embroidered towels, a mirror, a bath bowl, *kubkab* (wooden shoes), cosmetics like henna and special soil brought from Aleppo for washing the hair, and her *wazra* (wrap-around), to be worn after washing. The latter were handwoven in Hama, Syria, in an elaborate style of expensive silk for the wealthy, or cotton for those of more modest means.

The pre-nuptial bath was a ceremony in itself. Nuzha Hamdeh, a resident of the Bab al-Khalil quarter, gave this account based on her own wedding bath at Hammam al-Ein, which is still functioning today, run by Haj Ahmed al-Jawad:

'Two days before the wedding, the families of the bridal couple took the bride-to-be to Hammam al-Ein. The bride's mother packed all the bath items, as well as embroidered handkerchiefs to be given as gifts to all the women attending. They left their home quietly, carrying bottles of orange sherbet. It was customary for the girl's family to be sombre when she was leaving her natal home. In contrast, the groom's family left their home in a lively **zaffeh** *(a procession of clapping, dancing and playing music) carrying with them a platter of* **oozeh** *(rice and meat) decorated with jasmine branches.*

'The men left the women at the door of the bathhouse where they were met by the **mashta** *(female beautician). She first used* **halwa** *(a toffee-like mixture of sugar and lemon juice) to remove the women's*

Above Collection of *bukjehs* handmade in Damascus for Jerusalem women, early 20th century

unwanted body hair, and then she rubbed their bodies with sesame oil. Then she and the other women applied henna decorations on the bride's arms, hands and feet, in accordance with the groom's wishes. I had henna only on my feet, because we were the modern generation who did not want too much henna. And finally, they bathed in water scented with lemon, rosemary and sage. Then the women dressed and assembled in the bath's diwan (sitting room) *to have tea and sherbet, with some music and dancing. Before going home, the groom's mother sprayed everyone with rosewater.'*

The bath was also used for therapeutic purposes. Nuzha did not have a child in the first year of marriage, so her family took her to Hammam al-Ein once a week for a steam bath. After a year of this vapour treatment, she became pregnant. When she gave birth to a baby boy, the proud new father rewarded the *mashta* with a gold pound.

THREADS OF IDENTITY

Mufeida
Multiple exiles

Above Mufeida in Amman, Jordan, 2009

In Amman in 2004, I had the opportunity to interview an old family friend, Mufeida, who grew up in Jerusalem before the city was occupied and divided. Mufeida was a city girl who married into a village family – something that was not very common at the time. Her husband's village, al-Tira, was one of the hundreds destroyed by the Israeli army during and after the 1948 war. This story is less about costumes and traditions and more about one woman's resilience. She told me about her life and the effects of the two wars she witnessed:

'I was growing up too fast, my mother said, and I had to start wearing longer skirts. We were living in Bab al-Sahera (Herod's Gate) beside the Rockefeller Museum in Jerusalem, and my father owned and managed the Palestine Hotel at Bab al-Khalil (Jaffa Gate). My sister and I were attending the Jerusalem Girls' College where Muslim, Christian and Jewish girls sat side-by-side and visited each other's homes.

'Every day my sister and I took the No. 33 bus to the French Hospital; from there, we walked the rest of the way to school. Our best friends were Widad Salameh and Sameeha Abdo. One day, on the way home, Sameeha told me that a young man was following us. He got on the same bus and sat beside us. He spoke to me but I didn't answer. He got off at the same stop and saw where my home was, then went on his way. This pattern was repeated for a while, and I started noticing him and his smile. The next thing I knew he and his family came to our home to ask for my hand in marriage. During the summer holiday in 1942, we got engaged. This was an uncommon occurrence because Muhammad, my handsome fiancé, came from a village called al-Tira in northern Palestine, and Jerusalem families usually did not "give away" their girls to people from outside the city.

'Muhammad was a social worker in the Welfare Department. He was transferred to Bethlehem where he rented a house and began furnishing it. My mother and aunts got busy preparing my trousseau which was all Western-style, apart from the lace and crocheted linens. We bought fabric from Akkad and Maraka and took the fabric for my wedding dress to Nash'at Abdo, a famous dressmaker in Bab

One day, on the way home, Sameeha told me that a young man was following us. He got on the same bus and sat beside us. He spoke to me but I didn't answer

al-Zahera. I had it made like a dress I had seen in Arab movies. I also had seven formal dresses made, each one a different colour, and wore them all at the wedding party, changing from one into the other, as was the custom.

'For our honeymoon we went by car to Lebanon, then back to our home in Bethlehem for a week. Then, in accordance with tradition, Muhammad took me to his hometown, al-Tira, near Haifa, for wedding celebrations which was a cultural experience for me. His family met us at the entrance to the village, and everyone was singing. Muhammad rode to his family's home on a horse adorned with a beautiful saddle and bridle, and they took me to the Nijem family's home next door. Muhammad's family came in the evening, as was the tradition, and took me to their home in a procession. There was dancing for seven nights on the **bayader** (threshing floor), but I was not allowed to go, as the bride has to stay at home. When I insisted on going to watch the dancing, they brought me their traditional al-Tira costume and long trousers, and I became the centre of attraction at

Above Wedding photo of Mufeida and Muhammad al-As'ad, 1946

THREADS OF IDENTITY

Wearing an old traditional dress and a scarf, I crossed the river on foot with my three children. A Jewish patrol was passing nearby, and we all ran and hid in the Khatib farm

Above Detail of al-Tireh dress, Haifa area (circa 1940)

the bayader. I basically broke the rules of segregation, which I think was possible because I was seen as an outsider. At the end of the week, we went back to our new home in Bethlehem. A few years later my husband was transferred to Acre where we made many friends and I gave birth to a baby boy.

'In 1948, as the British were preparing to leave Palestine, Acre came under attack from the nearby Israeli military units. People were leaving for Lebanon, but since my second son was just born in May, we wanted to stay, but when the new baby was only seven days old, a large truck arrived at our door filled with 20 of my in-laws who were escaping from al-Tira and heading for Lebanon. Muhammad told me to take our children and join them. He stayed on because he was responsible for a large reform school for boys.

'At al-Naqoura, on the Palestinian-Lebanese border, Lebanese soldiers made us get off the truck and sent it back. We spent hours waiting around, until a man from the Masri family passed by in his car and offered to take my children, my mother-in-law and me to Tyre. We got to Tyre and then sent a truck to pick up the rest of the family. Once everyone was together, we rented two rooms – one for the men and another for the women and children.

'We then moved to the village of Jwayyeh in southern Lebanon, where we rented a whole house. It was without running water, but we managed well. Four months later, my husband came with our friends from Acre, George and Nijmeh Hakim, and our two families decided to move to Tripoli in northern Lebanon where the men could look for work. Muhammad and I found a house to rent, and there I had my third child.

'Muhammad worked for the International Committee of the Red Cross with the refugees. I took my children to a school and volunteered to teach there and they employed me two months later. The headmistress, Iqbal, who was Lebanese, was most understanding and allowed me to bring my baby to school.

'Some time later, with the help of the Red Cross, we were allowed to go back to Jerusalem and work for UNRWA. I was thrilled because I would be able to see my family with whom I had lost contact and I

Above Mufeida in 2009 showing the Tireh dress, Haifa area, given to her by her in-laws as a wedding present (circa 1940)

found them living in a small room in the Old City. While working for UNRWA, we were transferred to Ramallah and then Nablus, a town that we liked and felt settled in.

'In 1967 my children and I went to Lebanon for our summer vacation, but we had been there for only a week when the June War broke out. We rushed back, as did many others, but when we arrived in Amman I discovered that in the chaos, my documents showing I had residency in Nablus were gone. Later I heard that people were crossing the Jordan River on foot in order to return to their homes in the West Bank, so I put on an old traditional dress and a scarf, and managed to get across the river by foot with my three children. But once across, we noticed an Israeli army patrol was passing nearby, so we all ran and hid in the Khatib farm. The farmers were loading tomatoes on their truck, so my children and I, along with other families, hid amongst the tomatoes while they drove to the Balata Refugee Camp. From there it took us almost a whole day to find a car to agree to take us to Nablus. When we finally reached our home, Muhammad burst into tears.

'The next day the magnitude of the war dawned on me: we were now part of Israel. At first, we did not want to leave and my husband was able to stay at his job, but with so many new restrictions imposed by the occupation authorities, living conditions became impossible. One day, Israeli soldiers came and gathered all the young, educated men of the city and took them away; our son, Asaad, was one of them. He was imprisoned for 10 months without trial, and then deported to Jordan.

'We loved Nablus, but after this incident, we felt there was no future for our children there. We did not want our family to be divided, and there were no opportunities for higher education, so in 1969, we decided to move to Amman. Before moving, we went to the Old City of Jerusalem to see my mother. She was crying because she felt she could neither live without her children nor live outside Jerusalem, and this was tearing her apart. In the end, she chose to stay in Jerusalem.'

THREADS OF IDENTITY

Above Striped silk and cotton, *'Itafi* dress worn in Jerusalem villages (circa 1925)

JERUSALEM

Above Beit Hanina dress of striped Syrian fabric and *weqayeh* with coins similar to Ramallah headdress, 1920

Jerusalem Villages
Focus on Lifta, Malha and Deir Yasin

The villages around Jerusalem that contributed greatly to the local economy were Lifta, Malha, En Karem, Deir Yasin, Ezariya (Bethany), Beit Hanina, Shu'fat, Silwan and Abu Deis, among others. The first four of these villages, on the western side of Jerusalem, were wiped out after being occupied by the Israeli forces in 1948. The last five, to the north and east of Jerusalem, still exist as Palestinian communities, but suffer constant encroachment by Jewish settlements.

THREADS OF IDENTITY

On December 1947, the Zionist Stern Gang threw hand grenades and shot randomly at people in Lifta's coffee house. They repeated attacks on a weekly basis until February, when many Lifta residents left their village for Jerusalem

Left Chest panel *(qabeh)*, from a Lifta *ghabany* dress (circa 1930)

Above The village of Lifta as it stands deserted since the population was driven out in 1948

Lifta was one of the richest villages in the Jerusalem area. The villagers had substantial land holdings and also worked in the city. This exposure to modern city life gave Lifta women a taste for urban life, and they were the first in the area to incorporate silk fabric into their traditional costumes. Textile dealers in Jerusalem were happy to cater for their taste because they set the style for other villages. In the 1930s, Jamila Hazboun Mahyub of Bethlehem embroidered eight silk costumes and three velvet jackets for the wedding of a bride from the Hammoudeh family of Lifta.

In December 1947, the Zionist Stern Gang threw hand grenades and shot randomly at people in Lifta's coffee house. They repeated attacks on a weekly basis until February, when many Lifta residents left their village for Jerusalem.

Malha was built on a plateau south-west of Jerusalem. A highway linked it to the city, so many of the villagers worked there in commerce and services. Others farmed the village land. The women of Malha had some of the most beautiful and lavish costumes.

THREADS OF IDENTITY

The people of Malha fought the Zionist forces until being driven out of their homes during the ceasefire in mid-July 1948.

Deir Yasin was surrounded by terraces of fig, almond and olive trees. It was the site of an old mosque known as Sheikh Yasin and the ruins of a Byzantine monastery, al-Deir. Besides agriculture, some villagers worked in the stone quarries that supplied the building boom in Jerusalem during the Mandate period. It was a very prosperous village.

On 9 April 1948, the Zionist Irgun and Stern gangs massacred up to 120 men, women and children there.

Women from villages in the Jerusalem area, in contrast to their counterparts in other parts of Palestine, made their costumes out of imported Syrian silk which came in stripes of different colours, like *asawri* in yellow and black stripes, or *atlas* in red, yellow and black stripes. Lifta women made costumes of *ghabany*, white silk covered with yellow chain stitch embroidery, and trimmed the sides and sleeves with green and orange silk. Proximity to Jerusalem exposed village women to the variety of imported fabrics available there. For example, the use of the Damascus-produced *ghabany* for the bridegroom's *qumbaz* (overcoat) in the 19th century made women want the same fabric for the bride's dress.

Left Simplified *qabeh* (chest panel) as worn in Jerusalem-area villages like Malha, En Karem and others (circa 1910)

Above *Qurs*, headdress typical of Jerusalem-area villages (circa 1930)

THREADS OF IDENTITY

Left *Abu Qutbi* dress made of narrow panels of *heremzy* silk with couching, worn in Malha, Azariya and Silwan (circa 1920)

Middle Lifta *ghabany* costume made of fabric with chain stitch machine embroidery. Couching stitch embroidery on *qabeh*, sleeves and side panels (circa 1925)

Right En Karem *tahriry* wedding costume with couching applied to *heremzy* silk on sleeves, *qabeh* and side panels (circa 1920)

JERUSALEM

THREADS OF IDENTITY

Above Silver amulet holder, filigree work, Jerusalem villages

The colours and embroidery of Jerusalem area village costumes were greatly influenced by Bethlehem styles. Like the women of Bethlehem and Beit Jala, these village women applied the *tahriry* stitch (couching) to make intricate designs. Most women embroidered their own costumes at home. However, during the Mandate period, workshops flourished in both Bethlehem and Beit Jala. From such workshops, better-off village women would order a full trousseau, including the *malak* costume, a headdress and shawl, a handwoven belt, embroidered silk dresses, linen dresses for everyday wear, and a short-sleeved, heavily embroidered, velvet jacket to wear over their costume.

On their heads, women from this area wore round, embroidered skullcaps with cross stitch or couching embroidery, embellished with gold or silver coins, and covered by an embroidered linen shawl.

JERUSALEM

Above Front and back of a traditional velvet jacket with cord couching embroidery made in Bethlehem and Beit Jala workshops for villages around Jerusalem and Bethlehem (circa 1925)

JERUSALEM

On their heads, women wore round, embroidered skullcaps with cross stitch or couching embroidery, embellished with gold or silver coins, and covered by an embroidered linen shawl

Left *Khirqa* (head shawl), linen with cross stitch, worn in Jerusalem-area villages (circa 1930)

Above A man looking over Jerusalem, 1940s

There was not as much variety in men's clothing, but some of their styles changed too. In the early 1930s, as an expression of Arab nationalism, both village and city men adopted the *kaffiyeh* or *hatta*, a large square scarf held in place by a looped cord called *agal* which originated with the Bedouin but was later adopted by all. The urban fez, associated with Turkish influence, and the village *tarboosh* went out of style. The *kaffiyeh* was originally white, but later black-and-white checked or red-and-white checked ones became popular among young men. Older men favoured the black and off-white *kaffiyeh* made of light wool, especially in winter.

The headdress a man wore was the most visible statement of which group he belonged to. My friend, Alice Faris, said that when her father commuted between Jaffa and Jerusalem during the 1930s for his work in the pharmaceutical business he took three kinds with him. Since it was a time of conflict pitting Palestine's Arab population against the British authorities and Zionist immigrants, Alice's father would wear a hat when passing through Jewish areas, a fez when in the city, and a *kaffiyeh* in the villages.

Chapter 8

Jaffa

Left Port of Jaffa (circa 1910)

Above Floral shawl from Beit Dajan area, made in either Ramallah or Jaffa factories (circa 1940)

Jaffa was a vibrant cultural centre in the pre-1948 period. The roots of the city's modern cultural movement can be traced to the founding of printing presses, publishing houses and a number of newspapers and magazines in the last quarter of the 19th century. The first presses were set up to print wrappers for Jaffa oranges. Later, they developed into fully-fledged publishing enterprises. By 1947, there were 50 publishing houses in Jaffa, and a large number of bookshops had opened in the city.

215

Threads of Identity

Above One of the first printing presses in Jaffa (circa 1920)

Below Packing oranges in Jaffa (circa 1920)

The first presses were set up to print wrappers for Jaffa oranges. Later, they developed into fully-fledged publishing enterprises

Close contact with Egypt via the railway and the sea facilitated cultural exchange, with Jaffa poets and writers becoming well known all over the Arab world. The establishment of literary clubs enabled writers, poets and artists from other Arab countries to present frequent programmes in Jaffa. Among the 20 or more active cultural clubs, the most important were the Islamic Sports Club, founded in 1926; the Orthodox Club, founded in 1924; and the al-Arabi Club, established in 1943 by a group of American University of Beirut graduates to promote Arab nationalism, heritage and music. Among the founders of al-Arabi Club were Raouf Halaby, Ahmad and Akram Abdul Rahim, Dr Hasan Far'on, Dr Hanna Kayyali and Dr Hamdi al-Farouqi.

Above Jaffa City, main road (circa 1925)

Left Crude cut diamond jewellery from Damascus, worn by Arab urban women

Above Mrs Farajallah in a silver embroidered costume and hammered silver shawl, 1920s

In the early 1900s, trade unions were formed in the Jaffa area, headed by Michael Mitri, who was killed by the Zionists because he exposed the Histadrut, the Labour Zionist trade union, which sought to eliminate Arab labour. There were also four women's societies with programmes for Arab nationalism, and in 1930 a branch of the Arab Women's Union was founded in Jaffa.

Theatre productions started around 1900. Egyptian groups came to Jaffa to perform each spring, and local singers performed on stage as well.

As Palestine's main port, Jaffa was subject to diverse foreign influences. Many local citizens were honorary consuls for European countries. This influenced the dress style of women. They could pick and choose between what was best of the Ottoman style and what appealed to them from Europe.

THREADS OF IDENTITY

Many Jaffa women wore fashionable European-style dresses with an Oriental touch. A sewing course was a must for every young girl. Most of them sewed for themselves, while others became famous seamstresses, such as Koukab, Barq, Biki and Asfar. Styles also demanded a good class of jewellers, such as Abu Radwan, Abu Sara, Sakkejha, Copty, Hreish, Surady and others. Besides clothing, the typical bridal trousseau in Jaffa around 1900 included a chest, a bureau and a cupboard with mirrors on the doors, plus numerous special items needed for visits to the public bath.

Most Jaffa men wore European-style suits, while some continued to wear the traditional attire of baggy trousers, vest, shirt, belt and *tarboosh* (fez). In the 1940s, Egyptian singer Muhammad Abdul Wahab performed in Jaffa, and many young men imitated his style of dress – a white silk jacket and white leather shoes. Jaffa men were also known for showing off their gold watches. Many sported pocket watches with gold chains pinned to their waistcoats. Some even fastened gold pound coins to the links of watch chains, displaying these across their chest.

Above left Jaffa coffee shop, 1930

Above right Farid Basha Khurshid wearing a jacket embroidered with *sarma* stitch (circa 1870)

Above Man's silk brocade *qumbaz* (circa 1900)

Threads of Identity

Left Festive velvet costume from Jaffa area, with silver and silk cord couching, also called *rasheq*, 1930; note the orange blossom pattern embroidered in vertical lines on each side of centre skirt panel (circa 1930)

Above Back panel of silk cord couching embroidered in the "domes" or "watches" pattern, Salameh (circa 1930)

Jaffa's economy thrived because of the orange groves in surrounding villages and its port on the Mediterranean. A significant number of Jaffa families, like the Ghargours, Tajis and Damianis, owned orange groves and lived part of the year in the countryside and part in the city. These families were intricately connected to those who farmed their land who, in turn, were relatively prosperous. For example, the dress of Beit Dajan, Yazur and Safiriyya villages was extremely lavish with heavy embroidery topped with golden couching, and Beit Dajan women of the farming families spoke to me of two-storey houses which were unusual in villages.

223

Beit Dajan

The inhabitants of Beit Dajan, one of the largest villages in the Jaffa area, had great success with their orange groves, and their prosperity was reflected in their dress. It was noted for beautiful, handwoven fabric and embroidery, and a great variety of costumes and since it was the market town for many other villages, such as Safiriyya, Abbasiyya, Yazur, Sheikh Muwannis and Kafr Ana, the influence of its embroidery work spread throughout the area.

Starting in 1969, in Amman, I was introduced to people from Beit Dajan by Wafa Jibril who worked for my father-in-law and became interested in my research about his hometown. From my interviews and discussions with the older generation from Beit Dajan, it became obvious that the economic conditions in the area had been good from the 19th century. This perception is confirmed in the accounts of European travellers, such as H B Tristram, who passed through the Jaffa area in 1860, and wrote in his *Journal of Travels in Palestine* about how astonished he had been to see miles and miles of orange groves and palm trees there.

Left Chest panel of *thob abyad*, white linen dress, from Beit Dajan, with couching and cross stitch (circa 1925)

Above Newly married couple from Beit Dajan (circa 1940)

THREADS OF IDENTITY

Above Festive *thob mukhmal* (velvet) from Beit Dajan, with silver and silk cord couching (circa 1930)

226

The prosperity explains the generosity of bridegrooms and their families in buying fabric, jewellery and other wedding gifts, and the relative lavishness of marriage celebrations

One reason for this prosperity was to be found in the Ottoman Land Law of 1858. Traditionally, most cultivated land was considered to belong to the state, but with the new law, those who cultivated land obtained a title to it. This served as a powerful incentive for extensive cultivation. The resulting prosperity explains the generosity of bridegrooms and their families in buying fabric, jewellery and other wedding gifts, and the relative lavishness of marriage celebrations.

Wafa Jibril and his family introduced me to Ruqiya al-Santareasy, the best embroiderer from Beit Dajan, as well as to elderly men and women who remembered a lot about pre-1948 life in the village. It was very interesting to visit them in Amman. Our guide, Wafa, knew them all, and although the village population was divided into two different clans, they were nearly all related. From Wafa, his aunts, Ruqiya al-Santareasy and her mother (Im Said), the daughters of Sheikh Yusuf Dajani and others, I gathered detailed information about the village before its evacuation in 1948.

In 1940, Beit Dajan encompassed 17,327 dunums of land (1 dunum equals 1,000 square metres), and the population stood at 5,500. There was a Roman castle in the centre of the village, a few Islamic shrines, and an old mosque. Most people cultivated grain or oranges. Many kept horses and took great pride in caring for them. Both men and women produced baskets, leatherwork such as saddles, wooden bridal chests and wooden crates used for shipping oranges to Europe. The villagers also made pottery for their own daily use, especially the clay pots used to cook food over open fires.

JAFFA

Whenever a family built a second storey, the woman of the house would embroider this new pattern on her dress

On Mondays, people from Beit Dajan went to trade at the market in Lydda. On Wednesdays, they went to the Ramla bazaar. According to the village sheikh, they were richer and more cultured than other villagers in the area. Beit Dajan was situated on the crossroads between Jaffa, Jerusalem, Gaza and Haifa. In 1930, the village was connected to the railway, and there was a small train station. By 1937, buses appeared and replaced horse-drawn carriages.

During the 1930s and 40s, many young men found work in nearby British military camps. They were well paid, and this caused a building boom. For the first time, two-storey houses were built and filled with furniture bought in Jaffa. This quickly expressed itself in the local embroidery, with the emergence of a new pattern called *alaly* (second storey). Whenever a family built a second storey, the woman of the house would embroider this new pattern on her dress. At the same time, costumes became more lavish and costly.

The village was divided into two sections, each with its own *mukhtar*. A boys' school and a girls' school were established in 1930. In 1938, the first trade union was founded. It was active until 1948, when all the inhabitants of Beit Dajan were driven from their homes during the war.

Left Detail of back of festive cotton velvet dress from Beit Dajan, with silver and silk cord couching (circa 1930)

Above Detail of side panel with *alaly* (second storey) pattern on the right, and *kanabayat* (sofas) pattern, on the left (circa 1935)

229

Ruqiya al-Santareasy
from Beit Dajan to Amman

Above Ruqiya al-Santareasy, 1974

Anyone interested in Palestinian embroidery in Amman knows Im Ibrahim, or Ruqiya al-Santareasy. She is an icon, having used her skills and knowledge of patterns to open a workshop in her house, eventually hiring around 90 women to embroider cushions, runners, wall hangings and dresses. Her workshop became a social enterprise, sustaining the families of the women who worked there, and her products are sold throughout the city and to Palestinians in the diaspora.

Ruqiya is the daughter of Sheikh Mustafa Abbas of Beit Dajan, who studied at al-Azhar University in Cairo. He was among those who conducted awareness campaigns to alert people to the value of their fertile land as their only source of income, warning them not to sell it or to work in the newly established Jewish townships nearby.

When Ruqiya was to be married, she and her sister prepared a good *jehaz* (trousseau). Manneh Hazboun of Bethlehem helped with the silver couching. Ruqiya's fiancé was a trained teacher, and he wanted her to include some city-style clothes in her *jehaz*. With the improvements in transportation and communication, women came across styles of other areas and imitated them, for example the *smadeh* (coin-decorated headdress) was becoming less popular and was worn only for special occasions, and for everyday women were starting to wear blue crocheted caps decorated with glass beads that covered all their hair. When cotton velvet appeared in the Jaffa textile market, women bought it and tried applying cross stitch embroidery to it, but the pile of the velvet covered the embroidery, so they solved the problem by applying silver couching instead. The Bethlehem *malak* costume began to replace the *khedary* style, and the black *shambar* was replaced by embroidered pink and wine-red shawls that were made by machine in Ramallah and Bethlehem.

Above Ruqiya's *thob aswad* (black dress), made after Manneh Hazboun introduced couching to Beit Dajan (circa 1935)

Threads of Identity

The coin-decorated headdress was becoming less popular and was worn only for special occasions. For everyday wear, women were starting to choose blue crocheted caps decorated with glass beads

Left Chest panel of Ruqiya's festive *thob aswad* (black dress) from Beit Dajan, with cross stitch and silver cord couching (circa 1935)

Above Beaded crocheted headdress introduced by the British Mandate authorities for school girls to replace the traditional headdress with coins (circa 1935)

People from Beit Dajan would attend Friday prayers at al-Aqsa Mosque in Jerusalem and return home the same day. Im Ibrahim told me how she always kept her eyes open in the mosque to see what other women were wearing, and then copied the new embroidery patterns that she saw. New patterns originating in Eastern Europe also appeared on the market in the copybooks that came with the French company DMC's cotton thread.

By the end of World War II, Jews at a nearby settlement had begun harassing the people of Beit Dajan. One night, Jewish militiamen bombed a bridge as a group of British officers were crossing it, killing some of them, along with Ruqiya's future father-in-law. This caused the family to postpone her wedding for one year. During that time, Ruqiya helped other brides with their trousseaux while completing her own.

Left *Mshakhla'* (golden necklace) given to every Jaffa-area bride, originally brought from Egypt, later made by Jaffa jewellers

Above Hairpin made in Jaffa, worn in surrounding villages

At her wedding, Ruqiya's jewellery included more gold than silver, as the former was beginning to replace the latter. She was given 35 gold pounds by the bridegroom. Always entrepreneurial, she used this present to buy a modest orange grove. With help from her family, she planted cypress trees around the perimeter of her property, just as she embroidered a row of cypress trees across the back of her costume. In this orange grove, Ruqiya held gatherings for her women friends where they would embroider. Manneh Hazboun, the couching expert, was often invited to join the group.

Once a year, the people of Beit Dajan took part in a festival at the shrine of the Prophet Rubin. Palestinians from the whole area gathered in the village of al-Nabi Rubin, south of Jaffa, and spent one or two weeks there, living in tents and enjoying the festivities. On these occasions people would have a chance to see the costumes of Jaffa and other villages, when men and women wore their finest attire.

During the late 1940s, the conflict between the British and the Jewish settlers intensified, as did that between Palestinian Arabs and Jews. When the British forces started withdrawing in May 1948, armed Jewish groups mounted a major offensive. Suddenly, villagers from the area which was to become Tel Aviv began streaming into Beit Dajan as refugees. Witnessing their plight, the people of Beit Dajan determined that they would never leave their homes. However, they soon heard that Lydda and Ramla had fallen, and villages were being evacuated one by one. When Jewish forces surrounded Beit Dajan, people panicked.

Threads of Identity

JAFFA

Today, Im Ibrahim continues to run her embroidery enterprise from her home in Wadi Abdoun in Amman, having succeeded in sending all her eight children to college

Ruqiya was pregnant at the time. She hastily collected a few of her costumes and the title deed to her orange grove, and found herself heading on foot towards Nablus, along with her extended family. In Nablus they stayed in an empty school for the summer and then, with other relatives, they rented a small apartment in the Old City where they remained for three years. Then they left for Damascus where relatives had told them that life was cheaper and work more abundant. However, after three years in Damascus, her husband had still not found work, and they moved to Amman where eventually her husband got a job teaching. By this time they had eight children, and clever, resourceful Im Ibrahim went into embroidery.

Today, Im Ibrahim continues to run her embroidery enterprise from her home in Wadi Abdoun in Amman, having succeeded in sending all her eight children to college. She feels responsible for the welfare of all the women who embroider for her, but decreasing demand has limited her sales. Using her extensive social network, she has managed to find other jobs for her employees or their family members. She is what you would call a true social entrepreneur.

Im Ibrahim still has the deed to her home and orange grove, and has made many copies of it. She firmly believes that one day this document will serve as proof of her right to return to Beit Dajan.

Left Style of the *malak* costume prepared in Bethlehem for Beit Dajan brides (circa 1930)

Above left DMC pattern book introducing European patterns to Palestine

Above right Im Ibrahim and author, 2008

237

THREADS OF IDENTITY

Im Said
memories of a former life

Above Back view of Im Said showing her Beit Dajan headdress, 1974

Right *Jellayeh* – the most festive dress of Beit Dajan and other Jaffa area villages, black linen, unique because of the short sleeves and skirt opening trimmed with silk patchwork (circa 1920)

Im Said is Ruqiya's mother. She relished talking about her past, not forgetting any detail. In fact, her information was so rich that it usually took me several months to digest it all and I would go back to her for details that I had missed.

'What exactly did your trousseau consist of?' I would ask.

Im Said explained that she had started embroidering when she was 12 years old. By the time she was 16 she had completed her trousseau. It consisted of four main costumes: a *jellayeh*, a green and black dress, a grand white dress and an everyday dress. In addition to the embroidery on these costumes, she also embroidered her hat and head shawl. Everything was left in separate pieces for her mother to sew together when she got engaged. It was considered bad luck to finish the costumes before the bridegroom appeared. As she said: 'If you did, he might never come.'

Judging by Im Said's trousseau, a village woman in the 1920s would need to have the following.[14]

Jellayeh: This was the most expensive and ornate costume of the *jehaz*, made of dark indigo-blue linen, heavily embroidered and trimmed with silver patchwork. It had short sleeves and a slit in the front of the skirt. It was worn over trousers by the bride for her first public appearance after the wedding.

Thob khedary: a green-and-black striped dress of linen and silk, woven in Majdal.

Thob abyad: a dress of handwoven white linen embroidered with a cypress tree pattern, to which amulets were attached.

Thob aswad: a dress of handwoven black linen embroidered with a pattern of moons and pine trees, to which amulets were attached.

[14] Much of the following information appeared in 'Costumes and Wedding Customs in Beit Dajan' in *Palestine Exploration Quarterly*, Jan-June 1975.

JAFFA

Threads of Identity

Left *Thob abyad* (white dress) from Beit Dajan linen, couching and cross stitch with amulet pattern on both sides of the skirt (circa 1920)

Above left Beit Dajan headdress with Ottoman and Austrian coins (circa 1935)

Above right *Khirqa* (headcover) from Beit Dajan (circa 1928)

All these costumes were worn in the course of the wedding and for festive occasions thereafter. Cleaning them was no simple matter. Im Said told me how she would take her costumes to the citrus grove where there was a well with a pump. She would put salt and vinegar in a basin and wash the costumes in running water without submerging them, so the colours did not run.

Im Said boasted that Beit Dajan's embroidery stitches and patterns were the best in the area, and that the costumes of the Jaffa area were the best in all Palestine.

THREADS OF IDENTITY

Beit Dajan is now inhabited by Jews from Yemen and Ethiopia, while the people of Beit Dajan, like Im Said, have been relegated to refugee camps

I visited Im Said when she was living with her son in the Hussein Refugee Camp. The house was on the main street in a very crowded, noisy area. While she was always welcoming, she could not hold back her tears when describing her two-storey home in Beit Dajan with its little private garden and lemon, mulberry and fig trees. She loved to tell us about the beautiful white horse they had owned. Her father always had the horse decorated, ready for any village bride who wanted to borrow it to ride from her parents' home to her bridegroom's house.

Im Said also told me about the social and cultural life of the village. Although the men worked hard in agriculture, they would return home in the afternoon for lunch and then go to one of the three coffee shops in the village. There they played backgammon, chess, dominos, cards and mancala, or sat and smoked a *nargileh* (hubble-bubble). Once a month, a man called Abu Darwish came from Ramla to Mahmoud Bakr coffee shop to perform *karakoz* (shadow theatre) with funny or historical themes. The performance always stopped at a point in the story that made the audience eager to catch the next one the following month. During the summer, *hakawatis* (storytellers) came from villages in the mountains to the coffeeshops, where they sat on a raised platform and related folktales. At harvest time, gypsies came to Beit Dajan to work, and they danced in the coffeeshops for entertainment.

In 1948, after other villages in the area had been attacked, all the inhabitants left Beit Dajan for fear of assault by Jewish forces stationed at nearby Rishon Lezion. They expected to return after the war, but this was impossible. Instead, Beit Dajan became part of Israel and was renamed Beit Dagon. It is now inhabited by Jews from Yemen and Ethiopia, while the people of Beit Dajan, like Im Said, have been relegated to refugee camps.

Left above Detail showing machine embroidery of *shirwal* (trousers)

Left below *Shirwal* (trousers) worn in Beit Dajan

Above The author with Beit Dajan women in Hussein Refugee Camp, Amman, 1978

Halimeh and Ruqiya Dajani

Above Halimeh and Ruqiya Dajani, daughters of Sheikh Yusuf, in Hussein Refugee Camp, Amman, 1974

Also living in the Hussein Refugee Camp in Amman were Halimeh and Ruqiya Dajani whom I met through other Beit Dajan connections. Traditionally in Palestine, the bridegroom was expected to provide everything for a new home, but this was not the case with Halimeh and Ruqiya, the daughters of Sheikh Yusuf Dajani. As the richest man in Beit Dajan, Sheikh Yusuf showered his generosity on his daughters and they wore the most expensive costumes and jewellery in town. Halimeh and Ruqiya set the style for other Beit Dajan women. Their father did not wait to receive their dowries, but straightaway bought them everything himself. Both daughters married late, and their relatives told me that it was because nobody in town was considered good enough to marry them and because they had so much that young men were intimidated, feeling they could not provide for them.

When I met Halimeh and Ruqiya in the refugee camp in 1972 they were very poor and alone, but the other refugees from Beit Dajan took care of them. They retained a certain status because they were still known as the daughters of Sheikh Yusuf, and they had once been the trendsetters in Beit Dajan. While they lived in poverty, they had kept their pleasant disposition and sense of humour, whether about the past or present. They would say of the British Mandate officers:

'They were not to be trusted. They would always stop in our orchard and we would serve them our best meals. Then they would pick and eat our fruit, ride our white horse, swim in our pool and then say: "Thank you very, very much" (the sisters would mimic this in accented English), *and then just disappear. Many groups of them came, but our father never complained. Although they promised him many things, they never kept a single promise.'*

I visited the two sisters over many years and each time I would learn something new about their attire and their lives. Once when I went, their room was locked. Upon enquiring I learned from the neighbours that they had become unable

While they lived in poverty, they had kept their pleasant disposition and sense of humour, whether about the past or present

Above Halimeh Dajani with the author in Hussein Refugee Camp, Amman, 1978

to live on their own and had been taken to an old people's home in Zarqa, a town adjacent to Amman. I felt terrible sadness and stood for a moment thinking of their past glory, their beautiful embroidered costumes, their jewellery, and their orange groves where most of the people of Beit Dajan had gathered for lunch at one time or another. It was sad to think that these lovely women, once at the centre of a warm and vibrant social life, were now in a completely strange place surrounded by people they had not known before.

As I was talking to the neighbours, Halimeh's beautiful tiger cat emerged from a window. The neighbours were now feeding the cat as they had promised, out of respect and love for Halimeh.

Chapter 9

Ramla & Lydda

Ramla and Lydda were historical cities in central Palestine, situated about 20 kilometres apart. Both had Christian and Muslim archaeological sites. Prior to 1948, they served as central markets for a large number of surrounding villages. Ramla was the centre for 62 villages, and Lydda for 59. Cotton was cultivated in the region and during the 19th century the harvest was sufficient to export to France, as well as provide for local weaving. Some of the cloth was dyed with indigo in the vats of Lydda's Old City. Both cities had a number of government schools, as well as private Muslim and Christian ones, with Ramla offering higher education as well.

Left Lydda and the Church of St George (al-Khader) in 1900

Above Detail of the *rasheq* embroidery

Threads of Identity

Above The Taji Building of Abd al-Rahman al-Taji in Wadi Hunein, Ramla area in 1930s. This picture was damaged and his grandson, Said, carefully retouched it

Below Sons of Abd al-Rahman al-Taji and their friends in front of the house, 1930s

Ramla & Lydda

The two cities closed ranks and worked together when it came to Arab nationalism and resisting Zionism

Over the centuries, these two cities competed with each other. Lydda's importance derived from its location on an old caravan route between Egypt and Syria. In the days when carrier pigeons were used, Lydda was a postal centre. During Ottoman times, Lydda ceded its prominence to Ramla, but regained it during the British Mandate, when the largest railway station in Palestine was constructed there.

Despite centuries of rivalry, the populations of the two cities closed ranks and worked together to promote Arab nationalism and resist Zionism. On 15 May 1936, workers in Ramla and Lydda went on strike in protest against the policies of the British authorities, and they urged people to stop paying taxes. This was the start of a six-month strike in Palestine and was one of the sparks that ignited the 1936-39 revolt against British colonialism and Zionist immigration.

Above Tower of the Martyrs in Ramla, 2006

THREADS OF IDENTITY

Women in the towns of Ramla and Lydda in the twenties wore plain, long dresses with long sleeves

There were special days observed jointly by Christians and Muslims in the area for centuries. Each September, as mentioned before, a festival was held at the shrine of al-Nabi Rubin, which belonged to the Islamic *waqf* and was opened to everyone in the vicinity of Ramla, Lydda and Jaffa. There was a similar annual festival at the shrine of al-Nabi Saleh (the Prophet Saleh) each spring. Another occasion for Christians and Muslims to meet was a ceremony each year on 17 November at the Church of St George (al-Khader) in Lydda. The festival marked the burial of St George and the end of the olive harvest.

Women in the towns of Ramla and Lydda wore plain, long dresses with long sleeves. However, the city markets sold all the materials used for village costumes, which were more colourful and fully embroidered. The two towns attracted visitors from all around the region because of their markets, the Lydda railway connection, and the saints' festivals. As a result, the costumes throughout the area had similar styles and materials.

Left *Qabeh* of Lydda area dress called *mudawara* meaning circular neckline (circa 1930)

Above Samiha, Mustafa and Zuhra al-Taji in Wadi Hunain, Ramla area, 1935

Above Festive *thob karmazut* (watered silk taffeta dress), couching on *heremzy* silk, worn in Deir Tarif and Beit Nabala villages (circa 1935)

RAMLA & LYDDA

There was more innovative and creative embroidery used by villagers of this area than in Jaffa or Ramallah

Above Detail of couching in silver cord

Costumes were also influenced by the styles and embroidery patterns of Ramallah and Jaffa. However, different textiles were used. Watered silk taffeta, called *karmazut,* was first introduced in this area, as was *tubsi,* pink-and-white-striped linen. The cut of the dresses was narrower than in other areas, and the yoke was often rounded. Both couching and cross stitch embroidery were used. There was more innovative and creative embroidery used by villagers of this area than in Jaffa or Ramallah. This could be due to the effects of mission schools or shopkeepers' cleverness in always offering new things. While merchants used the Syrian names for the fabrics they sold, village women usually invented names of their own. The embroidery patterns in the area were rather dainty and sometimes given names with political connotations connected to current events.

Ramla & Lydda

Left Back panel of costume from Lydda and Ramla area (circa 1930)

Above Workers from Lydda area, 1910s

Ramla Villages

Im Zuhdi of al-Ne'ane
Innovating new embroidery patterns

Above Im Zuhdi in the 1970s

Women in the villages on the plains and mountains around Ramla wore costumes of white or black, with tight sleeves. They claimed to have the finest embroidery stitches in the area. With the help of Im Zuhdi, a refugee who worked as a janitor at the Ahliya Girls' School in Amman, where my daughters were educated, I was able to buy a number of good costumes from villages of the Ramla area, and acquire a great deal of information from the women who owned these dresses. While all the stories are rich, I am focusing only on Im Zuhdi.

Im Zuhdi came from al-Ne'ane, a village south of Ramla, which in 1948 had a population of about 2,000. The people worked in agriculture, and al-Ne'ane was known for its watermelons and sesame seeds. The village was built on top of a *khirbet*, the site of an ancient ruin, so old pottery shards and mosaic pieces were constantly turning up in the fields. The women collected the broken pottery, crushed it and mixed it with clay to produce new pots, some of which they sold at the Wednesday market in Ramla.

Im Zuhdi was known as a creative embroiderer who would introduce patterns from other villages and give them new names. One of these was 'The Branch of Zuhdi', named after her son, which was copied by other brides at that time. On one occasion, two police officers from the British Mandate government, a Muhammad Sa'dy and a Mr Brookman, visited al-Ne'ane while Im Zuhdi was developing two new patterns. As a result, she named the patterns after them.

In 1948, the people of al-Ne'ane, like those of other villages, stood fast against the Zionist militias' attacks aimed at terrorising them out of their village. But when the Israeli army appeared with tanks and big guns, they were forced to evacuate their homes. Im Zuhdi insisted that I write down the name of each and every village she and her family passed as they started their long march which ended in Amman. Like al-Ne'ane itself, all these villages were destroyed by the Israeli army during or after the war, and in the following passage, I am honouring my promise to Im Zuhdi to document the name of these vanished villages.

RAMLA & LYDDA

Above Im Zuhdi's festive dress, style typical of al-Ne'ane, al-Qubab and other villages that learned Bethlehem couching, renaming it *rasheq* (circa 1930)

THREADS OF IDENTITY

Above Im Zuhdi's linen dress displaying fine cross stitch, silk patchwork and silk *rasheq* on the sleeves (circa 1930)

'We walked to al-Qubab, Abu Shusha, Innaba, Sarafand, Deir Abu Salama, Jimzu and al-Haditha before we got to Beit Nabala. There were thousands of refugees in Beit Nabala, and the Arab army stationed there gave us bread and water. Then we found out that the army had to leave. People panicked, some mothers lost their children. The army tried to calm them down, but the situation was extremely chaotic.

'Our march started again, this time towards Ramallah. Now I did not know the villages we passed since we were no longer in the Ramla area. I know we stopped at the Latroun Monastery (near Jerusalem), and the priests distributed bread and water; they must have been baking day and night. We had a good rest at the monastery before walking on to where the refugees were assembled near Ramallah, and there the Red Cross helped us. But the march had to continue. For us, it ended in Amman, Jordan, in what became the Wihdat Refugee Camp. We were given tents, and I started by dividing our tent into corners to make it easier for my family. I looked for cleaning jobs and found one with the Ahliya Girls' School, where I stayed for many years.'

I maintained my friendship with Im Zuhdi until she passed away in 1990. She would come often to our house and scrutinise the different dresses in my growing collection. In her proud, critical eyes, no costumes were as good as those from al-Ne'ane. She always looked at the way others started and ended their embroidery patterns. She noticed that the patterns were often not complete because the seamstress had not started in the middle of the fabric. She would also criticise the choice of colours. Her greatest disappointment was that her daughters, whom she had trained in traditional embroidery, shifted to doing modern, French-style embroidery (*Aubusson*) for society ladies in Amman because they made more money that way.

Above Sleeve from Im Zuhdi's dress with *rasheq* and patchwork

THREADS OF IDENTITY

Aysheh
of Abu al-Fadl

Above Aysheh al-Sutaria of Abu al-Fadl in the 1980s

Right Back panel of Aysheh's dress showing patterns of the different areas her tribe moved to: the hem is from the Naqab, "Tents of the Pasha" (fourth row up) and *"Saru"* or cypress tree (seventh row up) from Hebron, and *rasheq* (on the sides) from Ramla (circa 1940)

Aysheh al-Sutaria was one of the long serving sources for my growing collection. She would regularly appear on our doorstep with exquisite and rare pieces for sale. Aysheh had many contacts in the refugee camps of Amman and fully understood my interest in buying costumes. We would always haggle for a while over the price and finally settle amicably over a cup of tea and I would gain some information about her life.

Aysheh was from Abu al-Fadl village on a hill north of Ramla. She was from the Sutaria Bedouin tribe that originated in the Khan Younis area of Gaza. A century earlier, for some reason, the whole tribe had moved from there to the Hebron area where they worked as hired farm labour. There the women were influenced by the local embroidery patterns and copied some of them, like 'The Tents of the Pasha' and 'The Keys of Hebron'.

Aysheh said that her tribe found the land around Hebron too mountainous, so they moved again to Abu al-Fadl, which was surrounded by good agricultural land and connected to the railway. Here also the men and women of the tribe worked as farm labourers on citrus plantations belonging to people who lived in Ramla and Jaffa.

The Sutaria women copied some of the Ramla area embroidery patterns on their costumes. Like other women of the Ramla area, they covered their head with a white shawl, but they wrapped their bodies in a black or dark blue *abaya*, like the Bedouin women of Khan Younis.

Aysheh said that the people of Abu al-Fadl did not leave their homes in May 1948. After the ceasefire, however, Ramla was invaded by the Israeli army. Along with the people of the surrounding villages, they were expelled from their homes and forced to walk for days until they reached Ramallah. There they stayed for a few months, and then decided to go to Jericho where they registered as refugees in the UNRWA-run refugee camp. Aysheh was married, but never had children. She and her husband lived with his family, and she did farm work in Jericho, as well as embroidery for a YWCA project, making dolls dressed in traditional Palestinian costumes.

261

The 1967 war brought about another displacement. This time she walked with her family to Amman, where they eventually rented a room in Sweileh on the outskirts of the city. By that time, Aysheh had divorced her husband. He had wanted to marry again because she did not have children, but Aysheh would not accept living with a second wife. She began to make a living for herself by selling healing beads to Bedouin women and from this she branched out into buying and selling silver jewellery. She also discovered that shops in Amman were interested in buying Bedouin jewellery. Eventually she found me and others who were willing to pay more than the shops for her beads, jewellery and, later on as she expanded her business, old embroidery.

When I first met Aysheh, early in the 1970s, she was still a tall, strong and beautiful woman, living with her brother's family in the Baqa'a Refugee Camp, north-west of Amman. In the summer, she and her brother rented land nearby and earned a living by growing vegetables. I always enjoyed her visits because she really believed in the healing powers of her beads, charms and amulets. She was also very philosophical and had a great memory for traditional songs, proverbs and witty jokes. There was never a dull moment with Aysheh.

Once she disappeared for a while, but on her next visit she told me she had heard that her ex-husband was sick in hospital. She had taken a bunch of grapes and had gone to visit him, not knowing whether or not he would receive her. In fact, he had been happy to see her and told her that he still loved her. They spoke of how they had met farming the fields in Abu al-Fadl and how in the spring he had made her a bouquet of lupines and fastened it to her vegetable bags.

Aysheh continued visiting her former husband in the hospital until he died, and then she resumed her business of collecting folklore items. She spent much of her earnings on her brother's family, especially her blind nephew whom she loved. She paid for his education until he graduated from the university and became an Arabic teacher.

Left above Aysheh's magic beads

Left below Glass and stones used by Aysheh for healing

Above *Zeibaqah*, piece of bridal jewellery from Jaffa and Lydda area villages

Aysheh continued to visit me until she died of a stroke in 1995. This time, her beads did not help her. Aside from all the valuable information she shared with me, I treasure memories of the spicy jokes she told about the women she treated. Our discussions focused on her art of healing with beads and amulets. It is mainly through her that I became interested in collecting these items and trying to discover their significance.

The textile merchants of Lydda

In 1946, Lydda's population stood at about 19,000. It was occupied by the Israeli army on 11 July 1948, at which time the majority of the town's inhabitants were forced to leave.

In 1970, I met a number of women from the Lydda area who were living in refugee camps in Jordan. Originally from the villages of Jimzu, al-Qubab, al-Haditha, Beit Nabala, Deir Tarif, Qibya and Budrus, they spoke with nostalgia of Lydda's old *suq*. As brides, they had gone there with their parents and in-laws to do their wedding shopping. They would mention the names of shopkeepers they were particularly fond of, such as the Batshons, Zabanis and Haltys. This prompted me to look for some of these shopkeepers. Thus I discovered the special charm of Lydda's market before 1948. In the following I have chosen to focus on the Batshon family, although all the textile merchants I met had a similarly interesting wealth of information.

Salwa and George Batshon, known as Abu Bishara and Im Bishara after the birth of their first son, were married in 1935 and jointly managed the family textile shop. Prior to 1940, their textile sources were Arab countries. Silk and cotton thread was brought from Egypt, as was the striped fabric for men's *qumbaz* (overcoats). *Rohbani*, a roughly woven linen, was imported from Greece, Turkey and Egypt. From Majdal, in Southern Palestine, they bought a white fabric with red stripes on the selvedge that was used in Qibya, Shukba and Budrus for wedding dresses. Silk shawls were bought from the Diab brothers in Damascus. The Naser brothers in Bethlehem provided them with the *malak* fabric for wedding gowns. They also bought a type of cotton called *dandaky,* used for lining, and *breem*, a simple fabric used for men's underwear, from merchants in Nablus, who supplied all Palestine with textiles and apparel from Aleppo, Homs and Hama in Syria. It was a prosperous business from which evolved extensive social relations.

Left Syrian textiles sold in Lydda

During the early 1970s, I came across Im Bishara, who was living with her daughters in Amman. She was a healthy-looking woman and a gold mine of information on village life in Palestine, gleaned from the villagers who had come in groups of 30 to 40 to do wedding shopping in their Lydda shop.

There was only one bus daily. It would arrive from the villages in the morning and return in the afternoon. This meant that sometimes a group of villagers would have to sleep over in town. The men slept in the mosque and the women stayed at the house of Abu and Im Bishara. Members of their family would leave home for the night to make room for the guests.

One morning, Im Bishara got up and told her husband, 'Our children are sleeping all over town. This is impossible. We must build another storey upstairs and make it the sleeping quarters for our customers.' And so it was. The Batshons gained many customers because they provided free lodgings. In the morning, Im Bishara would send up a breakfast of *ka'ak* (round sesame flat bread) and *hummus* (mashed chickpeas) along with a variety of olives. This made the Batshons' sales shoot up, and other merchant families began to follow suit, setting aside part of their homes to accommodate groups from the villages, and providing meals.

Im Bishara became an advisor for many village women, while Abu Bishara became their trusted money-keeper. Villagers might leave money with him to buy sweets or other items for an upcoming wedding, and he would send the things to the village with the bus driver. Im Bishara knew what was needed in each village in terms of special dresses, as she was always in the shop helping her husband.

When shopping for a wedding, the villagers did not come on market day, which was Monday, but would often come on Friday in order to have the shop all to themselves. They would take Im Bishara with them to buy gold jewellery for the bride, and to the dressmaker to have things sewn for the wedding. If they were not weavers themselves, they would order rugs from Gaza for the bridal couple's new home, and *abayas* (cloaks) from Nablus for the bridegroom to distribute among male relatives. Other

The Batshons gained many customers because they provided free lodgings

shopkeepers were providing some of these services, but it seemed that the Batshons were the best. They would often be invited to village weddings, which were usually held after the harvest. Sometimes they attended, taking their children along, especially if the bridegroom was the son of the *mukhtar* or village chief. Although Im Bishara and Abu Bishara did not leave Lydda in 1948, despite Israeli army threats and later harassment, eventually they had to shut the shop as they lost both their textile sources and their clients, who mostly became refugees. Later they moved to Jordan. Although she always wore Western-style clothes, Im Bishara was extremely knowledgeable about the costumes and traditions of the villages around Lydda and I would take dresses that I had bought for her to evaluate. Often she would say: 'Ah yes, this material was certainly bought at our shop. Well, at least this dress has survived even if our shop did not.'

Above Linen head shawl trimmed with crocheted lace (circa 1940)

THREADS OF IDENTITY

# Collection *Ramla & Lydda Area*

RAMLA & LYDDA

Left Rounded neckline of a Kafr Ana dress (circa 1938)

Above Festive *rasheq* dress of *karmazut* (taffeta) fabric, worn in Deir Tarif, Beit Nabala and Kafr Ana (circa 1935)

THREADS OF IDENTITY

Above Festive linen dress of Beit Nabala (circa 1930)

RAMLA & LYDDA

Above Linen dress of Lydda area (circa 1940)

Chapter 10

Galilee

Galilee, the area of northern Palestine stretching from the southern Lebanese border to Nablus, encompasses the districts of Acre, Safad, Haifa, Nazareth and Tiberias.

The materials, styles and costumes that were in fashion here around the turn of the 20th century were stunning in their variety. Cotton was grown in Galilee, while silk thread was imported from Syria, and linen thread from Egypt. There were many weaving centres, most notably in Nazareth and Safad, which were commercial towns surrounded by villages that lived on agriculture.

Left Woman from Nazareth area

Above *Mandeel* (headscarf) with *oya* needlework (circa 1925)

Galilee was also the source of indigo and sumac dyes needed for the fabric used in women's costumes all over Palestine. Different shades of indigo were used, ranging from black to sky blue. The indigo plant was grown in the Jordan Valley around Lake Hula,[15] and in Beisan. It was fermented, dried and used at home for dyeing and on a larger scale at weaving centres. The sumac plant was cultivated in hilly areas and provided the reddish brown colour needed for the costumes of Kafr Yassif and other Galilee villages.

The great variety of costumes in Galilee may be due to the abundance of threads, textiles and dyeing centres. Also, Galilee's proximity to Syria and Lebanon, where styles were different, may have had an influence.

Above Tiberias and the Sea of Galilee, 1930

[15] This lake was drained by the Israelis in the 1950s, causing an environmental disaster as the remaining land could not be cultivated and now lies as wasteland.

GALILEE

Galilee's proximity to Syria and Lebanon, where styles were different, may have had an influence

Above left Mother and child from Nazareth area, 1920s

Above right A man from Nazareth, 1910s

THREADS OF IDENTITY

Left Woman's brocade *qumbaz* worn in Galilee towns (circa 1920)

Above Festive *karmazut* (taffeta) dress from Kafr Yassif (circa 1925)

GALILEE

Above *Durra'ah*, silk coat worn over long trousers and a long shirt in Galilee villages (circa 1910)

Nazareth

Nazareth is a special town to me as it is where my husband, Kamel, was born. It is home to Arab Christians and Muslims, and many churches and mosques were built in Nazareth over the centuries. The most famous mosque is al-Abyad (the White Mosque). Among the historical churches are the Church of the Virgin Mary, originally built in the 4th century and renovated many times, the Church of the Annunciation, St Joseph's Church, the Church of St Anthony and the Anglican Church, as well as the Carmelite, St Joseph and Terra Sancta monasteries.

The people of Nazareth were generally very highly educated and nationalistic. From 1936 onwards, they formed resistance groups opposing British colonialism and Zionist immigration. But after the 1948 War, the Israeli occupation army crushed all such movements. Many of the villages of the area were emptied of their Palestinian Arab population who were forced to take refuge in Nazareth, changing the social structure of the city. Where the villages once were, Jewish settlements flourished.[16]

Nazareth is an old weaving centre and marketplace, and the textile trade influenced all the villages around it. My knowledge of the city was greatly augmented by my husband's family. My mother-in-law described to me how each religious community had its own quarter. Mosques and other Muslim institutions were in the centre of the city. The Russian Orthodox church had a boys' school, a girls' school and a teacher training college of which her father, Iskandar Kuzma, was the director. The Roman Catholics had the Franciscan church, monastery school and orphanage, as well as a convent and a hospice and there was a Maronite church (Melkite).

Left Nazareth, 1930s

[16] In 1948, the population of Nazareth was around 13,000. Today it is 100,000, swollen by the influx of villagers who lost their land and by natural population increase. In order to create a new demographic situation favouring Jews over Arabs, in 1957 the Israeli government built Nazareth Elite or Upper Nazareth on confiscated Arab land, a large part of which belonged to the Kawar family. Other families who lost land in the area included the Fahoums, Zu'bis, Jarouras and al-Dahers. Meanwhile, Arab Nazareth has been pushed deep into debt, for the municipality only receives 4% of the taxes collected from its inhabitants.

Threads of Identity

Men from different parts of Palestine and Jordan, whether Christian or Muslim, went to Nazareth to find a wife. It was said that if you wanted a good homemaker, you should pick a Nazarene bride

Above Salma Mo'ammer (centre) with her parents and sisters in Nazareth, 1920

Below A family from Nazareth, 1938

Above Church of the Adolescence, 1945

The Protestants had a church, mission house, mission school, orphanage and hospital. The hospital, now one of the best in the area, was begun by the Edinburgh Medical Missionary Society in 1865, with the help of an Armenian doctor, Kaloost Vartan.

All these churches and schools were under English, Italian, Greek or Russian influence, and they competed with each other in various fields, especially education. The girls of Nazareth benefited from this situation and had the reputation of being well educated and the best homemakers in Palestine – good at cooking, sewing and embroidery. They produced a kind of lace needlework not found elsewhere in the Middle East. It was sold to tourists as well as used at home.

Men from different parts of Palestine and Jordan, whether Christian or Muslim, went to Nazareth to find a wife. It was said that if you wanted a good homemaker, you should pick a Nazarene bride.

GALILEE

Left Detail of crochet, a specialty of women from Nazareth (circa 1920)

Above Galilee-style silver *kirdan* (choker) worn by brides

My research into the costumes of this area was in part contingent on the new realities imposed by war and occupation. After the 1948 war, when Nazareth was absorbed into the State of Israel, the Palestinian Christians living there were allowed to cross into the Jordanian-administered part of Palestine to visit Bethlehem for a few days at Christmas. In this way, I got to know most of the Kawars of Nazareth.

After the 1967 war, when all of Palestine fell under Israeli rule, the situation changed again. We, in Jordan, had to apply for special permission to visit occupied Bethlehem. During these visits, I would extend my trip to Nazareth, where the doors of many homes were opened for my children and me. Kamel, my husband, went only once, for the occupation and the treatment meted out to Palestinians depressed him. He had known Nazareth when the Kawars had owned thousands of dunums of land in the vicinity. Suddenly he was faced with the sight of Israeli settlements spreading over his family's property.

Threads of Identity

Above *Sanduq al arus* (wooden trousseau chest) with inlaid mother-of-pearl, bought in Damascus for Galilee brides

Right Ottoman-style velvet jacket with silver-thread embroidery, worn in Nazareth, made in Damascus and Aleppo (circa 1900)

Whenever we went to Nazareth in the late 1960s we stayed with Naheel Kawar (Im Boutros), the eldest lady of the family, who was living in the old family home. She was a large woman with a big heart and she was our connection to many other relatives in Nazareth, some of whom we knew from our pre-1967 Christmas visits. There were many of the older generation still around who were well versed in the history of Nazareth – its culture, commerce, food and costumes – and they shared this information with me.

Prior to 1948, the people of Nazareth traded mainly with Damascus. When Naheel Kawar got engaged in 1920, she travelled to Damascus with her parents to buy the things needed for her trousseau, as well as a chest and some furniture. It was the time when styles were changing from the very traditional to the more modern. So her mother wore a brocade overcoat, while Naheel had her brocade made into a tight jacket and long skirt. At her wedding, Naheel wore a long, white European-style dress.

GALILEE

Threads of Identity

Nazareth Villages

During my visits, the Kawars took me to many villages around Nazareth where I met elderly ladies and had the chance to interview them about their heritage. It was amazing how much information they came up with to describe the styles and materials used in the costumes of the area.

The most important item women wore was a coat made of linen or silk brocade. There was great variety of decoration on this coat. In Majd al-Kurum and Sakhnin, it was made of silk and cotton with some embroidery in geometric patterns. In some areas, such a coat in the past had been heavily decorated with patchwork and embroidery. The patchwork came in geometric forms of plain or patterned silk (*ikat*) on the inside and outside of the coat. When richly ornamented, such a coat was called a *jellayeh*.

Left Linen *jellayeh* with silk patchwork on front and back (circa 1880)

Above Girl from Nazareth in silk patchwork *jellayeh*, 1920s

Threads of Identity

Galilee

Left Back of Galilee *jellayeh*, silk embroidery on linen in geometrical patterns using stem stitch, satin stitch and cross stitch (circa 1880)

Right Detail of Galilee *jellayeh*

A variety of stitches, stem stitch and satin stitch being the most common, and was worked into geometric designs

These beautiful coats were worn in al-Bassa, Beit Jann, Lubiya, Safiriyya, Deir Hanna, Sakhnin, Safsaf and other villages. The embroidery combined with the patchwork was mainly done in red silk thread with a variety of stitches, stem stitch and satin stitch being the most common, and was worked into geometric designs. These heavily ornamented coats must have gone out of fashion around 1900. They were replaced by a coat of similar style made of Syrian silks, but without embroidery.

Threads of Identity

Two distinguished couples from Safad, founders of the successful CCC construction group

Above Said Khoury and Widad Sabbagh Khoury
Below Hasib Sabbagh and Diana Tamari Sabbagh

Safad and Area

Travelling around Galilee one might come upon enclaves with divergent styles. In Safad, women wore a wrap-around cloak called *safadiya* – a long silk shawl in yellow and black stripes woven in Hama, Syria – especially for their town. In al-Tira village of the Haifa region, I met women in costumes unlike anything I had seen elsewhere in Palestine. Similar styles were to be found in al-Damun and Yajur. In these places the costume was worn over a *shintyan* (long trousers) with different belts and a variety of jackets. From 1900 on, their small headdresses with coins were replaced by silk veils and different types of headbands.

GALILEE

In Safad, women wore a wrap-around cloak called **safadiya** *– a long silk shawl in yellow and black stripes woven in Hama, Syria*

Above Modelling the silk *safadiya* cloak woven in Homs and Damascus for the women of Safad

Left This dress is unique to al-Tira in the Haifa area, displaying stem stitch, running stitch and hem stitch embroidery on cotton (circa 1940)

Above left Printed cotton *mandeel* with *oya* (needlework), worn by urban women in Galilee (circa 1930)

Above right Nazarene family; note the women's short jackets and silk *asba* (headscarves)

There was no difference between the dress of Muslims and Christians, but Druze women wore a long white shawl on their heads. In Nazareth after 1900, women covered their heads with a *mandeel* of block-printed cotton gauze or sometimes silk with beautiful *oya* (needlework) or crochet around the edges.

Another differing enclave in terms of dress was to be found around Lake Hula, among the Bedouin of northern Palestine. As the boundaries between Palestine, Jordan and Syria were only set in 1920, there was confluence of popular culture in this area, which does not necessarily correspond to present-day borders. Al-Hibb Bedouin near Lake Hula dressed just like the people of Hauran in southern Syria and villagers in northern Jordan. Similarly, the Bedouin around Beisan dressed like the Ghazawi tribe across the River Jordan.

Safad Area, Alma

Hind
and her exceptional costume

While visiting Beirut in 1970, my friend, Haifa Bibi, who was working on an embroidery project in the refugee camps, gave me a costume. This dress did not look like any other Palestinian costume that I had seen. It was white with red and black embroidery. I insisted that it was not Palestinian. 'Well,' said Haifa, 'you can come with me to the camp near Sidon and meet the people who gave it to me.'

Haifa had got the dress years before, so by the time we went to Ain al-Hilweh Camp, its original owner, Hind, had died. Instead, we spoke to her family who gathered around us, offering lots of information, not on the costume, but about Alma, the Galilee village from which they came.

Alma lay in the midst of fertile land in the Safad district of northern Palestine. There was an olive press, a water-driven mill and two large water pools, one on each side of the village. People derived their income from farming fruit orchards, raising sheep and goats, and keeping bees. All in all, there were 1,000 dunums planted with olive trees around the village. There were also Byzantine and Crusader archaeological ruins on the village land.

Abu Saher, Hind's husband, said his wife had been the best embroiderer in Alma. The cut of the Alma costumes was like that of Nazareth, while the embroidery resembled that seen in Syrian villages. Women in Alma wore embroidered trousers under their costumes and, on their head, a silk turban *(asba)*, handwoven in Hasbaya, Lebanons. The villagers shopped for their clothes in Safad and Acre, where they also bought gold jewellery. In 1940, Hind had sold her gold jewellery to help her husband build their stone house in Alma.

The people of Alma had decided to stay in their village when the war broke out in 1948, but in October of that year Israeli army units came and began expelling them from their homes and driving them towards the Lebanese border. The villagers tried to resist and some were killed, but the majority were forced to walk to Lebanon.

Right Hind's coat-like costume (circa 1930)

THREADS OF IDENTITY

Abu Saher told more about their pre-1948 life:

'We shopped in Acre and Safad, which was only 11 kilometres away. In these two markets we also sold our own products, such as dried figs, raisins and burghul (cracked wheat). We also produced charcoal and sold it in Safad, which was a very cold city. A few of my friends and I went to school in Safad. We walked there every day, but when it was very cold we slept over in rooms belonging to the mosque.

'My mother and other family members would ask me to run errands for them in Safad, usually buying embroidery thread. I remember it had to be a particular shade of red. If it wasn't right, I would have to take it back and exchange it. Often, all the family would accompany me to Safad. I would leave them in the market and join them in the afternoon after school when I would be treated to a special lunch. Then we returned together in the bus.'

At this point, women from the family joined in and told me about wearing their best embroidered dresses to the shrine of Nabi Yosha (Prophet Joshua) 10 kilometres away. People from other villages gathered there, too, wearing different costumes. Those from Sa'sa wore a more Bedouin-

Above Back of Hind's costume

GALILEE

Above A filigree silver fish made in Galilee, 1935

Hind had sold her jewellery to help her husband build their stone house in Alma

type of dress, like the clothes of northern Jordan. Villagers from Marus wore dresses of printed fabric without embroidery. Going to the shrine was like a fashion show for them:

'The women of Alma wore gold jewellery bought from Mikhail Shamma'a, known as Abu Farid, in Acre,' they said. 'Even our grandmothers wore gold, not silver, jewellery. We also bought from a Jewish jeweller in Safad, and our coloured silk scarves were from the Old City market of Nablus.'

On a trip to Palestine in the 1980s, I visited my cousin in Acre, and his sons took me around the country. They showed me the Israeli settlement, Alma, built near the site of the original village, now filled with rubble and overgrown with grass and bushes. I wondered which house had been the home of Abu Saher and Hind, the owner of that unique and beautiful costume which I now had. To think that she had sold her jewellery to build one of these houses, now in ruins, with only parts of walls still standing to reveal where doors and windows had once existed.

Acre

During the 1970s, I felt the need to acquaint my children with the part of Palestine occupied in 1948, before the Israeli government irreparably changed its Arab character. We planned a trip to Haifa and Acre, and I looked up old family friends, Jameel and his wife Asma, who were more than happy to receive us. Asma grew up in Acre, where her father was a jeweller. On her way to school each day she would meet Jameel, who was also a student. Asma became a teacher, while Jameel, who had studied history and archaeology, began working as a senior tour guide. They got married and built a house outside Acre's Old City walls, overlooking the sea.

In May 1948, with the Israeli occupation, most of the families in Acre left to avoid the war, but Jameel and Asma stayed in their home. A few months later, they were ordered to leave, when a new Israeli military law barred Arab families from living outside the city walls. They were given a small apartment in an old building within the walls. Asma was in tears whenever she mentioned their former home. 'I am a refugee in my own town,' she said.

Asma told me that as a child, she knew almost every face in the Old City, but this soon changed. The Israeli army emptied the villages around Acre, forcing about 5,000 Palestinian villagers to live in the Old City, where they had to pay rent to the state.

Asma and Jameel took us on a tour of Acre. They showed us the covered *suq*, which had been the jewellery market but was now interspersed with vegetable stands, souvenir shops, etc. She described how the market had been before, when the shops had catered to the surrounding villages. She would see village women in their traditional costumes shopping for jewellery, textiles and spices; there was even a shop that sold exclusively village-style furniture. With the Israeli occupation, this interchange had been destroyed. Perhaps we were seeing the same women, now residing in the city and shopping in the market, but their life had been totally changed, as had the market.

Left Castle gardens, Acre, 1920s

Threads of Identity

Above *Dababeh* (gold bracelet) worn in Palestine during the 1930s and 40s

Right Fabrics used for men's belts in the cities

We went to Hammam al-Basha, a public bath built in 1785, which had been turned into a museum containing a few archaeological pieces. Then we headed for the *khans* which formerly served as inns for visitors to Acre, each with its own stable and water fountain, but everything was badly neglected. Next we visited the Crusader Compound, the Jazzar Mosque, the prison, the city walls and the Baha'i shrine, before having dinner at Khristo's restaurant on the sea. Khristo had been in Acre for 30 years, and his restaurant is a landmark. On the way, we passed many churches, mosques, large old buildings and archaeological sites, but the town with its cobblestone streets and old covered markets had been allowed to decay by the Israeli government.

In the past, Acre's large Palestinian Arab community lived well. Asma showed me photos of family weddings and gave me a costume that had been kept in the family, as well as a headscarf, which I cherish.

I did not visit Acre again, but in 1995, Asma and Jameel came to Jordan and updated us on their life. Over the years, they had had five children. Life in the crowded city of Acre was becoming impossible. Their children received an education but did not find jobs, so the boys left for Germany to study and work. Asma and Jameel decided to move to a nearby village and build a house. Their daughters went into teaching, and Jameel kept busy gardening and beekeeping, while Asma kept house; but she often suffered from ill health. They had come all this way to Amman to hear the Lebanese singer, Fairuz, perform. When I went to see them off, there were seven busloads of Palestinians who had come from Israel for that same concert, eager to make up for the long decades when they had been excluded from Arab cultural events.

Threads of Identity

Acre Villages

Fatma
from al-Damun

During the mid-1980s, I visited Nahr al-Bared Refugee Camp near Tripoli in northern Lebanon with women of the Association for the Development of Palestinian Camps, 'Inaash',[17] that strives to improve the living conditions of Palestinian refugee families. One of the means for doing so was to provide women with embroidery work. At Nahr al-Bared, I met Fatma from al-Damun who was embroidering cushions to make a living. Apparently, Fatma was a very energetic person with exquisite embroidery skills. If her neighbours lacked the time to deliver their embroidery pieces to the centre, she would collect their finished work and bring it along with her own. While she was waiting for her turn to hand in her embroidery work, we started talking. Al-Damun, she explained, was a village in the Acre area, situated on the top of a hill and connected by road to Acre, Haifa and Safad. Most of the inhabitants were farmers as they had the waters of the Na'ani River nearby. People from al-Damun called themselves al-Zaidani after the family that ruled northern Palestine for 50 years. After speaking proudly of her village, Fatma talked about her exodus from Palestine in 1948, when she was 14 years of age:

'The men of our village were preparing themselves along with the Arab Liberation Army [a pan-Arab volunteer force led by Fawzi al-Qawaqji that entered Palestine in January 1948]. They were trying to prevent the Jewish forces from occupying more land when the British left in mid-May. Towards the end of May, the Israeli army attacked al-Damun after occupying Nazareth and Safad. The women and children of the village hid in the olive groves.

'The men soon joined us. Al-Damun was occupied and partially destroyed. A few days later, some men and women went back to the village where they saw that it was completely destroyed and animals were roaming the streets. My brother was one of those who went back. He found our dog and it followed him to where we were. We stayed among the olive and pomegranate trees for two weeks.

Above Nahr al-Bared Refugee Camp, Lebanon, 1948

Right Woman's *qumbaz* in Syrian brocade (circa 1920)

[17] Website: www.inaash.org

GALILEE

'One day we saw a group from the Liberation Army walking towards Lebanon. It was so depressing, it looked like a funeral. From the way they were walking, we understood that the battle was over; they had lost Galilee

Above Galilee, October 1948: Palestinian families driven from their homes walking towards Lebanon

'The war started up again, so we packed our belongings and decided to leave for the village of Sakhnin. We walked in the green valley of al-Rameh, Deir Hanna and al-Mughr, passing streams, mills, pomegranate trees and cactus. Then we heard that Sakhnin had been occupied, so we changed directions to go to al-Buqei'a where we spent September and October.

'One day we saw a group from the Liberation Army walking towards Lebanon. It was so depressing, it looked like a funeral. From the way they were walking, we understood that the battle was over; they had lost Galilee.

'Some of the villages we passed were vacant. People were leaving because of what had happened in the town of Safsaf, where the Israeli army had gathered 40 men in the centre of town and killed them.[18]

'We arrived in al-Buqei'a where we lived for two months in fear and poverty. We were living in deserted houses – all the women together and all the men together. A lot of people passed us in trucks not knowing where to go. The men from our village believed we would be going back to our homes, so they wanted to stay in the area. The Liberation Army was still present in some places. Whenever the Israeli army won a battle, a truce was enforced during which they would take more land, and send trucks with loudspeakers around the villages calling on people to leave. My family was with a group of about 50 people who started walking towards the Lebanese border because the Israeli army was attacking Tarshiha, which was where we wanted to go.

'After a few days at the border, we crossed into Lebanon and headed for Ramesh, but found it very crowded, so we continued on to Bint Jbail where we stayed in the mosque. The second day the men found a two-room house for us. When we got there, we realised that

[18] According to Walid Khalidi (*All That Remains*, Washington, 1992, p 491), 52 men were tied up, dropped into a well and shot.

Above Bridal kohl holder (circa 1900), and reed flutes from Damun

the house had no water. We moved again to where other refugees had gathered. They put us on trucks and drove us to Tyre where we were put on a train. Many rumours were circulating; one story was that they were sending us north to Aleppo, Syria.

'At the border, the Syrians would not accept us and we were sent back to Tripoli, Lebanon. There we stayed in train compartments. People and organisations in Tripoli were very helpful and provided us with food and water. Then we were ordered to leave the train and a group of 50 of us from the same area was sent to a hangar where we stayed until January 1950.

'The people of al-Damun were clever in working with reeds; they wove mats and baskets, and made flutes. We found reeds nearby and made large mats to use as room dividers and put on the floor. Living in the hangar was the most difficult part of our journey, but the men still believed we were going back to al-Damun.

'During the year we spent in the hangar there was no medical care, and my baby sister died. All through the trip my mother had been the backbone of the family; she was very patient and a good manager. Out of dry bread, she would invent a good meal for all the family. But she broke down and cried continuously when she lost my sister. We couldn't understand what was happening to our mother.

'At the beginning of 1950, orders came for us to be moved again, this time to a new camp which came to be known as Nahr al-Bared. We went there, but many people remained scattered over the area until 1951 when another camp, Baddawi, was constructed east of Tripoli.

'We started to adjust to life in the new camp. It was better than the hangar because we had more privacy, but it was very difficult to live without work and money. Summer and winter, the children went to school barefooted or in plastic sandals. Reeds were available at the river and the men still made flutes, but this musical instrument, which had been for festivities and special occasions, now sounded very melancholic to us, for it was our connection to al-Damun.

'Because we were living among so many Palestinians and sharing similar problems, a sense of togetherness developed among us. This helped us to live with the problems – the open sewage canals between the houses, muddy floors, dirty water, etc. Despite all the time and work required to deal with such problems, the women often gathered together in the afternoon and discussed current events, like the incessant Israeli air attacks, or the plight of the children, the unemployed men and our situation as stateless refugees.

'Thanks to the ladies at Inaash, I learned the Galilee stitch and I embroider for them now and make some money that way. I never got married, but I am in a better situation than my friends who did. It is about 40 years now that we have been in this camp. It has become more crowded and there is even more unemployment. We are living in the hope of our right to return to our land in al-Damun. No one can take this right away from us, or from our children and their children. Refugees' right to return is supported by international law, and the same law makes it illegal to occupy another people's land. As you see, this camp does not solve the problems of the refugees. It only creates other problems.'[19]

Left *Tabaq* (straw mats) made by women in Palestine, especially Galilee, used to place dishes on for meals

Above House keys kept since 1948 as a proof of ownership

[19] A special note of thanks is due to Hussein Lubani whose excellent book, *Al-Damun* (Dar al-Arabi, Beirut 1999), made me even more appreciative of Fatma's interview and her tragic exodus.

Iqrit

Abu Elias
exiled from Iqrit to al-Rameh

Above Abu Elias from Iqrit, 1972

My husband Kamel's aunt, Emily, was married to Dr Elias Deeb in al-Rameh, a large town in Galilee. In 1972, we went to visit her with our four children. It was an ordeal to get a permit to travel from Jordan to Bethlehem to see my parents, so once there, we wanted to see as many relatives and places as possible.

Al-Rameh lies amidst an abundance of old olive trees. When he was showing us around their home, Emily's husband showed us a large well filled with olive oil, rather than water. The well had been used as an olive oil store by his grandfather who used to donate oil to all the neighbouring churches. Their olive oil was the best, he said.

We were taken all around al-Rameh and the surrounding area. By chance, I met a community living in al-Rameh who had come from the village of Iqrit. I thought it would be an opportunity to interview women about their costumes. However, the men did not give the women a chance to talk. They spoke first and they had a lot to say. The most articulate of the group was a man named Abu Elias.

This is the story of Iqrit, as he told me:

'The village of Iqrit was situated near the Lebanese border, connected to Acre by the highway. Historically it was linked to Tyre, Lebanon, and was occupied, along with Acre, by the Crusaders. Most of us were Greek Catholics and we farmed and raised livestock and were well-to-do. Iqrit stood on a hill, at the top of which was the church. Oak and pine trees surrounded the town's farmland. Some of the old houses on the hill had beautiful mosaic tile floors which dated back to the Byzantine period. There were many wells that were still in use, and the town was famous for its old wine press.

'When the 1948 war came, we decided to stay in our village and not fight. At the end of the year, Israeli soldiers came with trucks and

Every few years, our case comes up in the Israeli courts, but each time we are disappointed. Even if the civil court accepts our demand to return to our village, the ruling will be overruled by the military court

Above People from Iqrit in front of their church, the sole remaining structure in their village which they can only enter for funerals

told us that we had to leave temporarily, but would soon be allowed to return. We gathered some personal belongings and were taken away, some of us to the Lebanese border, and others came here to al-Rameh.

'Since 1948, we have been pleading with the Israeli authorities to let us return, but to no avail. We are only allowed to go to Iqrit's church for funerals and to bury our dead in the cemetery. Every few years, our case comes up in the Israeli courts, but each time we are disappointed. Even if the civil court accepts our demand to return to our village, the ruling will be overruled by the military court.

'Please write about our case in the Arab press,' said Abu Elias. 'It is unique in history. We see our tumbled-down houses when we go to church, yet we cannot go near them. I can only go back to my village if they are taking me to be buried in the cemetery.'

I was overwhelmed by the story of Iqrit. When Abu Elias finished talking, I was in a daze. For a moment, I was still in Iqrit. I did not have the heart to ask these people about their costumes and jewellery. It seemed so unimportant compared to the story I had heard. I thought it could be postponed, but unfortunately, there was never another chance.

Collection *Galilee Area*

GALILEE

Left Detail from back of a linen *jellayeh* from Galilee (circa 1880)

Above Silver disc worn over a *fez*, made in Syria, worn by Druze women

Threads of Identity

Both pages *Jellayeh hamra* (red dress) with patchwork on front and cross stitch on back. Flowers were later added (1930) to the front by machine embroidery. One of the rare pieces that survived from this area (circa 1880)

GALILEE

THREADS OF IDENTITY

Both pages *Jellayeh* worn over *shirwal* (embroidered trousers) of indigo-dyed, handwoven cotton (circa 1900)

GALILEE

THREADS OF IDENTITY

Above Handwoven and lined, cotton *jellayeh* from Shafa Amr (circa 1890)

GALILEE

Above left Silver necklace with filigree medalions

Above right Silver bracelets of the style worn in Galilee

Below *Karameel*, silver decoration to cover the end of a hair braid

317

Chapter 11

Nablus

Nablus is a region that is rich in agriculture and industry, closely linked to the nearby areas of Tulkarem, Qalqilia and Jenin, and encompassing villages such as Anabta, Dannaba, Jaiyus, Deir al-Ghusun, Jiljuliya, Bal'a, Attil and Shweikeh.

Left Nablus in the 1930s

Above *Koota* (hanging sewing basket) of straw, wool and silk to hold needles and thread, made by women in the Nablus area

Women from Nablus villages would usually say that they worked hard in the fields alongside their families and had no time for embroidery

Left *Qabeh* (chest panel) of Tulkarem dress of light voile cotton with embroidery only on *qabeh* (circa 1945)

Above Im Amin from Qalqilia wearing *thob muraddan* with silk belt typical of Nablus area, 1970

The most common attire in Nablus villages used to be a short-sleeved, velvet or silk coat worn over a simple, long dress of transparent white gauze with a wide silk belt knotted at the front. Under the dress, women wore long, coloured trousers which were intended to show through the gauze. On their heads, they wore a *saffa* (horseshoe-shaped headdress) with gold coins bordering the face. A rolled silk scarf of red or green was tied around the headdress.

Fatma Samara from Anabta, who lived in Amman, was my main source of information on the costumes of the Nablus region. Her mother-in-law also contributed clear descriptions. According to Fatma, the cut of the costumes was similar throughout the area, but different fabric and colours were used in different villages. Embroidery was limited in this region, with only a little cross stitch around the yoke of the dress, which was made of transparent white gauze. In some villages between Ramallah and Nablus, embroidery was altogether absent. Women from these villages would usually say that they worked too hard in the fields alongside their families and had no time for embroidery.

THREADS OF IDENTITY

Nablus was mentioned by many Arab geographers and historians in the past, all of whom described the city's beauty and the industriousness of its inhabitants

Above Old City of Nablus, 1940

Below Shaka'a soap factory in Nablus with soap piled in stacks to dry, 1920s

City of Nablus

Situated between two mountains in central Palestine, Nablus is a 5,000-year-old city, with a rich history and tradition. The ancient parts of the city have been continuously inhabited, with renovations being made over the years to add modern conveniences. Lying on a caravan route, it has always been a trading centre. Being surrounded by fertile land and having plentiful water resources helped to develop a variety of industries in the city. In the past, Nablus was famous for its soap, olive oil, goat cheese, *halaweh*, sesame and black cumin oil – products that were exported to neighbouring countries.

Nablus was mentioned by many Arab geographers and historians in the past, like Ibn Battuta (1355), al-Maqdisi (1529) and al-Nabulsi (1730), all of whom described the city's beauty and the industriousness of its inhabitants. Many armies occupied Nablus and then departed, leaving behind a heritage of ancient buildings, including castles, baths, churches, mosques and marketplaces. During Ottoman times it was an industrial and commercial centre, and also became the residence of some European honorary consuls.

By continuously living in Nablus, people have preserved every part of it, especially the Old City, called the Kasbah. In the heart of the Kasbah is Khan al-Tujjar, the Merchants' Inn, the covered part of a long, shop-lined street that runs through the whole town and is the centre of the old market, also called Suq al-Sultan. There are two mosques, simple rest houses serving as hotels, water fountains, public baths, etc. The covered market houses Suq al-Qimash, the fabric market, that used to sell textiles imported from Damascus. It also encompassed workshops for tailoring, quilting, weaving of *abayas* (cloaks), woollen saddles and horse blankets, leatherwork (shoes and belts), and bridal accessories such as head shawls, jewellery and round coloured bars of soap. In this street were also the traditional sweet shops selling *kenafa*, *tamreya* pastry and *zalabya* (fried balls of dough dipped in sweet syrup).

THREADS OF IDENTITY

Left Traditionally dressed bride of Nablus area, 1870s

Above *Asawer mabareem* (silver bracelets) from Nablus also used in other areas

Below *Habbeyyat* (silver bracelet) made by Qirri in Nablus

In the old market, one always saw groups of villagers doing their wedding shopping. It resembled in many ways *Suq* al-Hamidiyeh in Damascus, which also originated as a market for bridal shopping.

After the Israeli occupation, Nablus was cut off from Syria and other parts of Palestine, this old suq lost much of its original richness, and many of the shops that remain now sell imported, used clothing. In the spring of 2002, the Israeli invasion and reoccupation of the West Bank inflicted heavy damage on the Old City destroying many shops.

On a visit to my parents in Bethlehem during the late 1960s, I learnt that my school friend, Qadar Masri, was also in Nablus visiting her family. So off I went to meet up with her in what turned out to be a journey into the past.

Qadar's sister took me to the most famous jeweller in Nablus, who was a woman. Every bride in the Nablus area knew Majeedeh Abed al-Nour. She had inherited the trade from her father, and carried on the business with her Armenian partner, serving the whole area. Her jewellery was of a high quality and distinctive design. I was also impressed by her warm, strong personality.

Threads of Identity

Above left A couple from Jenin; the wedding dress is trimmed with lace, not embroidery, and topped by an *atlas* silk cloak, 1940

Above right Wedding picture of Taha Taher and Shahera Hashem, Nablus (circa 1950)

Right Silver fish were worn in Nablus area and throughout Palestine

Other jewellers who worked in Nablus in the first half of the 20th century were Zakharia, Salfiti, Asfour, Durzi and Qirri. Each catered to the taste of specific towns and villages. Much of their work was filigree, especially fish-shaped pendants, *kirdan* (chokers), *hebbayyat* (bracelets) and *karameel* (silver or gold pipe-shaped hair ornaments to put at the end of braids). In the mid-1930s, many of the silver pieces were replaced by gold.

Qadar also took me to all the old mosques, the Byzantine church and the soap factories of the old *suq*. Prior to 1948, there were as many as 30 soap factories.[20] We also visited Hammam al-Beyk, the public bathhouse located on the Tuqan family's property. Other public baths in Nablus, which date from the Roman, Mamluk and Ottoman periods, were Abaza, al-Eker, al-Shifa and al-Reesh, all built over water springs.

[20] By 2008 there were only two soap factories left, owned by the Shaka'a and Tuqan families.

THREADS OF IDENTITY

Above *Bukjeh*s were large scarves used to wrap clothes and bath needs. They were made in Damascus, early 20th century

Right Modelled Tubas village old costume from 1912, given to the author by Greta Tuktuk

The *hammam* was an important social centre in former times. Men and women would go on separate days. Children were known to climb up on the roof to peek through the circular, coloured glass windows on the dome in order to catch a glimpse of the bathers. The famous Nablus soap was mixed with herbs, like basil and sage, to soften and scent the skin. Certain textiles were imported from Hama, Syria, especially for use in the bath. Every woman had a silk or velvet *bukjeh*, a square embroidered cloth for wrapping the items to be taken to the *hammam*.

Besides caring for their personal hygiene, the bathers engaged in making plans for forthcoming weddings and other festivities. Older women were constantly on the lookout for young girls who might make suitable wives for their sons. Women socialised, gossiped and engaged in matchmaking while undergoing beauty treatment, all the while showing off their *wazras* or *bukjehs*.

NABLUS

THREADS OF IDENTITY

Wardeh
from Qalqilia

Above Im Amin, Wardeh, from Qalqilia 1970

Right Velvet coat worn over a long white dress in Nablus area, and also in Qalqilia, Anabta and Atara (circa 1940)

In 1987, my late father spent some time in the al-Maqassed Hospital on the Mount of Olives in Jerusalem and I would visit him every day. In the room opposite his was Wardeh, a woman in her late 80s from Qalqilia. When she was not in pain, she was embroidering. When I asked about her embroidery, Wardeh explained that it was not for her but for friends in the Ramallah area. She proudly explained that it was not the tradition of women in Qalqilia to embroider their costumes, yet their dress was just as elegant as that of the Ramallah women who spent so much of their time embroidering. When I asked her why she was embroidering, her answer was simply that she could not stay idle.

With each passing day I would find that she was becoming more eager to chat with me about her past. I felt that I had opened a precious part of her that had been shut. Her father was a big landowner, and according to her, their land was 'the most fertile in the entire Arab world', and they were the best farmers. She would repeat that their land was gold and it gave them gold. Everyone worked in the fields – men and women, young and old – cultivating citrus, cereals, flowers and other crops. They had wells to fall back on when rainfall was insufficient.

Wardeh married her second cousin. She was happy because she always had liked him, and he owned good land. After their formal engagement, they went to the Nablus market for their *kisweh* (wedding shopping). Wardeh remembered in detail what she had bought: white *rosa* silk and three pieces of cut velvet for her traditional dress, which opened down the front, and a large silk belt, purchased by weight. For her head, she bought a green scarf, a longer scarf for special occasions, a band of gold coins, and silver *karameel*. From Zakharia, they bought broad silver bracelets and chokers. They also purchased a piece of silk (*ikat*) for trousers to go with her costume, as well as for cushions and quilts. Then on to the *attareen* (perfume sellers) and spice market to buy henna, cloves for necklaces, indigo, herbs for tea and amulet beads for protection from evil.

NABLUS

331

Threads of Identity

Wardeh was sure, however, that the Qalqilia-style dresses were nicer than all the others she saw which were closed at the front and gathered at the waist

Above Syrian silk *shentian* (trousers) worn under a dress by women from Nablus and Tulkarem

In the course of that day, Wardeh came across women from other towns and villages, such as Sabastiya, Deir Sharaf, Jenin, Jaiyus and Kafr Qasem, who were also shopping for their weddings. She was sure, however, that the Qalqilia-style dresses were nicer than all the others she saw which were closed at the front and gathered at the waist. By contrast, Qalqilia's dresses opened at the front from the waist down; women were proud to show the long trousers they wore underneath.

Once married, Wardeh lived with her husband's family and worked at home and in the fields. In 1948, half of their land was occupied by the Israeli army, and their well was taken away. They quickly obtained a permit to dig a new one. At night, they sometimes went and picked fruit from their orchards which had been occupied, but this was very dangerous. Meanwhile, Wardeh had four children.

In the 1967 war, all of Qalqilia was occupied. Their wells no longer belonged to them, their produce was heavily taxed,

and the possibility of marketing their produce in Jordan became very limited. Conditions worsened as a large number of people were left with smaller plots of land; some were unable to farm, but Wardeh's family stayed.

'I tended my herb garden next to the house and my two goats, besides helping the family work the farm that was getting smaller and smaller. I wove many straw mats and baskets and sold them, and taught my daughter how to make them. I'm happy we stayed in our town and didn't leave our fertile land. I sold the gold coins I got at my wedding to help my sons when they married.'

A few days later, I looked into Wardeh's room and saw her bed was empty. I was told that she was well enough to leave and I was relieved to know that she had left the hospital for her home in Qalqilia.[21]

Above Nablus headdress, with a scarf wrapped around it and tied to the side

[21] The situation in Qalqilia has worsened dramatically since I met Wardeh. In the 1948 war it lost 40,000 dunums (80%) of its land, and 75% of its population became refugees. Between 2004 and 2008, Israel confiscated half of the remaining land, while encircling the town with the separation wall. This 8-metre wall separates Qalqilia from both Israel and the rest of the West Bank. A locked gate is opened only at certain hours.

Threads of Identity

The *Janna wa Nar* (Heaven and Hell) dress of Asira and Tubas villages

During my trip home to Bethlehem in 1970, I was invited to visit Siham, a married cousin who lived in Nablus. While visiting her with my children, two lovely women brought us lunch. It was *musakhan* (chicken with onions and sumac, on white bread). These women were from the villages of Asira and Tubas, and I jumped at the opportunity to ask about costumes there. They told me that their mothers had worn dresses called *Janna wa Nar* (Heaven and Hell). It was made of white, handwoven fabric with stripes of red and green on each side; the red was for hell, the green for heaven. This costume had a little patchwork around the yoke and a *tarabulsi* (thickly folded silk belt with a large knot in front).

On other trips to this area, I visited Tubas and learned more about the *Janna wa Nar* costume. Yet, I could never obtain one for my collection. Back in Amman, in 1972, my friend Greta (Mrs Sami Khoury) gave me such a costume, along with the headdress and scarf that went with it. The dress was her mother's, which was a surprise to me because I knew her mother was British. However, when Greta's mother was a volunteer nurse in 1920 at the Anglican hospital in Nablus she had a patient from Tubas who made the dress for her as a present. Later, she married Dr J Tuktuk, the director of the hospital, and eventually, she passed the dress down to her daughter, Greta. This is the sole dress I was able to obtain from this region and I am greatly indebted to Greta.

Left *Janna wa Nar* (Heaven and Hell) dress worn in Anabta, Asira and Tubas, so-called because of the red and green colour of the pleats on the skirt, the silk stripes down the front, and the appliqué on the sleeves and hem (circa 1915)

THREADS OF IDENTITY

Collection *Nablus Area*

Left *Qabeh* of "Heaven and Hell" dress, 1912

Above *Hidim* (coat dress) costume from Tulkarem and Qalqilia area, made of *nawa'eer* (satin *atlas* fabric) with cord trimming (circa 1930)

THREADS OF IDENTITY

Both pages *Hidim* or *qumbaz* (coat dresses) of the Nablus area, 1930-1940s

NABLUS

الحاج أمين الجفار وأولاده

Nablus

Left *Ikat* fabric made in Damascus

Above *Hidim* (coat dress) of the Nablus area made of *atlas* satin *ikat* (circa 1930)

Chapter 12
Gaza

Gaza has always been at the crossroads of civilisations. Standing on the southern frontier of the land of Canaan, it formed a strategic border with Egypt. It was one of the five royal cities of the Philistines. Between the 2nd and 3rd centuries AD, it was a commercial and cultural centre within the Roman Empire. As the chief trading post for frankincense from southern Arabia, Gaza flourished during the Byzantine period. During the 7th century, many people in Gaza adopted Islam. At the beginning of the 12th century, Gaza was occupied by the Crusaders until freed by Salah al-Din. It was subsequently ruled by the Mamluks, and then the Ottomans, despite a brief period in 1799, when it was taken over by Napoleon. The Ottomans were defeated by the Allied forces during World War I, paving the way for British rule.

Left The seashore of Gaza, 1930s

Above Gaza headdress with rows of Ottoman coins in front and embroidered *lafayef* at back to wrap around braids (circa 1950)

THREADS OF IDENTITY

Above Gaza City, 1930s

Below Ancient boundary line between Palestine and Egypt at Rafah, 1920

Above Rushdi Shawa, mayor of Gaza City (1938-1951), and his wife, Shafeeqa Husseini, with their eight children, 1940

Gaza was a market centre on the edge of the desert, endowed with fertile land and a good harbour. It also had abundant fresh water sources to sustain extensive orchards and cereal cultivation. For centuries, Gaza was known for its production of dark-coloured pottery, rugs and camel hair cloaks, and villagers from the surrounding area shopped for textiles and jewellery there.

From Gaza, caravan routes branched out in many directions. The urban population and the Bedouin tribes cooperated in this commerce. Pilgrims converged there before setting out for Mecca for the annual pilgrimage. Gaza City was surrounded by many other important towns and villages and formed a league known for extensive trade connections along with Ascalan, Faluja, Isdud, Tell es-Safi and Majdal. Other significant towns and villages of the area included Beit Lahya, Yebna, Hamama, Khan Younis and Rafah.

THREADS OF IDENTITY

Left Gaza village women in typical striped costumes

Above Detail of Gaza village costume with embroidery and colours which are different from villages in other parts of Palestine (circa 1930)

During the 1948 war, many of these towns and villages ceased to exist or were changed radically as their native inhabitants were driven out. Some were totally destroyed whereas others were renamed and turned into Israeli towns. Several remained Palestinian, but were flooded with refugees from other areas of Palestine, whose own villages were destroyed or taken over by the newly created Israeli state.

Traditionally, the fabric for Gaza-area costumes was woven in Majdal. The village *thobs* had a variety of cuts, from the wide costumes in Faluja to a slim cut in Isdud. They were decorated with large blocks of embroidery in geometric patterns done in shades of pink, red and orange, sometimes accentuated with silk patchwork on the front, sides and sleeves. City women in Gaza never wore a traditional *thob*. They had their own style, which consisted of a full black skirt worn over a simple gown and a short cape over their head and shoulders.

THREADS OF IDENTITY

Above Majdal-area festive dress, silk patchwork on Majdal cotton (circa 1925)

348

Majdal

For centuries, Majdal was Palestine's weaving centre. There was a loom in every home, and the town's cotton, silk and linen cloth was sold in city markets throughout the country. Majdal weavers provided a great variety of special fabrics, catering to the particular costumes and headdresses worn in towns from north to south. The most common type of fabric they produced was plain dark cotton, with panels of colour woven into the selvedge, and with silk warp and cotton weft. As the principal town between Gaza and Jaffa, Majdal was also the site of a big market every Wednesday.

Abu Issa and other Majdal weavers in exile

In 1968, in Amman, I met Abu Issa, one of the best known Majdal weavers. He was enthusiastic and proud. Every time I interviewed him, he would gather other weavers from Majdal. These men were not about to yield to their difficult circumstances, so most of them had started weaving again in Amman. Due to a shortage of space they used pit looms rather than upright ones. They produced beautiful textiles and even introduced new colours. For a while, most of them did well. Abu Issa would recount to me the names of other Majdal weavers who had had to leave their towns, but remained in Gaza as refugees in the Jabalya Camp. In recent years, the production of Majdal textiles has dwindled since most of these weavers are getting on in years and the skill has not passed on to the new generation. Aside from the decreasing demand, weavers in refugee camps are unable to market their products because of Israeli-imposed border closures.

THREADS OF IDENTITY

Previous pages Detail of Gaza-area dress of *beltaji* fabric woven in Majdal, showing *akeedeh* (connecting stitch) in yellow and red thread particular to the area (circa 1938)

Above Isdud costumes in Majdal handwoven fabric (circa 1935)

Right Detail from the dress above showing *mukkas* (scissors) pattern typical of Gaza dresses

352

Isdud

Isdud was another one of the Philistines' five major cities, known for extensive commerce. In the 18th and 19th centuries, travellers would stop to rest on the road between Ramla and Gaza in Isdud's well known *khan*. In 1912, German traveller Karl Baedeker stopped in Isdud and described the town's beautiful location on the slope of a hill; he estimated the population at 5,000. In the 1948 war, the inhabitants were driven out and the town was incorporated into Israel and renamed Ashdod.

The costumes of Isdud and surrounding villages were very different from other parts of Palestine. They were made from fabric woven in Majdal, usually dark blue with pink and green silk stripes on the sides, called *beltaji*, or with one pink stripe on each side, called *jiljily*. The dresses had a narrow cut and straight sleeves, a V-neckline and an embroidered, V-shaped chest panel and were worn without a belt. Rather than being in rows, the embroidery on the sides of the costumes was arranged in large blocks and done in shades of pink, as elsewhere in Gaza. Everyday dresses were very simple; sometimes there was only a little embroidery in the shape of an amulet near the neckline. There was no embroidery on the rest of the dress, but a connecting stitch, special to this area, was used on the seams.

THREADS OF IDENTITY

Hasna
from self-sufficient farmer to refugee

In the early 1970s, I met Hasna in the Baqa'a Refugee Camp outside Amman. She was taking her children to the YWCA-sponsored kindergarten and I was there to join friends who were volunteers there. Hasna's story is not unlike those of other refugee women. It includes dispossession and a long march towards the unknown. It also includes strife, resilience and survival. Hasna's dignity and fond memories of her family and her community in Isdud gave her the strength to face adversity.

She married young and was widowed young, left with four children. Together with her husband's family, she farmed their land which had two wells to use for irrigation. They were able to produce enough to live well and send her children to school. In the 1940s, their main crops were wheat, citrus fruit and bananas. Villagers from all around the area were attracted to Isdud on Wednesday which was market day. Moreover, having a railway station made it easy for people in Isdud to transport their produce.

Other relatives worked in handicrafts. Hasna's uncle came from a family of felt-makers. Using a difficult, time-consuming technique, they pressed wool to produce the felt used for items such as rugs, jackets and hats. Her other uncle produced black pottery. They loaded their products onto camels and sold them in other villages. But then, Hasna recounted, came 1948:

'In May 1948 there were constant battles all around us between the Israeli forces and the Egyptian army. The young men of our town helped the Egyptian forces as much as they could. This went on until October. Then there was a heavy Israeli attack on Isdud from the sea. The Egyptian forces and many Isdud residents left town, heading southwards. Our family decided not to leave, and my father-in-law took my older son and went to the mosque for safety, since it was expected that males would be targeted first. The rest of us stayed at home.

Above Pottery-making in Gaza area 1930s

Right Popular pottery still produced in Gaza

GAZA

Threads of Identity

Above Festive *jellayeh* costume, linen with *heremzy* silk appliqué and cross stitch with typically large Gaza patterns and colours (circa 1935)

When they came to us, my mother-in-law pleaded with the soldiers; she offered them dates and figs. They ate these, then pushed her around

'Later we learned that a few hundred people had stayed and had put white sheets over their doors but these were mostly older people; none of the youth who had fought remained. Suddenly one morning Israeli soldiers appeared and went from house to house, expelling people from their homes. When they came to us, my mother-in-law pleaded with the soldiers; she offered them dates and figs. They ate these, then pushed her around. In a short while, we were kicked out of our home.

'Hurriedly, each of us collected a few of our personal belongings which we wrapped up in sheets. I packed three of my best costumes. We left Isdud some time in October 1948 and arrived in Faluja in November where at first we stayed in schoolhouses with other refugees.

'When I noticed women wearing costumes different from ours I realised that the people of Faluja were refugees just like us. Our costumes in Isdud were made from **beltaji** fabric handwoven in Majdal with two pink stripes on the front and back. The costumes were narrowly cut and we wore them without a belt. The women of Faluja had very wide dresses and brightly coloured belts. They were wearing all their jewellery. Probably they planned to sell pieces of it at some stage. We, on the other hand, never wore jewellery because we embroidered jewellery patterns directly on our dresses, like **qalayed** (necklaces) hanging down below the neck opening.

'After some time, we were happy to learn that a truce had been signed. But then the Israeli army came and we were again forced out. Those who objected were beaten, regardless of their age. We were then driven towards Hebron. All the villages we passed on the way had been evacuated. My father-in-law died on the way. The men buried him near Beit Jibrin.

'In Hebron we were placed in mosques and schools, and then taken to a refugee camp called Aroub, between Hebron and Bethlehem. The years from 1949 to 1955 were very bad ones; we lived on rations from UNRWA and we had no work. At least the children went to school in the camp.

'Then I began doing embroidery work for a foreign organisation, and they liked my work and asked me to embroider the Isdud patterns on table runners. The money I earned was sufficient and my mother-in-law was a great help as she took care of my children while I embroidered to make a living.

THREADS OF IDENTITY

Both pages Front and back of a festive linen *jellayeh* with *heremzy* silk front panel and sleeves from Beit Jibrin area (circa 1925)

GAZA

My favourite pastime these days is gathering my grandchildren together and telling them stories

'Life in the camp was very difficult. The one thing that brightened my life was my son finishing school. I planned to send him to a teacher-training college in Bethlehem, but this was in 1967. As the war started, our camp was bombed by Israeli planes. People in their thousands started heading for Jericho, but the Israeli planes continued to drop napalm over the crowds. When we reached Jericho, we were shocked to see that the refugee camp there was also emptied. We continued walking. This nightmare ended in Jordan, in the Baqa'a Refugee Camp.

'Baqa'a was very cold and muddy and there was no work for me in this region. My son, who finished school with high grades, got a job keeping accounts for a bakery and brought home bread and some money. Later on, he married a girl from Faluja who worked at a sewing centre. When they had children, I took care of them so she could continue working. My son took on additional jobs, keeping accounts for different shops.

'My daughter married a young man from Beit Jibrin. On her wedding day, her mother-in-law gave her a costume from Beit Jibrin. She proudly wore it during one of the wedding celebrations.

'My favourite pastime these days is gathering my grandchildren together and telling them stories about Isdud and our fertile farm in our homeland. I often take out my old dress and allow my granddaughters to wear it. They look adorable in the oversized dress and it gives me joy to see them happy and giggling, saying that they look like Grandmother. I was happy when our neighbour, who is a teacher, decided to teach the Isdud embroidery patterns in her sewing class. When I go to these classes, I take along my three costumes which I have carried with me all my life.'

Left Back panel of an old dress from Gaza area (circa 1910)

Above Child's amulet, agate stone with Ottoman coin and two frogs, to protect from disease

THREADS OF IDENTITY

Summail

Fatma Jaber
of Summail village

Above A family from Summail showing Fatma's aunt seated in the middle, 1948

Right Festive *Thob Irq el-Loz* (Branch of Almond Blossoms dress) from Summail and Berqosia, linen with *heremzy* patchwork, *rasheq* embroidery (village couching) with some cross stitch (circa 1920)

One of the most attractive costumes in my collection originates from Summail, a village south-east of Gaza City. Situated between Beit Jibrin and Majdal, Summail was a Crusader outpost, the site of a Crusader church and a very old mosque. It was an agricultural village, but was totally destroyed by the Israeli army in 1948. The land of Summail became part of Israel and its population became refugees.

I met Fatma Jaber through her son, Ribhi, in Amman. He has been selling me costumes and jewellery since the late 1970s. He is a virtual encyclopaedia on Summail and its traditional dress, and can quote numerous proverbs on the subject that he learned from his mother.

When his mother died in 1990, I was lucky enough to acquire her particularly exquisite dress. It has a special name: *Thob Irq el-Loz*, meaning 'Costume of the Branch of Almond Blossoms'. It combines Majdal fabric with Syrian silk in orange, red and green, with *rasheq* and cross stitch all around. I have not seen this combination anywhere else in the Gaza region. It is unique.

I was fortunate to meet Ribhi's mother, and she told me how her costume came to be. As a young bride, she had bought the fabric in Majdal and embroidered it herself. She applied more *rasheq* than usual because she wanted her dress to be different and she embroidered the pattern of an amulet to ward off the evil eye of jealousy for she knew that when she wore this costume, it would be the most beautiful one in town.

Fatma told me her story of how she had left Palestine:

'The Israeli army attacked Summail one week after the British left. My husband instructed me to take our baby and daughter to Faluja, leaving our two older boys with him. I knew Faluja well, since I had often bought fabrics and thread in the market there.

'With my baby and daughter, I went to the family of the merchant, Abu Radi, who used to buy our products. He took us to his home

GAZA

Threads of Identity

GAZA

Fatma's dress has a special name: Thob Irq el-Loz, meaning 'Costume of the Branch of Almond Blossoms'

Left *Qabeh* (chest panel) of same dress, in patchwork (circa 1930)

Above Detail of same dress showing amulet pattern in *rasheq* embroidery

where there were already other refugees. A week later, Abu Radi told us to get ready to leave as the Israelis were approaching Faluja. We all worked together to prepare bundles of bread and water. All the women and children got in his truck with him and his brother. They didn't know where to go as all the roads were blocked except for the one to Hebron. After some time, I managed to get to al-Aroub Refugee Camp where we were joined six months later by my husband and sons. Life was very difficult at the camp, so in 1965 we decided to join my brothers in Jordan. We rented a place in Jabal al-Jawfah quarter of Amman. Ribhi, my youngest son, started selling vegetables and besides making some money, he brought vegetables home to us.

'In 1973, I learned that my elder brother was buying costumes from the people of Summail and selling them. My son, Ribhi, went along with him a few times and also accompanied Aysheh, a Bedouin woman who collected costumes.[22] This is how Ribhi entered the trade. He would bring the costumes he bought home and I would clean and iron them. He would then go out to sell them. He did well and never went back to selling vegetables.

'The Summail costumes were of superior quality compared to those of our neighbouring villages. The **qabeh** *(chest panel)* was divided into five parts, each embroidered in a different pattern. The front of the skirt was adorned with patchwork in Syrian silk. Ribhi wanted me to keep some of the Summail costumes which he bought, but after my husband died, I stopped wearing coloured costumes and only wore simple, embroidered black dresses.'

Ribhi still collects costumes for me, mostly what I call the 'new dress' – post-1948 costumes. He has promised to give me first choice of the costumes he buys from older women. For this privilege, I have to be ready to receive him whenever he likes, which is usually at 7am. When he is in the mood, Ribhi also entertains me with proverbs and songs about the costumes.

22 This is the same Aysheh whose story is in chapter 9.

Collection *Gaza Area*

GAZA

Left Necklace of old Roman, Venetian and Islamic beads collected over the years, worn for protection, passed from mother to daughter

Above *Kowkaba jellayeh* decorated with silk ribbons in the middle, shaped like roses (circa 1910)

THREADS OF IDENTITY

Both Pages Front and back of an old dress in a mixture of styles from Ascalan and Beit Daras (circa 1910)

Right Detail of a side panel of the same dress

368

GAZA

369

Threads of Identity

Above Front and back of a dress from Beit Hanun and Beit Lahya (circa 1935)

GAZA

Above Isdud-area dress; each side panel has a *qaws* (arch) at top and bottom, and *wesadeh* (cushion) pattern in the middle (circa 1935)

Threads of Identity

Above Headdress of Faluja-area villages showing Bedouin influence in the hanging *sfeefeh* with coins and tassels (circa 1925)

Above right *Ghudfeh* (linen shawl) from Qastina (circa 1910)

Right Qastina village dress, linen, silk cross stitch embroidery, one of few white dresses from Gaza area (circa 1910)

GAZA

Threads of Identity

Above Front and back of a rare dress of Tel al-Safi village, near Beit Daras, linen fabric, silk patchwork and cross stitch embroidery. Yellow colour on sleeves shows that it is old because they used yellow silk earlier than orange silk (circa 1920)

Below left Silver bracelets made in Egypt for villages in Gaza area

Below right Rare, old handwoven woollen felt rug from Isdud, Gaza area (circa 1900)

GAZA

Left Dress worn in Masmeyeh and Qatra villages, Majdal fabric, silk patchwork and *rasheq* embroidery (circa 1930)

Below Front and back of festive dress from Aqir between Jaffa and Gaza (circa 1925)

Chapter 13

Southern Palestine

For centuries, the Bedouin of Southern Palestine moved about freely in the Naqab and Sinai deserts, for there were no fixed boundaries during the Ottoman period.[23] After World War I, the British Mandate authorities established borders that restricted their movement. By that time, they had already begun a semi-sedentary life, farming in one place for part of the year, before moving on to better pastures.

[23] The Naqab (Negev) in Southern Palestine stretches between Bir Saba', the Sinai and Aqaba in Jordan.

Left Bedouin couple, 1900s

Above Gold nose-ring with blue beads worn by married Bedouin women

Southern Palestine

Left *I'del* (handwoven Bedouin bag) with black and white *saha* pattern that appears throughout the Belad al-Sham region

Above Bedouin camel rider on a handwoven saddle, 1930s

The Bedouin, who were usually armed, were led by tribal sheikhs. These leaders were sometimes powerful if their tribe was large, but their power waned with the emergence of a central government. While each tribe moved about in a specific area and considered this territory its own, legal rights to the land were never established. As their power and freedom of movement declined under the British Mandate, they were increasingly pushed aside to make room for government plans and Zionist colonial projects.

In most Arab countries, Bedouin women's costumes tend to be simpler than village ones. There are, of course, reasons for this: the village population generally has more money and is nearer to city bazaars. However, the opposite is true of the Bedouin of the Naqab. Their dresses are relatively opulent and costly.

Unmarried women or widows had blue embroidery on their costumes to show their status. If a widow remarried, she added pink embroidery to the blue

Above Left to right
Shinyar (lower back panel) of dress worn by remarried women; Back of festive dress worn by married women; Back of unmarried or widowed woman's dress (circa 1935)

Compared to village costumes, Naqab Bedouin costumes are more voluminous with longer, winged sleeves and denser embroidery on the front and back of the skirt, using a repeated geometrical pattern. The dresses were originally made of handwoven, indigo-dyed fabric, although in the 1920s this changed to machine-woven cotton bought in Bir Saba' or Gaza. At the bottom of the dress is a 5-centimetre band of running stitch done in blue thread, to protect the hem from wear and tear. The Bedouin also believed that this band protected the wearer from evil.

Each tribe had its own distinctive style. Moreover, each tribe was subdivided into *ashiras,* or clans, which had minor but obvious differences among their costumes. The shape of the *qabeh,* or chest panel, varied from tribe to tribe, and was sometimes replaced by a narrow piece of red silk, rather than embroidery. In some tribes, unmarried women or widows had blue embroidery on their costume to show their status. If a widow remarried, she added pink embroidery to the blue.

THREADS OF IDENTITY

SOUTHERN PALESTINE

When married, women wore a burqa, or face ornament, decorated with chains, beads and coins, that showed which tribe or family she came from

Left Festive Bedouin jacket, cotton with cross stitch, decorated with Palestinian coins and buttons (circa 1930)

Above Silver frog bracelets made in Egypt

Above right A Bedouin woman with her face ornament, 1935

A number of accessories went along with the traditional costume, such as a headdress called *wuqa*, covered with coins or cowry shells. In certain tribes, the headdress had a flap at the back with buttons and a fringe. When married, women wore a *burqa*, or face ornament, decorated with chains, beads and coins, that showed which tribe or family she came from. The belt worn by the Bedouin required a lot of work, as described in an interview below. The woman's head shawl was made of black gauze embroidered in shades of red. Some tribes embroidered their jackets, such as the knee-length jacket with short sleeves worn by the Tayaha tribe, or the short jackets also with short sleeves, worn by other tribes.

383

Threads of Identity

Judging by their dress and jewellery, the Bedouin of the Naqab seem to have been relatively well off

Above left Gold nose-ring worn by married women

Above right Bedouin *wuqa* (headdress) trimmed with cowry shells, buttons and coins, *atlas* and cotton fabric (circa 1925)

Judging by their dress and jewellery, the Bedouin of the Naqab seem to have been relatively well off. They kept cattle in addition to camels, goats and sheep. Besides trading in livestock, dairy products and wool, they were engaged in the salt trade. They collected salt from around the Dead Sea and sold it in the markets of Bir Saba' and Gaza.

Changes appeared in their costumes in the 1940s and subsequent decades: sleeves became narrower; synthetic fabrics were sometimes used; and wild combinations of bright colours emerged.

SOUTHERN PALESTINE

Above Bedouin festive dress of the Tayaha tribe with patchwork on sleeves (circa 1930)

Threads of Identity

SOUTHERN PALESTINE

For centuries, the Bedouin of Southern Palestine moved about freely in the Naqab and Sinai deserts, for there were no fixed boundaries during the Ottoman period

Left Festive Bedouin headdress from the Tayaha tribe of Naqab (circa 1925)

Above Bedouin men dancing at a wedding, 1920s

Hamdeh
of the Tayaha Tribe: attaching a tent to an urban dwelling

Right Detail of Bedouin woman's *sfeefeh* (belt) made of braided wool and goat hair, topped by narrow black belt decorated with cowry shells, coins and hanging woven pieces (circa 1920)

Faizeh, an attractive young girl, worked at the hairdressers I used to go to in the 1980s. During our conversations I became curious about her Bedouin background. She came from the Tayaha tribe. Her parents lived in Wihdat Refugee Camp in Amman, while her grandmother, Hamdeh, lived out of town on the Airport Road.

During the Ramadan feast, *Eid El Fitr*, Faizeh invited me to visit her grandmother, Hamdeh. While we were warmly welcomed, it was obvious that Hamdeh was unhappy. Soon enough she opened up: her son had not come to visit her for the feast. However, she was not angry with him, as she figured it meant that he had no money to give her as is customary, for if a man has no money to offer his mother and sisters, he visits after the holiday instead.

When Hamdeh, her husband and their four children were forced to leave the Bir Saba' area in 1949, they entered Jordan through the south. They worked hard to attain refugee status and were given a room in Wihdat Camp, but Hamdeh and her husband could not tolerate living there. The camp was way too crowded after the free Bedouin lifestyle they had been used to. They let their eldest son have their room and they moved out and rented a one-room dwelling on the outskirts of the city and erected a tent beside it. This at least simulated their earlier Bedouin life. In the summer they simply lived in the tent. For work they would find farming jobs on a seasonal basis. She described her former life in the Naqab to me:

'There were many wells in our area, but we moved around within the territory of our tribe, the Tayaha, in search of good pastures. Some of the men of our tribe worked in the city, while others stayed to help with the animals. We had everything we needed. We made yogurt, **labneh** *(strained yogurt), cheese and* **samneh** *(clarified butter), part of it for our own use and part to be sold in the city. We had enough meat and could sell some of our animals if we needed money. We wove our own tents, as well as rugs and bags, from the wool of our animals. Life was hard, but we would never have given up our Bedouin ways for a life in the city.'*

THREADS OF IDENTITY

Here Hamdeh paused to make us coffee. She complained that her granddaughter, Faizeh, did not visit her often enough. We drank the coffee, and I asked if I could visit her again.

On my second visit, Hamdeh was not distracted by the feast and I was able to get further information about her wedding, her costumes and her jewellery. She had been aware, she confided, that the birthmark she bore on one of her eyes detracted from her looks and that was why in 1928 she had accepted to marry a widower who already had three children. Nevertheless, being the daughter of a chief, she had insisted on having everything that a Tayaha bride should have. The Naqab Bedouin did their shopping either in Bir Saba', Gaza or Faluja. Hamdeh went to Bir Saba' to buy cloth and embroidery thread for her costumes. Her bridal jewellery was purchased from Saba in Gaza, and her beads and home accessories were from the Faluja market.

Hamdeh had begun embroidering her costumes with the help of her mother when she was 14. She made about eight costumes. Besides the dresses, the belt itself, consisting of two pieces, was a major undertaking usually made by women specialised in the art. First, black and white wool was plaited into long strips. These were then sewn together, alternating the black and white strips, to produce the wide, striped section of the belt. Then a narrower belt was woven in black and red wool, and decorated with shells and beads. This was wrapped around the waist on top of the wider belt. A bride would weave long bands with tassels and attach them to the front of the belt to hang down her skirt. A Bedouin woman would not wear the woven belt until she had given birth to her first child. Her relatives wrapped it tightly around her waist many times to keep her stomach firm. Such a belt was worn instead of the corset used by urban women.

'I watched Im Taha weave my belt,' Hamdeh told me. 'When the two pieces were finished, I took it home and sewed Palestinian coins and buttons to it. We Bedouin attach many items to our costume. Do you want to hear about them?'

Above Embroidered *karameel* (hair decorations)

Right Detail of patterns used by remarried Bedouin women, 1940

390

THREADS OF IDENTITY

Above Front and back of an embroidered Bedouin jacket for young girls, Khan Younis area (circa 1935)

SOUTHERN PALESTINE

I assured her that I did, so she continued:

'On our heads we wore a headdress with a small amount of embroidery, which had two long bands of silver coins on each side of the face. Long embroidered karameel with beaded tassels were worn to decorate the hair. Over all this was a large embroidered cloth that covered the head and part of the body. Costumes and head covers were always made of black fabric. This was in the past. Now you see nothing of our original way of life.

'Something, which only the Bedouin wore, is the burqa, *the face ornament worn by married women. This starts with a piece of embroidered fabric to cover the forehead. Each tribe has its own design. You know which tribe a woman belongs to by her* burqa. *It is decorated with coins, chains, and beads.*

'From the jeweller in Gaza, they bought me silver bracelets and a gold nose-ring. I haven't mentioned the jacket. It was waist-length or three-quarter-length, and embroidered. Beads were bought in Faluja, and my friends and I made them into necklaces of different lengths.'

I paid more visits to Hamdeh and could see that she was becoming miserable, because the Airport Road was being built near the very spot to which she had moved to find peace and quiet. She could not bear the traffic and the buildings close by, yet they could not move elsewhere because she and her husband worked for the landowner and were unlikely to find other jobs.

Above Festive, embroidered Bedouin jacket, Rafah area (circa 1940)

Sabha
of the Tarabeen Tribe

Just as Hamdeh was very proud of everything the Tayaha tribe produced, from embroidery to dairy products, so was Sabha who took pride in her tribe's specialty: weaving. I met Sabha in the Suf Refugee Camp near Jerash, where the Mennonites had started an embroidery centre. She invited me to her small spotless room where, over a cup of coffee, we talked of her past and present life.

Sabha comes from the Tarabeen tribe that, like the Tayaha, lived south of Bir Saba'. They herded livestock and camels, and were known for their high quality weaving. They dyed the wool locally or in Faluja, using a lot of indigo. Sabha told me how weaving underpinned their way of life:

'You see, in our home in Palestine, our furniture, cushions, storage containers, tent, and the decorations for the horses and camels were all woven. And our hair and belt ornaments were woven. Woollen sleeping bags were woven for the bride and groom, as were coats for men and women. So alongside the art of embroidery, we Bedouin women mastered the art of weaving, but, alas, here in the camp we don't weave. This is another life.'

She explained the whole process to me in full detail: the men would shear the animals to obtain the wool then wash it. After teasing it, the women would spin the wool with a wooden hand spindle. The spun wool was looped into skeins ready to be dyed, but some was set aside to be kept in its natural colour, because black and white sheep's wool and beige camel hair were used for decoration.

The ground looms used by the Tarabeen were constructed from sticks and beams. The warp threads were stretched between the two warped rods and the weaving could begin. This sounds simple, but actually such weaving is a complicated process with intricate techniques that the Bedouin women mastered well. One example is the *saha* pattern which is similar to brocade weave.

Above A Bedouin woman weaving on a horizontal ground loom

Right Bedouin festive dress (circa 1935)

SOUTHERN PALESTINE

Threads of Identity

Above *Karameel* (hair decoration) with coins, buttons, pearl beads and beaded fringes

Sabha said that their weaving was of such high quality that they could always successfully market it if they wished to. They made small items like bags, bands and rugs, and took them to sell on market days in Bir Saba'. People came from Gaza, Hebron and other places seeking the weaving of the Tarabeen tribe. Sabha's mother also took butter and cheese to sell at the market, and this was the first thing to be bought.

Sabha got married and was starting a family when they were forced out of their land and had to flee to Jordan, where they became refugees and were placed in the Suf Camp.

SOUTHERN PALESTINE

People came from Gaza, Hebron and other places seeking the weaving of the Tarabeen tribe

Above *Saha* pattern woven in Bedouin rugs throughout Belad al-Sham

As refugees they received basic rations, but they lost their livelihood which was completely dependent on their environment. A few years after they came to Jordan, Sabha's husband died of a stroke, leaving her alone with four children. This impelled her to find work at the Mennonite Centre, where she was the main embroiderer. She also did embroidery for a centre in Amman. Unfortunately these centres focused on embroidery and Sabha had to put aside her weaving to earn an income. She would have loved to weave as well, but at that time it was not possible due to the lack of raw materials and markets.

THREADS OF IDENTITY

Mariam
of the Azazmeh Tribe, Wadi Araba

In the 1950s, the Israeli authorities embarked on efforts to change the demography of the Naqab desert. Many of the Palestinian Bedouin were driven off their land and were either resettled or expelled. One of the groups most affected by these measures was the Azazmeh tribe, because a natural gas deposit was discovered under their land. At least nine Israeli settlements were built in the area where the Azazmeh had herded their livestock and engaged in cultivation, among them Dimona, the site of Israel's nuclear power plant, and Ketziot, where a large military detention camp was erected to incarcerate Palestinians.

In 1989, my friend Myrtle Winters, UNRWA photographer from 1967 until 1990, asked me to accompany her to Wadi Araba, a desert area in Jordan, south of the Dead Sea. She wanted to visit a group of Bedouin from the Azazmeh tribe who were forced out of Palestine, but were unable to be registered as refugees in Jordan, and so lived in limbo in the middle of nowhere. Myrtle had photographed them coming out of Palestine in 1969, and wanted to see what had become of them 20 years later.

The family we visited was a clan of the Azazmeh tribe who had previously lived in Wadi al-Akhdar, meaning the Green Valley, between Bir Saba' and Faluja. In winter, they had pitched their tents in the valley near the water springs, where cultivation was possible. In summer they moved to the top of the hills, taking their livestock. This had been their area for as long as anyone could remember and they never moved far from it.

In the Azazmeh's settlement in Wadi Araba, I met many women, among them Mariam, an elderly woman with sharp eyes and an even sharper memory. She spoke with authority about the Azazmeh embroidery, costumes and jewellery, and about what had happened to the tribe since being forced out of their land. While she talked, other women and some children gathered around us. They were all listening intently to Mariam who I later learned had a prestigious status in her community due to her strength of character.

Above A tattooed Bedouin woman from the Azazmeh tribe, 1985.

Right Bedouin shawl (circa 1935)

THREADS OF IDENTITY

Above Bedouin women selling silver jewellery and beads at the market in Bir Saba'

Right Woven and beaded bag for coffee beans

The following are excerpts of what Mariam told me about their way of life:

'The women of our tribe worked alongside the men, cultivating and caring for the sheep, goats and camels, but when it came to socialising in the evenings, the men got together separately and so did the women. Men gathered in the chief's tent, and often would be entertained by the tribe's singer and player of the rababeh *(a single stringed instrument played with a single stringed bow)*.

I had two sisters and two brothers. One of my brothers, Nayef, was very clever in elementary school, and my mother said she wanted to send him to school in Bir Saba' and then to college. Each of us had favourite animals that we took special care of. My dog, Nimir, was the most beautiful saluki in our tribe.

Southern Palestine

*I remember one year when my aunt took us to the Faluja
market a week before the feast. There was a Ramadan fair
with horse and camel races, and dancing in the marketplace*

'The fasting month of Ramadan and the feast that followed it were very special events for us. I remember one year when my aunt took us to the Faluja market a week before the feast. Most of our tribe was going that day to sell livestock and shop for the feast. My aunt bought me fabric for a dress and embroidery thread. We also bought sweets, clothes for all the children of the family, and boxes of snuff as presents for the older members of the family. There was a Ramadan fair with horse and camel races, and dancing in the marketplace. Then we walked to the spot where our tribe had agreed to meet to return home. A few years after that, when I was preparing for my marriage, we made the same trip to the market, but I saw everything differently then as I was both excited to be buying so much and nervous about the wedding.

'One day a few years after my marriage, at the break of dawn, the Israeli army arrived and literally forced us out of our tents, into their trucks and dumped us in the middle of an arid mountainous area south of Hebron. Some families managed to take a few belongings or animals but none was able to take the tents. During the first few days we could not take the cold weather and some of our animals died. I had two daughters and the youngest died during that time.

'Since we were living out in the open with limited cover, the tribe decided to move towards the Dead Sea where it would at least be warmer. After a time we crossed over to Jordan, staying near the Dead Sea. During this period, our big tribe was scattered to different places. I don't know how, but we learned that the Azazmeh tribe was in Wadi Araba, so we started the long journey in that direction. We found them and they encouraged us to stay, but they themselves did not know why they were there. They had been pushed into the area by Israel. Jordan would not accept them, and UNRWA would not register them as refugees because they had been expelled after the war was over.'

The Jordanian government's reluctance to accept these people was due to the fear that if this group were to be

THREADS OF IDENTITY

At the break of dawn, the Israeli army arrived and literally forced us out of our tents, into their trucks and dumped us in the middle of an arid mountainous area south of Hebron

accepted, then Israel might push all the Bedouin of Southern Palestine into Jordan. Because of this political issue, the Azazmeh have stayed year after year in the same spot, living in limbo.

Before coming to Wadi Araba, Mariam's mother had sold her jewellery and some of their embroidered costumes in Kerak, Jordan and bought sheep and goats to make a living. Their tents were worn out, and some people had built small cement shelters for themselves. Every now and then, people in Amman remember their sad story, and some organisation starts a project there. One of these was to teach leatherwork, using goatskins, and some of the accessories they made were placed in gift shops. In one of these projects, Mariam learned how to make rugs from old clothes. The Azazmeh's embroidery was excellent and they did work for the Women's Union in Amman, but this generated very limited income.

After coming to Jordan, Mariam had more children who are now adults, and her mother passed away. One of her sons is very clever and had independently studied and passed the *tawjihi*, the general secondary level government examination, receiving a high mark; but he could not go on to college to study because the family had no official status.

The Azazmeh in Wadi Araba still speak fondly of Wadi al-Akhdar, the water springs, their feast days and their trips to the city markets. This is the past they have lost; but what they have managed to keep is their togetherness. In Mariam's words:

'The only good thing is that we stay together as a tribe. I really cannot understand how a family in the city can live alone with just their children. There is a very special feeling of security when we are together. We women long to sit together and embroider wedding dresses in the afternoons as we did in Wadi al-Akhdar, but now everything that the girls wear is from used clothes stores.'

Right Coral necklace interspersed with mother-of-pearl bars, agate, pearls and silver beads

THREADS OF IDENTITY

Collection *Southern Palestine*

Left *Qabeh* of a Bedouin dress (circa 1935)

Above Bedouin bridal necklaces of cloves, Venetian beads, coral and mother-of-pearl. The cloves are used for their fragrance

THREADS OF IDENTITY

Both Pages Front and back of a cotton Bedouin dress from Bir Saba' area, decorated with military buttons and cross stitch; note hem with rows of running stitch found on all Southern Palestine Bedouin dresses (circa 1940)

SOUTHERN PALESTINE

Threads of Identity

SOUTHERN PALESTINE

Left Dress of Bedouin woman who has remarried and added pink embroidery, Bir Saba' area (circa 1935)

Above *Burqa* (face ornament) worn by married Bedouin women in the Naqab; embroidered band shows which tribe she comes from (circa 1935)

Threads of Identity

Both pages Details of cross stitch on back yokes of Bedouin dresses from the Bir Saba' area (circa 1940)

SOUTHERN PALESTINE

Chapter 14

The New Dress
Born of Camp Life and Resistance

The 1948 War and the occupation of the greater part of Palestine marked the beginning of the Palestinian diaspora. Large numbers of Palestinians were displaced, and their culture was dispersed with them. Some migrated to Western countries, but most ended up in refugee camps in Jordan, Syria and Lebanon. Here, Palestinians from different villages and towns were thrown together in crowded living quarters. This intermingling exposed the women to the costumes and customs of areas other than their own.

Left At a festival in Ramallah, 1970s

Above Cushions from the *Inaash al-Mokhaim al-Falastini* (Revival of the Palestinian Camp) Centre in Beirut

Threads of Identity

Above left *Qabeh* (chest panel) from a Bethlehem *malak* costume. This is an example of couching (circa 1920)

Above right An example of machine-made couching embroidery, which replaced the hand embroidery, 1980

The first few years of exile did not produce new costumes, because most people could not afford to add to their wardrobes. But by the 1960s, refugee women had started making new dresses of cheap fabric with machine embroidery.

As the years went by, a refugee costume style evolved as a result of the exposure to different Palestinian patterns, as well as those copied from Western magazines. The new camp dresses were usually made with machine embroidery and cheap synthetic fabrics. As a collector, for many years I ignored this newly evolving dress. I could not relate to it aesthetically and was saddened to see the disappearance of the traditional patterns. Nevertheless, eventually I started to see that the evolution of the *thob* in refugee camps reflected changes in political identity which I could not ignore when documenting Palestinian heritage.

A new world of textiles

One major factor behind the change was the loss of and inaccessabilty to suppliers who had supported traditional dressmaking. Gone was the old textile world known to villagers and Bedouin who had shopped in the cities of Palestine. Gone were the familiar shops of the Za'balawis in Jaffa, the Zabanis, Haltys and Batshons in Lydda and Ramla, the Nasers in Bethlehem, the Barakats in Jerusalem, and Jeryes in Haifa. Gone too were the embroidery thread retailers who had also sold gold, silver and silk cording. Gone were the weaving centres in Bethlehem, Gaza and Ramallah. While women had previously bought from particular merchants – often knowing their wives as well – such familiarity was lacking in places of exile.

The first major change in the *thob* was the use of synthetic fabrics, which were easily available to refugees in their new locations in exile, and were cheap, practical and durable. The first synthetic fabric to appear on the market was called *trivera*, and this name came to be used for all synthetic cloth. A better quality fabric was the synthetic silk called *banama*, first used by Palestinians in Kuwait, since it was available in the market.

Changes also occurred in men's clothing. Male refugees had to adjust to a new array of textiles in Syria, Lebanon and Jordan. The plain white *kaffiyeh*, typical of Palestinian attire, was replaced by the black-and-white or red-and-white checked *kaffiyeh* worn in other Arab countries. By the early 1970s, the black-and-white *kaffiyeh* had become the symbol of Palestinian national identity. Even today, young men in particular continue to wear it with Western clothes.

THREADS OF IDENTITY

Adjusting to the diaspora, and its effect on the *thob*

In Jordan, Palestinian women discovered synthetic fabric in the early 1960s and began using it for their dresses, on to which they applied traditional cross stitch embroidery. The older refugee women in particular stuck to their original style of dress as much as possible. They bought fabrics that were like those they had used in the past and made similar style dresses but with less embroidery. Typical of this generation were Halimeh and Ruqiya, daughters of Sheikh Yusuf of Beit Dajan, whom I often visited in the Hussein Refugee Camp in Amman.

Palestinian refugees in Lebanon and Syria were mostly from northern Palestine where embroidery was sparsely used on traditional costumes after the 1920s. However, refugee women from these areas began to embroider to make a living, rather than for their own use. This is an important distinction in the change of the meaning and function of Palestinian embroidery.

Both Pages Women embroidering; the late Im Yusuf (far right), the famous cushion embroiderer in Amman

The New Dress

At first, they followed the old patterns of their hometowns or villages in Palestine. Later on, they began to see foreign handicraft magazines and their work took off in a whole new direction. Sometimes they copied the foreign patterns; sometimes they combined them with traditional patterns, such as 'the cypress tree' or 'orange blossom branch'; and at other times they created completely new ones. This is the point where what I call the new camp dress began to make its mark, often displaying a melange of Western and traditional patterns, and new colour combinations.

The attire chosen by younger women and ensuing generations born in exile was influenced by two, sometimes contradictory, trends: modern life and Western fashion on the one hand, and the desire to display their Palestinian national identity on the other. They were subject to a variety of influences in Jordan, Syria and Lebanon, as well as the impact of the Israeli market in Palestine. These factors brought about changes in fabrics, styles and embroidery patterns. Later, the Islamic trend in the Arab world also had its impact, with more and more women adopting Islamic-style dress.

THREADS OF IDENTITY

TYING THE THREADS

Embroidery as a symbol of Palestine

The rise of the PLO and the Palestinian resistance organisations in the wake of the 1967 Arab-Israeli war played a major role in the development of new costumes. This nationalist resurgence motivated a wide range of activities to preserve Palestinian heritage, which supported the efforts of the women who embroidered and wore the *thob*. Increasingly, embroidery and the *thob* served as symbols of the national cause. At the same time, new employment opportunities opened up for women, as the Palestinian Women's Union and other associations sponsored sewing and embroidery centres. The following are examples of some of the individuals and societies that contributed to preserving and developing Palestinian embroidery.

Left Im Adel in the dress she made combining old and new patterns. The Ramallah palm tree pattern, which had been used only on the back, was used here on the *qabeh* (chest panel) and *qumm* (sleeves). She rotated the pattern – a style rarely seen

Above A woman working at an UNRWA embroidery workshop

In Ramallah, Sameeha al-Khalil founded the *Inaash al-Usra* (Revival of the Family) association to assist hundreds of needy families and improve women's status by employing them in light industry such as embroidery, sewing, and food preservation. In addition the association opened a kindergarten and provided other social services. In Jerusalem, the Halaby sisters, Sonya and Asya, ran an embroidery centre where hundreds of girls were trained to embroider and document patterns. Unfortunately, it was later forced to close due to the high Israeli taxes imposed after the 1967 occupation.

In Beirut, a society called *Inaash al-Mokhaim al-Falastini* (Revival of the Palestinian Camp) was established by a group of talented women, including Malak Husseini Abdul Rahim, Najla Kanaze' and Serene Shahid. The aim was to improve the welfare of Palestinian refugee families by employing women to produce usable and wearable items of embroidery with creative patterns and colours. To this day, the workshops of this society produce the most exquisite pieces, including dresses, cushions, table runners and shawls. In addition to supporting the needy, this group has succeeded in teaching embroidery skills to new generations of Palestinian women born in exile, and developing embroidery for modern use.

In Amman, Leila Jeryes, Mariam Abu Laban, Hanan Ghosheh, the Asfour sisters, Intisar Khalifeh and others copied old dresses and created modernised *thobs*. They reproduced the jackets of Bethlehem and the Bedouin of Southern Palestine and put on fashion shows in Amman and other Arab capitals on a regular basis. I was often asked to help, so I gave old pieces or embroidery fragments to centres where they were copied and combined with new patterns.

In Syria, Heike Weber Awad founded the Anat workshop in Yarmouk Camp in 1988, to produce traditional embroidered costumes and accessories. Anat has since branched out to make creative innovations on traditional styles, using natural materials, in order to build bridges between modern life and tradition, and make Arab heritage part of everyday life.

In Egypt, Shaheera Mehrez opened a centre in Cairo that established embroidery workshops in al-Areesh, the location of a Palestinian exile community.

Above Girls learning embroidery at an UNRWA school

One of the organisations that did the most to keep the traditional embroidery alive was SAMED, the PLO's economic institution whose main aim was to protect Palestinian heritage. They assembled a collection of costumes and opened embroidery workshops in the refugee camps of the Lebanon and Syria. Many women donated their old costumes so that the embroidery patterns could be copied. In addition, SAMED workshops modernised the traditional embroidery and applied it to items that could be used every day. They also produced dolls clad in the traditional dresses of different Palestinian towns and cards featuring the special patterns of various areas.

SAMED also marketed the products of workshops established in occupied Palestine. This provided income for refugees, particularly women, and also spread information about Palestinian heritage and refugee life. Women who were not able to work full-time in the workshops produced items at home, benefitting from the new ideas they saw in SAMED products.

Threads of Identity

Above Traditional costumes and embroidery patterns incorporated in paintings by Palestinian artists
(1) Suleiman Mansour (private collection, Kamel Kawar)
(2) Abdul Hay Musallam (artist's collection)
(3) Samia Zarou (artist's collection)

THE NEW DRESS

Above Painting by Palestinian artist Ismail Shammout (private collection, Ali Abu Sitteh)

Embroidery and the *thob* have also served as inspiration for Palestinian artists who have contributed to heritage preservation by incorporating elements of embroidery and representations of traditional dress into their works. Some artists like Suleiman Mansour, Ismail Shammout and Joumana Sayegh express their inspiration in different artistic forms. Another artist, Samia Zarou, fits patches of traditional embroidery into her collages, while Abdul Hay Musallam paints embroidery patterns on the dresses of the women in his reliefs.

Changing styles – variations on a theme

The oil boom brought a degree of affluence to the Arab world in the late 1970s and in the 80s. Some of this trickled down to the refugee camps, particularly in Jordan, as family members working in the Gulf sent home remittances. There was a marked rise in the quality and decorativeness of costumes. The amount of embroidery on such dresses reached the point that the fabric scarcely showed. This was reminiscent of the situation in Ramallah, al-Bira and Bethlehem in the 1920s and 30s, when men who emigrated to work in South America sent money home to their families, funding a richer style of dress.

Among Palestinian women living in Kuwait and other Gulf countries, two different styles could be observed in the late 1970s and in the 80s. Either their costumes were very heavily embroidered in cross stitch, or they used machine-made couching. In the latter, Indian influence was apparent in the choice of colours and the increased use of metallic thread. Both of these styles were underpinned by relative affluence as compared to the refugee camps.

But just as the 1948 war had interrupted a period of prosperity in Palestine, the new spurt of affluence came to an abrupt end with the 1991 Gulf war. This forced most Palestinians to leave Kuwait and other oil-rich countries, and return to unemployment and an uncertain future in the countries where they relocated. However, Palestinian women from Kuwait continued to do beautiful work at the Centre for Palestinian Culture that they had established in Amman.

Starting in the 1970s, the embroidery patterns used for the new dresses seemed to express national allegiance to Palestine as a whole, rather than to a particular village or town. Palestinian national identity, rather than village identity, was becoming prevalent. In the process, new trends developed in specific refugee camps. One example is the Schneller Camp near Amman. Here the Ramallah embroidery patterns and dress style became the favourite, although most of the camp population came from villages around Jaffa or Gaza. Yet, whatever the changes, each new dress reproduced some detail from the old village style, showing that Palestinian women did not forget their villages of origin, even as they felt free to experiment with new styles.

THE NEW DRESS

Above Typical cushions in refugee camp houses in the 1960s and 1970s

Another sign that village identity had not been lost entirely was the new trend that began in the 1980s when brides in the refugee camps in Jordan made dresses for their trousseaux that replicated the traditional costume of their village of origin. This would be one of the dresses worn at the wedding alongside the modern Western white bridal gown that many now wear.

Changes occurred in home furnishings as well. The silk cushions made in Palestine before 1948, real masterpieces requiring much time and money, mainly disappeared, but they were later recreated in the new embroidery and sewing centres. However, in the 1960s and 70s the typical cushions in a bride's trousseau were plain white cotton embroidered in cross or satin stitch with pictures of flowers, trees, birds or girls. In the centre was an Arabic inscription such as 'You are the light of my eyes', 'I wish you a happy and blessed sleep', 'Life without you is unbearable', 'Our love is forever', 'In the name of God, the Merciful and Benevolent', and so on. At the same time, new items have appeared such as framed embroidery pieces as wall hangings. Some of these are traditional designs; others depict scenes of Jerusalem or other Palestinian locations. Many of them bear inscriptions such as 'Jerusalem is ours', 'We shall return', and 'May God protect us'.

1 2 3

4 5 6

7 8 9

The New Dress

Even with the use of new patterns, the cut of the *thob* did not change, and embroidery was still applied in the same way, on the chest and side panels. Like the original village costumes, the new dresses which emerged after 1970 have specific names derived from the fabric used, the type of chest panel, or the number of branches of embroidery applied vertically on the side panels. Below are the names of the new dresses worn in Jordan and Palestine, areas which should be understood as partially overlapping since the West Bank was administered by Jordan from 1948 until 1967. A large proportion of the Palestinians living in the West Bank and Gaza Strip and in Jordan, are refugees from the part of Palestine that became Israel in 1948.

Left
(1) *Thob qabeh ward*, dress with a floral design on the chest panel
(2) *Thob muwannas*, dress embroidered in shades of a single colour
(3) *Thob tara*, a hand-embroidered dress named after the embroidery hoop
(4) *Thob Ramallah*, a hand-embroidered dress named after the embroidery pattern
(5) *Thob tahriry*, dress with couching embroidery
(6) *Thob qabeh balat*, dress with a tiles design on the chest panel
(7) *Thob kharaz*, dress embroidered in beads
(8) *Thob Ariha*, Jericho dress
(9) *Thob saru*, dress of cypress trees
(Between 1965-1990)

The *Intifada* dress

The first *Intifada* which began on 9 December 1987 expressed Palestinian rejection of the Israeli occupation of the West Bank and Gaza Strip. Forty years after the establishment of the State of Israel and 20 years after the start of the occupation of the West Bank and Gaza Strip, Palestinians were drawing attention to their undeniable right to an independent state. As mass demonstrations continued on a daily basis, a new dress appeared which was not embroidered with either traditional or imported patterns. Instead, the traditionally cut *thob* was embroidered with an array of political symbols: Palestinian flags, the Dome of the Rock, maps of Palestine, olive branches and inscriptions like 'We shall return'. The embroidery and fabric of what I began to call the *Intifada* dress feature the colours of the Palestinian flag: red, green, white and black. Sometimes, the flag itself is rendered on the chest panel in embroidery or appliqué.

Such dresses were first made in Palestine in direct defiance of the Israeli ban on the public display of these colours, and after the imprisonment of Palestinian artists who used them in their paintings. Made to be worn in public demonstrations, they had the obvious advantage that Israeli soldiers could not snatch them from demonstrators' hands as they did with flags. The *Intifada* dress soon spread to Palestinian communities in exile, and became the most potent expression of all-Palestinian nationalism and resistance. In a new example of women's innovation and resilience, the traditional peasant *thob* became a widely recognised political symbol on TV screens around the world.

Thus another new dress joined the Palestinian wardrobe, alongside the traditional *thob* and the camp-style dresses of the diaspora. While adapting to shifting circumstances, Palestinians held fast to their identity.

Left An *Intifada* dress showing the Palestinian flag and "Palestine" written in Arabic in the form of a ship. "Eventually the ship will have to reach home" is embroidered below it, 1988

THREADS OF IDENTITY

Above Different *Intifada* dresses with embroidery of the map, flag and other national symbols of Palestine, 1990s

It is safe to say that the evolution of Palestinian embroidery among Palestinians living under occupation and those in the diaspora is a reflection of their experiences and sentiments. There was a need to adapt to contemporary circumstances which created the new camp dress. At the same time, people did not forget their identity and this was reflected in the *Intifada* dress as well as the modernisation and marketing of embroidery in support of womens' livelihoods. Additionally, many diaspora Palestinians of all economic strata own a dress that they wear on special occasions such as weddings. On any henna night (a ladies' gathering one night before a wedding) women wear only traditional dress. On these nights one can watch the rainbow of colours of women dancing and singing and experience the bitter-sweet taste of Palestine.

THE NEW DRESS

Above and right Chest panels and back of an *Intifada* dress showing typical Palestinian national symbols like the Dome of the Rock and the flag, 1990s

Chapter 15

Tying the Threads

For a small country, Palestine has an astonishing variety of traditional costumes. Its past history and location have understandably contributed to the diversity of its cultural wealth.

Each ancient site in Palestine was a *khirbet*, and a *khirbet* became a village over time, among them are the 418 that existed prior to 1948, but were subsequently destroyed.[24]

That is why it has taken me this long to publish the material I have collected on costumes because I wanted my research to be as complete and thorough as possible.

Left and above Part of the Kawar collection

[24] Walid Khalidi, *All That Remains: The Palestinian Villages Occupied and Depopulated by Israel in 1948*, Institute for Palestine Studies, Washington DC, 1992

So much of our cultural heritage has remained unstudied but, unfortunately, in many cases, the people who could provide that information are no longer with us. Yet, the costumes with their beautiful embroidery speak; they started out conveying a language of their own with different dialects telling stories of hope and success, whereas nowadays the stories are of yearning, nostalgia and despair, brought on by over 60 years of diaspora and occupation. They have become a symbol of national identity, shared by Palestinians everywhere, from those living in refugee camps in Syria, Lebanon and Jordan, to those remaining in Palestine and those in exile abroad. Today, wherever there is a Palestinian community, a gathering to mark a special occasion turns out to be a wonder-filled festival of Palestinian costume. Women attend these gatherings dressed up in costumes representing various areas of Palestine, which makes it apparent that the traditional costume is a national treasure linking the past to the present.

Over the years I have recorded different aspects related to textiles, embroidery, threads, and style of the costumes, but I have not elaborated on them in this book as I have felt it was more important to focus on the stories of the women who produced and wore the costumes, highlighting their skills, creativity, and the harsh changes they had to endure.

Each woman whose life history is revealed in these pages exhibits a strong sense of social identity and personal achievement, as well as resilience and faith. Their stories and dresses allow the reader to look back at Palestinian history through a special lens, focusing on women's potential for ensuring the continuity of the collective heritage and identity. Only by understanding life in Palestine before the diaspora can one begin to grasp the magnitude of its destruction, and the courage and determination it took to renew Palestinian lives and culture. The *thob* and embroidery, as living heritage, symbolize this renewal, having evolved from markers of regional or tribal identity into expressions of an all-Palestinian identity, invested with multiple meanings.

The costumes in this book are only a part of my collection, which extends to more than 3000 pieces of costumes, jewellery and other

TYING THE THREADS

Above The author with Abu Fuad Musaffi al-Assal in his shop in Aleppo, Syria, 2000

personal and household artifacts. Although I started collecting as a way to preserve part of my culture after losing my homeland, eventually I became equally concerned with preservation of the textile heritage of Jordan, Syria and other Arab countries. While I was actively building my collection up to the 1980s very few shared my appreciation of our Arab textile culture. Even today where there is increasing interest in preserving our heritage, the knowledge and appreciation of the textile heritage is still weak. I hope that the stories of my collection, will instil an appreciation of

TYING THE THREADS

the Palestinian and Arab costumes and traditions, and encourage further research as well as deeper understanding. I have built a collection to be proud of and cannot help but ponder its future. It is my ultimate ambition to see the collection physically housed in a permanent museum that will promote further learning. As this book shows, nothing is stagnant and everything is influenced by the course of time and changing environments. Moreover, the museum will be a centre for creativity and will serve as a repository of knowledge on embroidery and weaving techniques providing for their development and modernization. The heritage items and their documentation will be easily accessible for students, anthropologists, journalists, artists, craftsmen/women, fashion designers, historians, politicians and others who might be interested. In general, the purpose of this museum will be to share these traditions in the hope to shape a future with greater cultural understanding and therefore tolerance.

This will be tying the threads of identity for me.

Left Costumes from the Kawar collection

Glossary

abaya cloak
agal the braided cord which holds the *kaffiyeh* on to the head
alaly upper storey of a house
araqiyeh a type of headdress with coins worn by women from Hebron area
asawer mabareem twisted bracelets
asawri a yellow and black striped silk fabric imported from Syria for costumes worn by women in Jerusalem villages
asbeh a headband which was used to hold the headscarf in place
atlas a type of striped silk, originally made in Syria
aubusson tapestry embroidery
banayek the triangular-shaped side pieces of a traditional dress
barat a coin from the Ottoman period that contained no silver
bughmeh a silver choker worn by brides at their wedding
bukjeh a large embroidered cloth used to wrap bath items women took to the *hammam*
dabkeh a popular folk dance performed in Palestine and other countries in the Levant
dandaky a type of cotton fabric originally woven in India, from where it gets its name
deyal the lower back of the dress
dura'a a coat-like garment worn by women of the Galilee area. It usually had short sleeves and less embroidery than a *jellayeh*
ghabany a white silk fabric covered in chain stitch machine embroidery made in Syria
ghudfeh a shawl often used for covering the head in the Hebron area
habra a light black silk covering that a townswoman would wear when out of her home
hatta another word for *kaffiyeh*
heidary a cuff or bangle style bracelet
hidim a coat made from a fabric which is bright or patterned such as Syrian atlas silk
hijab amulet
hishey the pottery made in Ramallah, usually decorated with henna or soil
Janna wa Nar Heaven and Hell costume
jehaz trousseau
jellayeh hamra a red coloured *jellayeh*
jellayeh a richly embroidered festive dress with a slit down the front, worn over trousers
kaffiyeh a large square cloth worn by men as a headdress
karameel a silver or gold pipe-shaped hair ornament to cover the ends of braids
karmazut watered silk taffeta
kesaya linen shawl typical of the Ramallah area
khaddameh an everyday dress worn by Bethlehem women, made out of handwoven linen with cross stitch embroidery rather than couching
khedary handwoven linen, or linen and silk, with green and/or red stripes
khiarah literally means cucumber, but is a cylindrical silver piece with Islamic inscriptions attached to necklaces
khirqa embroidered veil from Ramallah
kirdan a silver choker
kisweh the shopping for a wedding which is traditionally paid for by the bridegroom's family
lafayef long, embroidered bands which are attached to the *araqiyeh* and then used to wind around the woman's braids
malak meaning 'royal', the *malak* fabric was a blend of linen and silk usually striped in red and black. It was almost exclusively used by the women of Bethlehem for their lavish malak costumes which were extensively embroidered with unique couching embroidery
mandeel mantilla or scarf, of thin cotton gauze or sometimes silk worn over the hair
mashaghlah a gold necklace worn by brides in the Jaffa area
mashkhas a gold coin with a picture of a saint, used in Palestine by the Crusaders.

Subsequently, the coins were sometimes used by villagers in their jewelry or as an amulet
maskeh silver amulet worn as a pendant with Islamic inscriptions
meklab a piece of cloth with beads, coins and amulets sewn on, worn by the bride on her back
mlaya a light cotton or silk covering that a townswoman would wear when out of her home
mudawara a circular collar
niello the technique used to fill in engraved silver or other metal in black design
oya the needlework lace that is attached to the edge of the *mandeel*
qabeh the embroidered chest panel on a traditional Palestinian dress
qumbaz a man's ankle-length overcoat
qumm sleeve
qurs a disc of silver or other metal that has a stamped design and is placed on top of a *shatweh*
rasheq an embroidery stitch used in villages which was a simplified copy of the couching embroidery stitch used by women in Bethlehem
rosa a fine silk fabric bleached white
roumi handwoven linen fabric either white or black
sabaleh herringbone stitch
safadiya a wrap-around cloak worn by people from Safad
saffeh from Ramallah, a headband decorated with many overlapping coins, which would then be attached to the front of the cap
sanduq al arus a wooden trousseau chest
sarma a technique of embroidery where gold thread is wrapped around cardboard
saru cypress trees
shambar a silk head shawl
shatweh a tall headdress made out of felt and cotton worn by married women of Bethlehem
she'arieh type of necklace worn in the Hebron area
shintyan long baggy women trousers made of cotton, silk or satin in brightly coloured patterns
shinyar the embroidered back panel of the bodice on a traditional dress
shirwal (or **sirwal**) baggy trousers often with embroidery on the hem
smadeh a headdress decorated with coins worn by women in villages on the coastal plain
tabaq round straw mat used to set meals on
taboon community oven where women would take their bread to be baked
tahriry a special term for the couching stitch developed in Bethlehem
taksiri a short sleeve jacket heavily embroidered with couching stitch
thob abyad a dress of white linen embroidered with a cypress tree pattern
thob aswad a dress of black linen embroidered with a moon and cypress tree pattern
thob ibb a long dress where the extra length of the skirt forms a fold in the centre that is used as a pocket
thob khedary a dress made from the *khedary* fabric
tubsi natural linen fabric with bright pink on both sides of the selvage
wazra a wrap-around cloth worn at the *hammam* after bathing
weqayeh embroidered traditional bridal headdress decorated with coins, worn in the Ramallah area
yalak coat-like dress
zaffeh a wedding procession of singing, dancing and music
znag a chin-chain attached to either side of the headdress to hold it in place

Photograph credits

Afaghani family archive: 48

Alistair Duncan: 191

Bert De Vreis: 93, 104, 112, 161, 192

Bonfils: 324

Eric and Edith Matson Photograph Collection, Library of Congress Prints and Photographs Division Washington, D.C: 66, 69, 73, 78, 92, 95(2), 101, 106, 113, 126, 134, 136, 137, 141, 144(2), 154, 176, 178, 181(1), 182, 183(1,2) 185, 203, 213, 214, 216(1,2), 217, 246, 255, 272, 274, 275(1,2) 278, 281, 287, 293(2), 298, 318, 322(1,2) 344(1,2), 376, 379, 387, 394, 400

Falak Shawwa: vi, 6(1,2), 20(1), 43, 44(1,2), 45(1,2), 46, 47(1,2,3), 49(1,2,3,4,5,6), 50, 53(1,2,3,4,5,6), 54, 55, 56(1,2,3,4,5,6), 57(1,2), 70, 72, 75, 81, 83, 89, 90(2), 91(1,2), 94, 99, 111(1), 116, 117, 118, 123, 125, 127, 130(1,2), 131, 132, 133, 140, 143(1,2), 151, 159, 162(2), 163, 165(1,2), 168, 169(1,2), 172, 173, 174, 175(1,2,3,4), 177, 180, 197, 206, 207, 208(1), 209(1,2), 211(1,2), 221, 223, 224, 226, 228, 229, 231, 232, 234, 235, 236, 239, 240, 247, 250, 252, 253, 258, 259, 262(1,2), 268, 269, 270, 271, 276(1,2), 277, 282, 283, 284, 286, 289, 291, 293(1), 295, 296, 297, 303, 306, 312, 313, 314, 315(2), 316, 319, 320, 325(1), 327. 331. 334, 337, 347, 348, 350, 351, 352(1,2), 253, 355, 356, 358, 359, 361, 363, 364, 365, 366, 371, 374(1,2,3,4), 375(1), 378, 380(1,2), 381, 381, 382, 389, 390, 291, 392(1,2), 393, 396, 397, 401, 403, 408, 409, 425(1,2,3) 428, 430(1,2)

George Azar: 249

Jack Persekian: 205

Jean Mohr: 109, 412

Kawar family archive: Front cover (1,2,3,4,5), 7, 9, 11, 17, 19, 20(2), 26, 28(1,2), 29(1), 34, 35, 36(1,2), 37(1,2), 68(1), 71, 74, 76, 82, 84, 87, 122, 139, 142, 144(1), 145(1,2), 149, 150, 153, 155, 156, 158, 160, 162(1), 164, 179, 181(2), 186(1,2,3,4), 188(2), 193, 194, 199, 219, 220(1,2), 225, 237, 280(1,2), 308, 326(1,2), 362, 383(2), 386, back cover (2,3,5)

Kamel Kawar: 51, 167, 198, 201, 431(2,3), 435

Khoury and Sabbagh family archive: 290(1,2)

Library of Congress Prints and Photographs Division, Washington, D.C: 80, 354

Lily Bandak: 189

Mary Kawar: xii, 31, 256, 260, 321, 330, 398, 416(2), 417(2), 418, back cover (1,4)

Munir Naser: 68(2)

Mushabak family archive: 146

Myrtle Winters: 68(3), 77, 108, 111(2), 114, 148, 233, 290, 329

Nabil Qutteineh: Front cover, inside cover, ii, 4, 5, 13, 23, 33, 38, 39, 40, 58, 59, 67, 79, 88, 90(1), 91(3), 96, 100, 102, 107, 110, 115, 119(1,2) 124, 129, 138, 152, 157, 170, 171, 184, 187, 188(1), 190, 195, 196, 200, 202, 204, 210, 212, 215, 218, 222, 241(1,2), 242(1,2,3), 254, 257, 261, 263, 264, 267, 273, 288, 300, 301, 305, 307, 310, 311, 315(1), 317(1,2,3,4), 325(2), 328, 332, 333, 336, 338(1,2), 339(1,2), 340, 341, 343, 360, 367, 368(1,2), 369, 370(1,2), 372(1,2), 373, 375(2,3), 377, 383(1), 384(1,2), 385, 395, 399, 404, 405, 406, 407, 410, 411, 413, 414(1,2), 426(1,2,3,4,5,6,7,8,9), 431(1), 432, 433, 436

Nizar Saleh: 14

Othman Akuz: 128, 135, 147, 285 (1,2)

Per-Olow-Anderson: 346

Shawwa family archive: 345

Shelagh Weir: 29(2), 86, 230, 238, 243, 244, 245

Taji family archive: 248(1,2) 251

Unknown: 95(1), 342

UNRWA Archives: 24, 97, 103, 120, 298, 416(1), 417(1), 419, 421

www.palestineremembered.org: 302, 304

List of Exhibitions of the Kawar Collection

1987/1988
Cologne, Germany (Rautenstrauch-Joest-Museum für Völkerkunde)
Pracht und Geheimnis Kleidung und Schmuck aus Palästina und Jordanien

1988/1989
Paris, France (Institut du Monde Arabe)
Mémoire de Soie Costumes et parures de Palestine et de Jordanie

1989/1990
Munich, Germany (Staatliches Museum für Völkerkunde)
Pracht und Geheimnis Kunsthandwerk aus Palästina und Jordanien

1990
Singapore (The Empress Place)
King's Road – Art and Culture of Jordan, 9000 years

1990
Tokyo, Japan (Takashimaya Gallery)
King's Road – Art and Culture of Jordan, 9000 years

1990/1991
Berlin, Germany (Haus der Kulturen der Welt)
Pracht und Geheimnis Kleidung und Schmuck aus Palästina und Jordanien

1991
Liverpool, England (National Museums & Galleries on Merseyside / Liverpool Museum)
Jordan: Treasures from an ancient land of the Desert Kingdom

1991
Aarhus, Denmark (Forhistorisk Museum in Moesgaard)
2000 years of colour

1992
Gothenburg, Sweden (Etnografiska Museum)
2000 years of colour

1992
Stockholm, Sweden
2000 years of colour

1992 Reykjavik, Iceland (National Gallery)

1993
Amman, Jordan (Centre culturel Français d'Amman)
Mémoire de Soie

1994
Bergen, Norway (Bryggens Museum, Artcenter 3/14)
Kawar-Samlingen/ Palestinske og jordanske folkedrakter

1994/1995
Oslo, Norway (Etnografisk Museum, Institut og Museum for Antropologi/ Universitetet)
2000 years of colour Folkedrakter fra Palestina og Jordan Kawarsamlingen

1997
Paris, France/ Paris (Municipal Cultural Centre)

2001
Amman, Jordan (Darat al Funun- Khalid Shoman Foundation)
The Memory of Silk

2002
Tokyo, Japan (Bunka Museum) *Costumes Dyed by the Sun*

2003
Bubikon, Switzerland (Ritterhaus Bubikon)
Anaths Erbe – Kleider und Schmuck aus dem Orient

2004
Riyadh, Saudi Arabia (The National Museum/ King Abdul-Aziz Historical Centre) *Palestinian Traditional Treasures*

2008
Lindau, Germany (Stadtmuseum Lindau)
Pracht und Geheimnis Erlesener Schmuck, prächtige Stoffe und Kleider aus Jordanien, Palästina und der arabischen Welt

Selected Bibliography

- Al-Arif, Arif, *A History of Bir Saba' and its Tribes*, Jerusalem, 1937.
- Al-Aref, Aref, *Al-Mufassal Fi Tareekh Al Quds* [History of Jerusalem], Al Andalus Library, Jerusalem, 1961.
- Al-Bawab, Ali Hassan, *Mawsu'at Yafa Al Jamila* [Beautiful Jaffa], Encyclopedia Vol 2, The Arab Institute of Studies and Publication, Beirut, 2003.
- Al-Dabbagh, Mustafa, *Biladuna Falastin* [Our Country, Palestine], 1972.
- Amir, Ziva, *The Development and Dissemination of the Chest-panel of the Bethlehem Embroidery*, Israel Museum, Jerusalem, 1988.
- Asali, K J (editor), *Jerusalem in History*, Olive Branch Press, Brooklyn, 1990.
- Asali, Kamel, *Some Islamic Monuments in Jerusalem*, Cooperative Press, Amman 1982.
- Baedeker, Karl, *Guide Book: Palestine and Syria*, Karl Baedeker Publisher, Leipzig, 1898.
- Baldensperger, Philip, *Beit Dajan*, Palestine Exploration Fund, London 1895.
- Balfour Paul, Jenny, *Indigo*, British Museum Press, London, 2002.
- Cohen, Amnon, *Palestine in the 18th Century*, The Hebrew University, Jerusalem, 1973.
- Crowfoot, Grace M and Phyllis M Sutton. "Ramallah Embroidery," *Embroidery*, 3/2, March 1935
- Dalman, Gustav, *Arbeit und Sitte in Palästina* [Work and Tradition in Palestine], Vol V,
- Fleischmann, Ellen L, *The Nation and Its "New" Women: The Palestinian Women's Movement 1920-1948*, University of California Press, Berkeley, 2003.
- Granqvist, Hilma, *Marriage Conditions in a Palestinian Village*, Scientific Society, Helsinki, 1931.
- Grant, Elihu, *People of Palestine*, Lippincott, Philadelphia, 1921.
- Kawar, Widad, *Costumes Dyed by the sun*, Bunka Publishing Bureau, Tokyo, 1982.
- Kawar, Widad and Katharina Hackstein, *Memoire de Soie* [Memories in Silk], Institut du Monde Arabe, Edifra, Paris 1988.
- Kawar, Widad, "History of My Collection" in Annette Damm, *2000 Years of Colorful Beauty: Costume and Mosaics from Palestine and Jordan* (Danish), Moesgaard Museum, Denmark, 19.
- Kawar, Widad and Tania Tamari Naser, *Palestinian Embroidery—Traditional "Fallahi" Cross Stitch*, Institute of Publishing, Beirut.
- Kelman, John, *From Damascus to Palmyra*, London, 1908.
- Kenyon, Kathleen, *Digging Up Jericho*, Praeger, New York, 1957.
- El-Khalidi, Leila, *The Art of Palestinian Embroidery*, Saqi Books, London, 1999.

- Khalidi, Walid, *Before Their Diaspora*, Institute for Palestine Studies, Washinton DC, 1984.
- Khalidi, Walid, *All That Remains: The Palestinian Villages Occupied and Depopulated by Israel in 1948*, Institute for Palestine Studies, Washington, 1992.
- Lamm, Carl J, *Cotton in Medieval Textiles of the Near East*. Librairie Orientaliste Paul Geuthner, Paris, 1937.
- Lane, Edward, *The Manners and Customs of the Modern Egyptians*, London, 1860.
- Pfister, R, *Textiles de Palmyre*, Paris, 1934.
- *Pracht und Geheimnis* [Splendour and Secrets], Catalogue of the Collection of Widad Kawar from the Exhibit at Rautenstrauch Joest-Museum, Cologne, Germany, 1987.
- Shahid, Serene Husseini, *Jerusalem Memories*, Naufal Press, Beirut, 1999.
- Sakakini, Hala, *Jerusalem and I*, Commercial Press, Amman, 1987.
- Scarce, Jennifer, *Women's Costumes of the Near and Middle East*, Unwin Hyman, London, 1987.
- Sutton, Phyllis M, *Thank You, Arabs*, Catholic Press, Beirut, 1972.
- Tamari, Salim, *Jerusalem 1948: The Arab Neighborhoods and Their Fate in the War*, Institute of Jerusalem Studies, Washington DC, 1999.
- Tamari, Salim and Issam Nassar (editors), *Ottoman Jerusalem in the Memoirs of Wasif Jawhariyyah*, Heinrich Böll Foundation, 2003.
- Tleel, John N, *I am Jerusalem*, Old City, Jerusalem, 2000.
- Thomson, W M, *The Land and the Book*, London, 1867.
- Tristram, H B *Land of Israel: A Journal of Travels in Palestine*, London: Society for Promoting Christian Knowledge (SPCK), London, 1865.
- Vester, Bertha Spafford, *Our Jerusalem*, Ariel Publishing House, Jerusalem, 1988.
- Weir, Shelagh, *Palestinian Costume*, British Museum, London, 1989.
- Weir, Shelagh, "The Bridal Headdress of Southern Palestine", *Palestine Exploration Quarterly*, Jan-June, 1973.
- Weir, Shelagh, *Spinning and Weaving in Palestine*, London, British Museum, London, 1970.
- Weir, Shelagh and Widad Kawar, "Costumes and Wedding Customs in Beit Dajan", *Palestine Exploration Quarterly*, Jan-June 1975.

Index

Aboud 7, 14–15, 27, 37, 64, 67, 74, 76, 78, 80, 84–7, 160
Absentee Property Law 105
Abu al-Fadl 64, 260, 262
Abu Elias of Iqrit 308–9
Acre Villages 302
Ahliya Girls' School 256, 259
al-Aqsa Mosque 188, 191, 233
al-Arabi Club 217
al-Asmar, Tayseer 194
al-Auneh Day 113
al-Bireh 64, 67
al-Buqei'a 64, 304
al-Damun 64, 290, 302, 305, 307
al-Haram al-Ibrahimi Mosque 107
al-Ne'ane 256–7, 259
al-Qubab 64, 257, 259, 265
al-Rameh 24, 35, 64, 304, 308–9
al-Santareasy, Ruqiya 227, 230, 233, 235, 237, 244, 416
al-Sutariya, Aysheh 260, 262–3, 365
al-Tira 198–200, 293
alaly 229
Aleppo 37, 41, 188, 196, 265, 284, 305, 435
Alma 64, 294, 297
Alya of Jericho 98–9, 101, 103
American Alliance School in Jerusalem 9
American University of Beirut (AUB) 9, 16
Amman 18–19, 28, 32, 35–6, 47–9, 104, 198, 201, 243–5, 256, 259–60, 262, 349, 402, 420, 442–4
amulets 31, 47, 49, 52, 55–7, 94, 111, 119, 238, 262–3, 353, 362, 440
Anabta 64, 319, 321, 330, 335
ancient beads 93–4
Aqabat Jaber Refugee Camp 22, 24, 97–8, 103, 120
Arab costumes 45, 437
Arab nationalism 213, 217, 249
Arab Women's Union 219
Asira 64, 335
Azazmeh tribe 398, 401–2
Bab al-Amud (Damascus Gate) 178, 181
Bab al-Khalil (Jaffa Gate) 177, 181, 198

banayek 61–3, 439
baskets 194, 305, 333
Batshons of Lydda 265–7, 415
bayader 199–200
Beaded crocheted headdress 233
beads 55–6, 97, 104, 111, 230, 233, 262–3, 383, 390, 393, 400, 427, 440
Bedouin 1, 48, 60, 62, 94, 213, 262, 293, 296, 377, 379, 381, 383–4, 387–8, 390, 394
Bedouin costumes 39, 379, 385, 392, 405, 410
Bedouin of Southern Palestine 36, 260, 377, 387, 402, 406, 420
Beirut 16, 18–19, 294, 307, 413, 420, 443–4
Beirut College for Women 16, 18
Beisan 61, 64, 274, 293
Beit Dajan 20–1, 37, 64, 156, 158–9, 223, 225–7, 229–31, 233, 235, 237–8, 241–5, 416, 443
Beit Hanina 65, 203
Beit Jala 65, 139–40, 145–6, 160, 162, 210
Beit Jibrin 21–3, 65, 357, 361
Beit Nabala 64, 259, 265, 269
Beit Sahour 65, 139–40, 162
belts 1, 41–2, 103, 220, 290, 323, 353, 357, 383, 388, 390
Benedictines 136
Bethlehem 8, 10, 12, 60–2, 82, 135–7, 139–43, 145–7, 149–51, 153–60, 162–7, 169, 171–3, 175, 210–11, 439–40
Bethlehem costume 11, 71, 82, 84, 89, 135–6, 142–3, 150, 156, 158, 160, 166, 210, 230, 257, 440
Bir Saba 52, 61–3, 65, 377, 381, 384, 388, 390, 394, 396, 398, 400, 406, 409–10, 443
Bir Zeit 65, 67
Bitounia 65, 67
bracelets 47, 51, 326
Branch of Almond Blossoms 362, 365
Bridal Headdress of Hebron Area 35
Bridal Headdress of Southern Palestine 444
bridegroom 52, 78, 104, 116, 150, 175, 227, 235, 238, 244, 267
brides 51–2, 103–4, 116, 130, 140, 146, 153, 160, 163, 199, 205, 233, 238, 265–6, 325,

445

439–40
British Mandate 9, 12, 52, 77, 177, 185, 233, 244, 249, 256, 377, 379
British Museum 35–6, 444
Brummana 9–10
Budrus 265
bukjehs 196, 328
burqa 383, 393, 409
camp dresses 414, 417, 430
Centre for Palestinian Culture 424
chokers 108, 283, 326, 330
Christians 55, 107, 137, 140, 198, 247, 251, 280–1, 293
Church Missionary Society in Palestine 35
church schools 139, 149
cloves 78, 116, 330, 405
communal oven 124, 126
Costumes and Wedding Customs in Beit Dajan 238, 444
couching 12, 60, 62, 82, 85, 135, 139, 156, 158, 160, 162–4, 166, 208, 210–11, 252–3, 440
cushions 22, 63, 90, 120, 130, 330, 371, 394, 413, 420, 425
Dajani, Halimeh and Ruqiya 22, 244–5, 416
Damascus 18, 21, 37, 41–2, 177, 187–8, 191, 197, 219, 237, 284, 290, 323, 325, 328, 341
Dead Sea 384, 398, 401
Deir Samet 65, 111, 119, 122
Deir Yasin 65, 140, 203, 207
deyal 62–3
dolls 104–5, 260
dressmakers 191, 194, 198, 266
Druze women 293, 311
Dura 65, 119, 122, 166, 294
Easter 182–3
Egypt 25, 44–5, 48, 61, 145–6, 185, 217, 235, 249, 265, 273, 343–4, 354, 374, 383, 420
embroiderers 10, 37, 82, 142, 158, 160, 164, 227, 256, 294, 397, 416
embroidery centre 32, 35, 98, 105, 135, 160, 394, 419–20
embroidery patterns 1, 39, 60, 62–3, 75, 82, 89, 101, 104, 233, 253, 256, 259–60, 417, 421–4, 427
embroidery thread retailers 415
En Karem 10, 16, 21, 64, 140, 149, 160, 203, 207–8
European patterns to Palestine 237
evil eye 57, 98, 101, 124, 362
exhibitions , 25, 35–7, 45, 442
Faizeh of the Tayaha tribe 388, 390
Faluja 61, 63, 65, 114, 116, 345, 347, 357, 361–2, 365, 390, 393–4, 398, 401
Faluja-area villages 372
festive dress 139, 172, 238, 269–70, 356, 375, 381, 439
flutes 305, 307
folklore 39, 84–5, 127, 243
Franciscans 136
Friends School in Ramallah 18
Galilee 60, 62, 64, 273–7, 279, 281, 283, 285, 289–91, 293–5, 297, 303–5, 307–9, 311, 317
Galilee costumes 24
Gaza 36, 47, 52, 60–1, 63–5, 229, 266, 343–5, 347, 349, 353–5, 361–3, 371–5, 390, 396–7
Gaza-area costumes 63, 114, 343, 347, 352
gold coins 51–2, 82, 126, 135, 155, 175, 321, 330, 333, 439
gold jewellery 25, 32, 47–8, 266, 294
Habiba of Bethlehem 150–1, 153–5
Haifa 64–5, 182–3, 199, 229, 273, 299, 302, 415
Halhoul 119
Hama 42, 196, 265, 290, 328
Hamdeh of the Tayaha tribe 103, 388, 390, 393–4
hammam 196–7, 328, 440
Hasna of Isdud 354
Hazboun, Manneh , 10, 142, 153–4, 156, 158–9, 230–1, 235
Hazboun Mahyub, Jamila 10, 142, 158, 160, 162–3, 205
headdress 1, 20, 41, 51, 60, 77–8, 82, 130, 135–6, 166, 175, 213, 233, 321, 383–4, 439–40

Index

Hebron 22, 35–6, 53, 60–2, 64–5, 107, 109, 111, 113–27, 129–31, 133, 260, 357, 396–7, 401–2
henna 80, 116, 119, 196–7, 330, 430, 439
Hidim (coat dress) 337, 341
Hind of Alma 294, 296–7
Homs 37, 41, 265, 290
Hussein Refugee Camp in Amman 243–5, 416
Im Bishara 150, 266–7
Im Fathy 32
Im Ibrahim 230, 233, 237
Im Kamel 101, 104–5
Im Suleiman 98, 101, 103–5
Im Zuhdi 31, 256–9
Inaash (Association for the Development of Palestinian Camps) 302
Institute for Palestine Studies 21, 433, 444
Institute of Jerusalem Studies 444
Intifada dress 429–31
Iqrit 64, 308–9
Irani
 Fuad 9
 Jalal 9
 Munir 9
 Najib 9
Irbid 49, 51
Isdud 21–2, 61, 64, 345, 347, 352–4, 357, 361, 371, 374
Israeli army 98, 105, 119, 122, 126, 158–9, 198, 203, 256, 260, 265, 299, 302, 304, 361–2, 401–2
Israeli courts 309
Israeli occupation 16, 27, 37, 86, 299, 325, 429
Itafi dress 202
Jaber, Fatma 362
jackets 11, 122, 142, 149, 155, 160, 164, 169, 220, 284, 290, 354, 383, 393
Jaffa 42, 49, 61, 64, 156, 158–9, 213, 215–17, 219–21, 223, 225, 229, 235, 241, 253
Jaffa and Lydda area villages 238, 263
Janna wa Nar dress 335
Jaradeh, Helweh 158, 164
jehaz 116, 230, 238
jellayeh 6–7, 60, 78, 82, 108, 114, 119, 238, 287

Jenin 25, 61, 64, 319, 326, 332
Jericho 22, 24, 64, 93–5, 97–9, 101, 103–5, 120, 260, 361, 427, 443
Jerusalem 9–10, 32, 41–2, 60–2, 64, 177–9, 181–3, 185, 187–9, 191, 193–201, 203, 205, 207, 213, 443–4
Jerusalem area villages 169, 175, 181, 202–3, 205, 207, 210, 213
Jerusalem Girls' College 198
Jerusalemites Hanna al-Jouzy and Khalil Salman 47
jewellers 11, 47, 57, 188, 220, 299, 325–6, 393
jewellery 1, 7, 21, 25, 29, 47–8, 51–3, 55, 57, 78, 104, 116, 227, 244–5, 297, 384
Jewish National Fund 105
Jibril, Wafa 225, 227
Jifneh 64, 67
Jordan 1–2, 8, 12, 18, 21–2, 39, 97–8, 104–5, 293, 396–8, 401–2, 415–17, 424–5, 427, 434–5, 442
Jordanian costumes 39, 45
kaffiyeh 213, 439
Kafr Ana 64, 269
Kafr Yassif 64, 274, 276
Kasbah 323
Kawar
 Kamel 18–19, 21, 279, 283
 Naheel 284
Kenyon, Dame Kathleen 94
khirbet 122, 256, 433
Kuwait 25, 415, 424
Kuzma, Mary 18, 21
Lake Hula 64, 274, 293
Lebanon 9, 16, 42, 61, 188, 199–201, 274–5, 294, 302, 304–5, 308, 413, 415, 417, 421
Lifta 16, 42, 64, 85, 140, 149, 160, 203, 205, 207
London 36, 65, 94, 443–4
Lydda 64, 74, 77, 85, 229, 235, 247, 249, 251, 255, 265, 267, 271, 415
machine embroidery 164–6, 208, 243, 312, 414, 439
Madani family 42
Majdal 21, 61, 63–4, 185, 238, 265, 345, 347–9, 352–3, 357, 362, 375

malak dress 11, 136, 139–40, 142, 145–6, 149–50, 153, 155, 210, 237
Malha 16, 21, 64, 85, 140, 149, 160, 203, 205, 207–8
Mansour, Suleiman 422–3
Mariam of the Azazmeh tribe 101, 103, 398, 400, 402
Masmeyeh and Qatra villages 375
Mount of Olives in Jerusalem 330
Mufeida of Jerusalem 198–9, 201
Musa, Fatma 114
Museum of Mankind 35–6
Musrara quarter of Jerusalem 10
Musallam, Abdul Hay 422–3
Nabi Musa 182–3
Nablus 25, 36, 41, 51, 60–1, 64, 201, 237, 265, 267, 319, 321–3, 325–7, 329–33, 335
Nablus and Galilee villages 9, 53, 319, 321, 325–6, 330, 338, 341
Naqab 60, 62–3, 65, 260, 377, 379, 384, 388, 409
Naser brothers in Bethlehem 145–6, 265
Nazareth 18, 21, 24, 35, 61–2, 64, 187, 273, 275, 279–81, 283–4, 287, 293–4
Nazareth area 273, 275, 287
necklaces 47, 51, 78, 104, 194, 330, 357, 393, 440
Ottoman coins 49, 52–3, 90, 130, 169, 175, 343, 361
Ottoman styles 18, 21, 177, 187–8, 219
oya 187, 293
Palestine and Jordan 21, 41–2, 52, 280–1, 443
Palestine Exploration Fund 35, 238, 443–4
Palestinian artists 422–3, 429
Palestinian Land Society 65
Palestinian Villages Occupied and Depopulated 21, 433, 444
Palestinian Women's Union 419
patchwork 60–1, 122, 129–30, 172, 259, 287, 289, 312, 335, 365, 385

patterns 8, 15–16, 30–1, 60, 103, 111, 145–6, 160, 162–4, 229–30, 238, 256, 259–60, 416–17, 419–20, 440

pottery 22, 80, 227, 439
Prophet Moses 182–3
qabeh (chest panel) 61–3, 205, 208, 321, 365, 381, 419
Qais 78
Qalqilia 60, 64, 319, 321, 330, 332–3
Qibya 65, 265
Qirri 325–6
Qubayba 64, 114, 120–1
Ramallah 7–9, 12, 60, 64–5, 67, 69, 71, 73–7, 79–87, 89–91, 101, 103–5, 253, 259–60, 439–40
Ramallah area 6, 14, 51, 53, 160, 330
Ramallah costumes 13, 16, 67–9, 71, 73, 82, 84, 87, 89–90, 101, 203, 253, 424, 443
Ramla & Lydda 62, 64–5, 85, 235, 247, 249, 251, 253, 255–7, 259–61, 263, 265, 267, 269, 271
Ramla area 248, 251, 256, 259–60
Ramla area embroidery patterns 223, 257, 259–60, 362
Red Cross 25, 105, 185, 200, 259
Rockefeller Museum in Jerusalem 198
Sabeeha of Deir Samet 122, 124, 126
Sabha of the Tarabeen tribe 394, 396–7
Safad 25, 41, 61, 65, 273, 290–1, 294, 296, 302
safadiya dress 41, 291, 440
saha pattern 394, 397
Sakhnin 65, 289, 304
Samara, Nour , 74–6, 87
SAMED 421
sarma 177, 188, 191
shatweh 150, 153, 162, 175
shawls 1, 32, 71, 82, 116, 124, 127, 172, 210, 290, 420, 439
shells, cowry 383–4, 388
shirwal 243, 314, 440
Silhy, Helaneh , 10, 164–6
silk 41–2, 62, 77, 109, 111, 114, 116, 139, 163, 169, 185, 187, 196, 208, 439–40, 442–3
silk abaya, embroidered 191
silk belt 187, 321
silk patchwork 108, 238, 258, 287, 347–8, 374–5

silver, hammered 188, 191
silver coins 124, 210, 213, 393
silver jewellery 11, 25, 47–8, 52, 55, 121, 155, 166, 325, 330, 393
sleeves 11, 61, 71, 82, 108, 129–30, 139–40, 191, 207–8, 238, 251, 256, 258–9, 335, 347, 383–5
soap 74, 84, 196, 322–3, 326
spools, wooden 159, 163
St Elias 182–3
St George 53, 55, 247, 251
stitch embroidery 62, 130, 230, 253, 293, 372, 374, 416, 439
Summail 65, 362, 365
suq al-Qatateen 185
Syria 20, 25, 37, 39, 41–3, 48, 61–2, 145–6, 154, 188, 273–5, 289–90, 293–4, 420–1, 434–5, 439
taffeta 122, 269, 276
Taffuh village 129
Tarabeen tribe 394, 396–7
Tayaha tribe 383, 385, 388, 394
tents 22, 24, 111, 120, 235, 259, 388, 394, 398, 401–2
Thob Irq El Loz 362, 365
Tiberias 61, 64–5, 273–4
Tireh dress 201
Tripoli 200, 302, 305, 307
trousers 7, 60, 78, 238, 243, 294, 314, 330, 332
trousseau 18, 21, 36, 74, 77, 103–4, 116, 153, 198, 210, 230, 238, 284, 439
Tubas 65, 335
tubsi dress 6–7, 78, 253
Tuktuk, Greta 328, 335
Tulkarem 9–10, 25, 61, 64–5, 319, 321, 332
Turkey 164, 185, 187–8, 265
Tyre 200, 305, 308
velvet 146, 170, 188, 191, 226, 230, 321, 330
velvet costumes 146, 154, 158, 205, 210
Wadi al-Akhdar 398, 402
Wadi Araba 65, 398, 401–2
Wardeh of Qalqilia 10, 330, 332–3
weavers 10, 13, 37, 41–2, 146, 156, 185, 266, 273–4, 279, 349, 415

wedding 36, 52, 78, 103–4, 119, 150, 153, 156, 162, 196, 201, 205, 233, 266, 332–3, 430
wedding dresses 6, 77–8, 140, 158, 162, 188, 198, 265, 326
Weir, Shelagh 35–6, 441
weqaya 77–8
Wihdat Refugee Camp in Amman 388
Yatta village 120, 127
Yazur and Safiriyya villages 223
Yemen 44–5, 78, 242–3
yom al-istikbal 194
Young Women's Christian Association 20
Zakariya village 130
Zarou, Samia 422–3